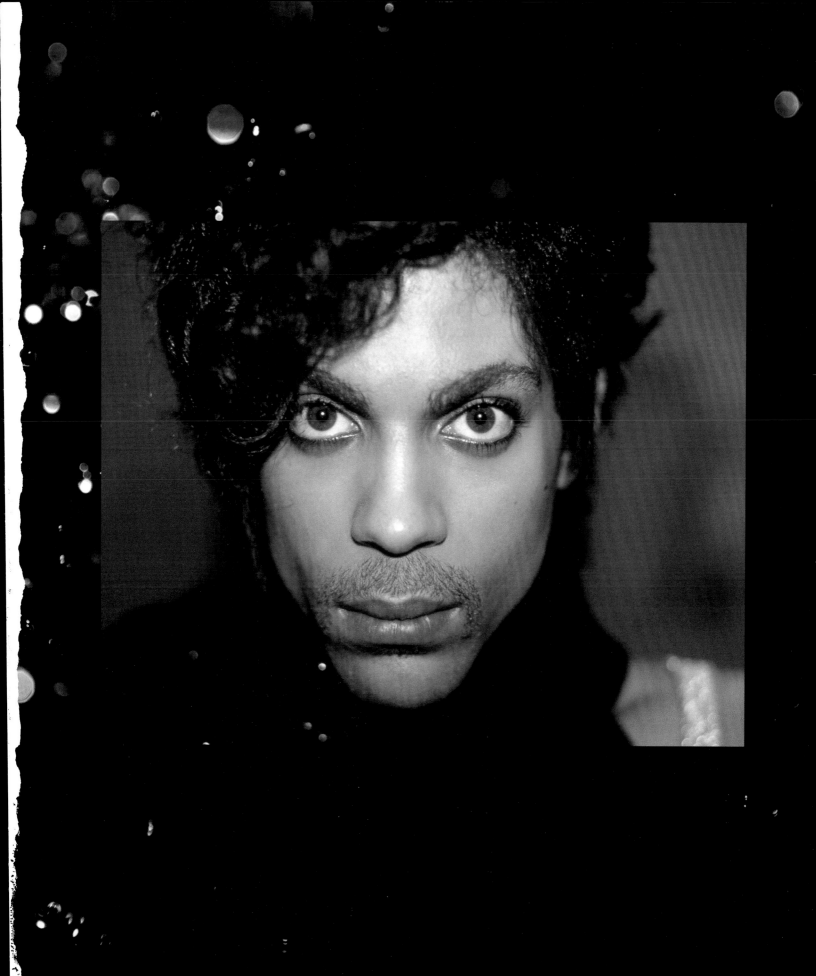

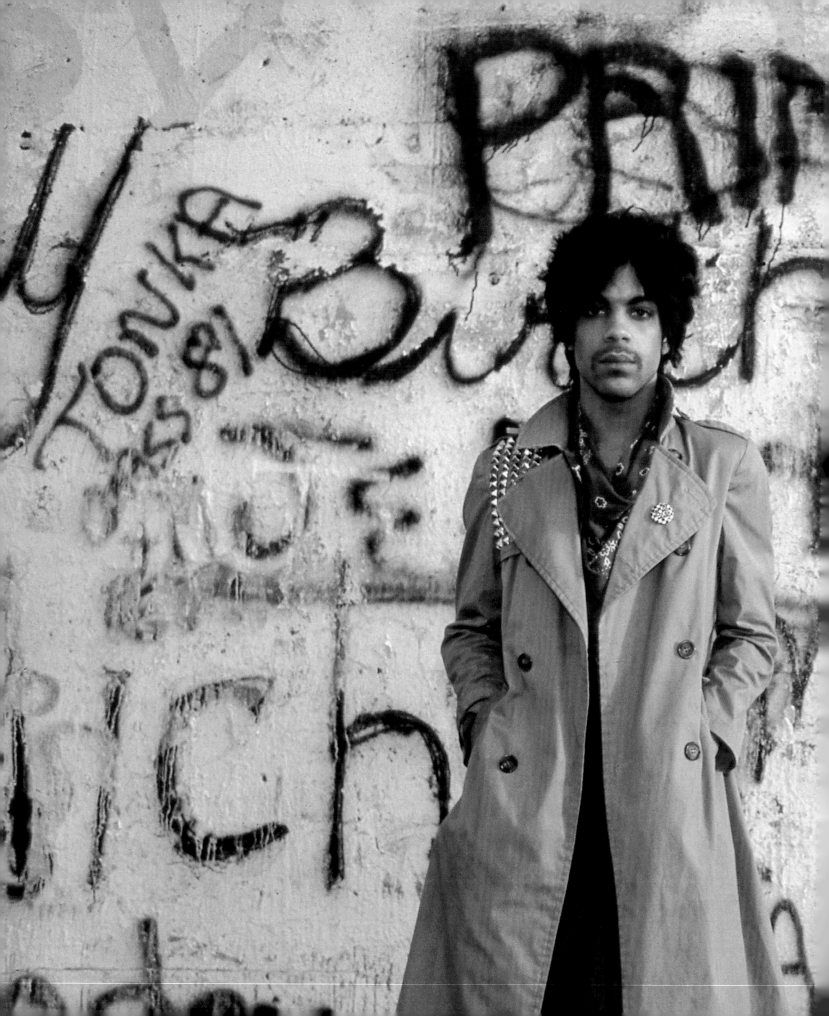

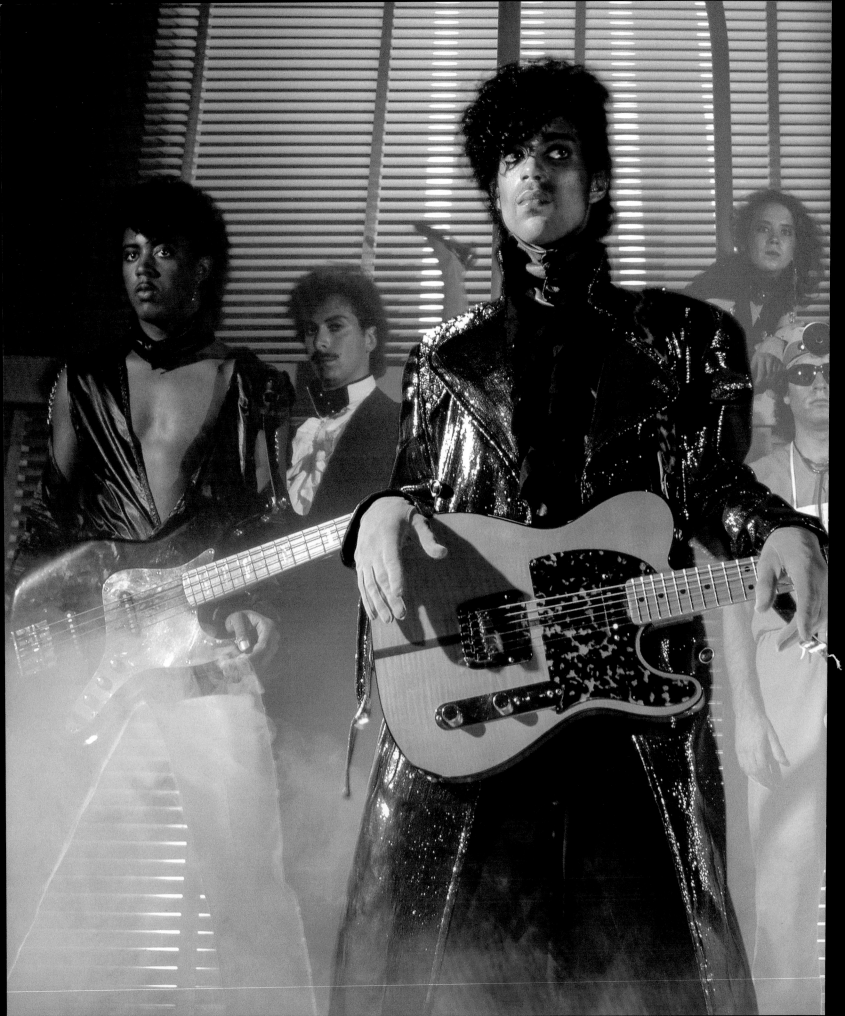

PRINCE

BEFORE THE RAIN

Photography by Allen Beaulieu

Foreword by Dez Dickerson

Introduction by Jim Walsh

With additional contributions by Eloy Lasanta

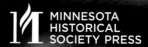
MINNESOTA
HISTORICAL
SOCIETY PRESS

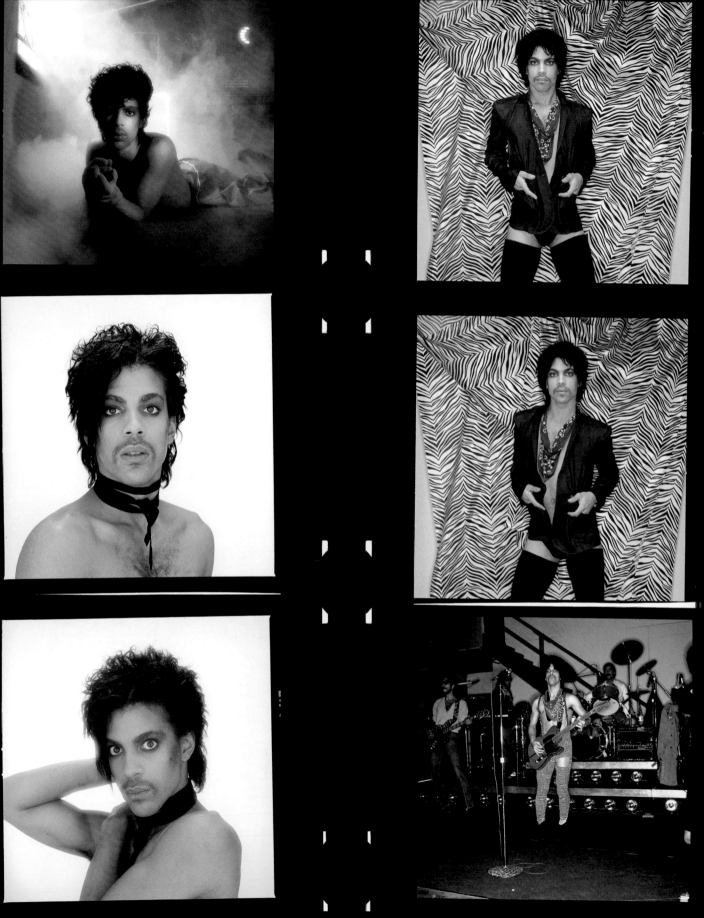

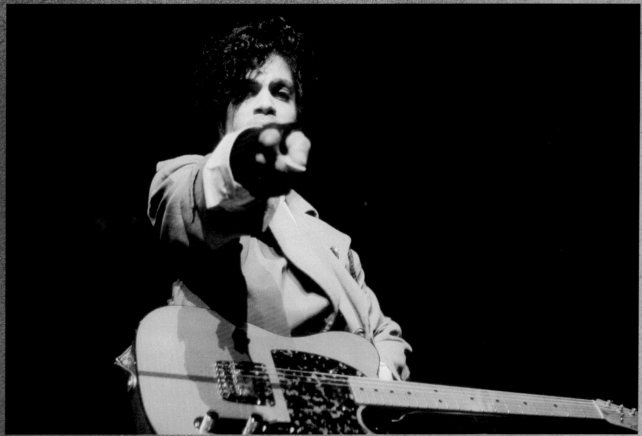

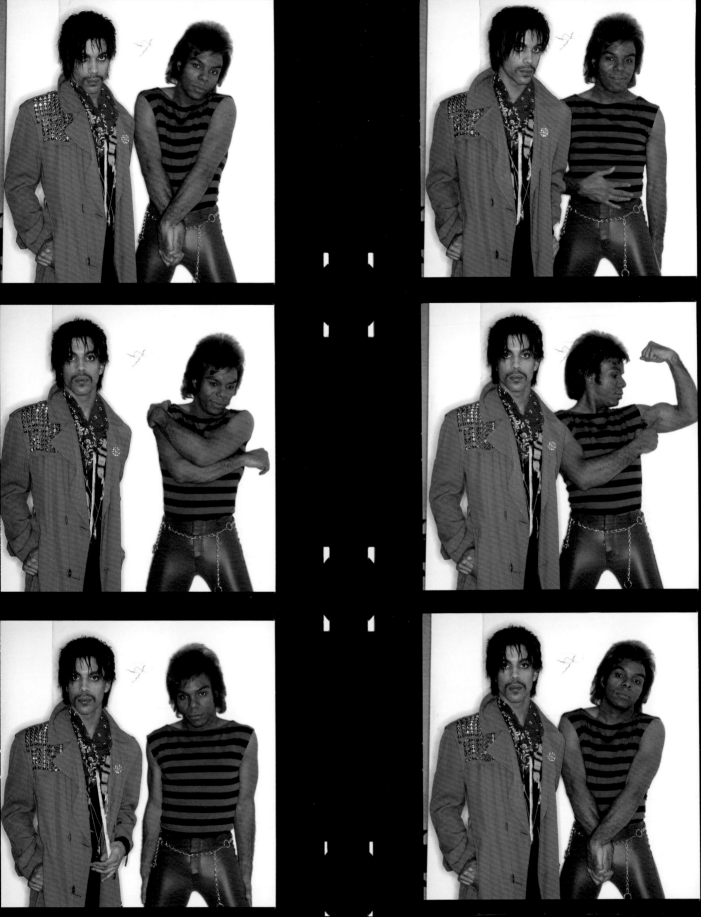

Foreword

By Dez Dickerson

Few artists legitimately bear the label of icon, and few icons are more synonymous with visual image than Prince. One man who was as responsible as anyone alive for capturing that iconic image is photographer Allen Beaulieu. Few people can say that their work helped to shape the image of a legend—Al can. Even fewer can say they were not only photographer but also confidant and friend.

I first met Al when a crazy quilt of disparate musicians walked into his studio for their first photo shoot as a band. At that point we were still in the beginnings of early rehearsals, learning the material, getting to know one another as people. Doing promo photos as a band in a photo studio was very much a new thing. Before that, there hadn't been any sort of visual component or brand consciousness. It had been purely about playing music together. Then we entered a whole new world of finding out how we mixed and meshed visually. We encountered that working with Al. We took a giant step toward becoming a band.

Allen's role in this is significant and, deservedly, legendary. Who can forget his stellar work in capturing and documenting the birth of a legend? His photographs of an artist heading down the path toward superstardom graced album covers, posters, and magazines everywhere, imprinting the image in the minds of fans for decades to come.

As was the case with Prince, I'm happy to call Al a friend—and someone who deserves recognition for his role in solidifying a visual presence that will last throughout the history of music and popular culture.

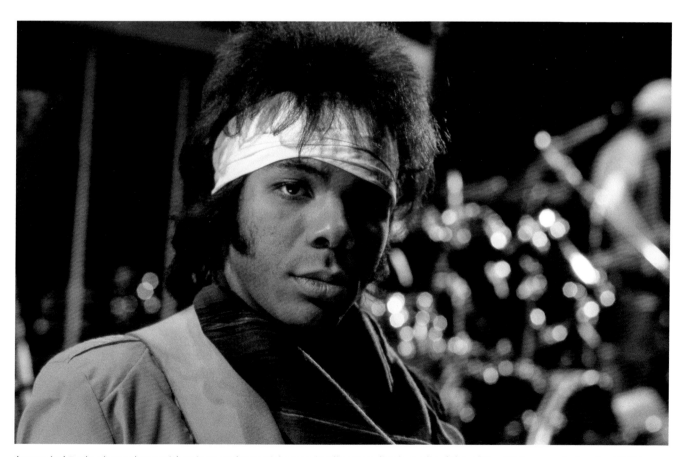

(opposite) Early photo shoot with Prince and Dez Dickerson in Allen Beaulieu's studio. *(above)* Dez Dickerson, during the *1999* tour.

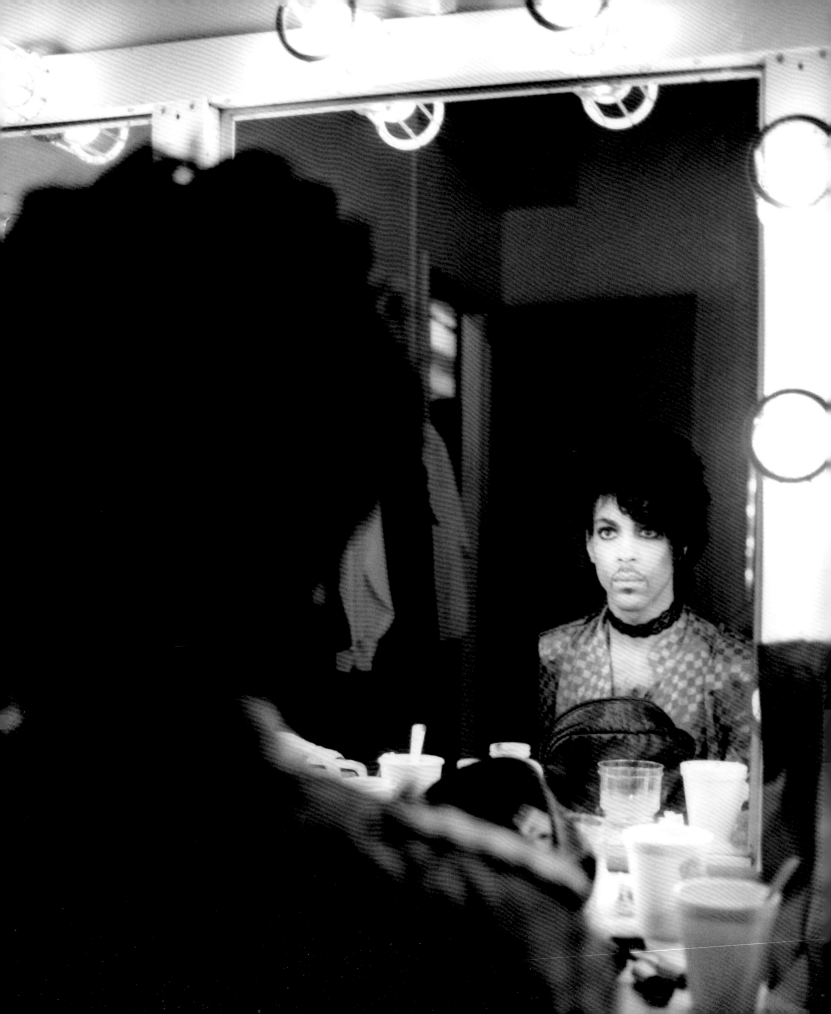

Introduction

A Musician and His Photographer

By Jim Walsh

Ask Allen Beaulieu about the death of his friend, inspiration, collaborator, and fellow artist Prince Rogers Nelson, and he'll tell you he "cried for days" afterward. Many of Beaulieu's photos that adorn Prince's early albums made their way around the world that supremely sad day of April 21, 2016.

Beaulieu was a witness to history and grand master of the iconic images that introduced the world to the young man who would become the rocking, sexy, steamy, soulful, gender- and genre-nonconforming genius/musician/angel of our lives and times. Ask Beaulieu what his elevator speech has been over the years about his time spent with Prince, and his voice cracks with emotion.

"I'll never say anything bad about the man," said Beaulieu, sitting in the living room of his suburban Minneapolis home. "The man was beautiful to me. He took me on three tours. I got to see the country. I got to see a rock star. I got to develop a rock star. Actually, when I was in New York doing fashion photography, I'd take my [portfolio] book around, and I got the greatest compliment from one art director, who said, 'I saw your work before I even heard Prince. I saw your work first.' That's saying something."

For many Prince fans in those early days, the sights often preceded the sounds. Before hearing the music, they saw Beaulieu's evocative, sexy, gritty, playful, powerful images on the covers of *Dirty Mind* and *Controversy* and the inner gatefold of *1999*, as well as album covers for the Time, Vanity 6, and Jesse Johnson and promotional photos of Sheila E., Apollonia, and Jimmy Jam and Terry Lewis. Over a relatively short period, Prince and Beaulieu became close friends and a two-man team that produced some of the most memorable pop music photographs of the early 1980s.

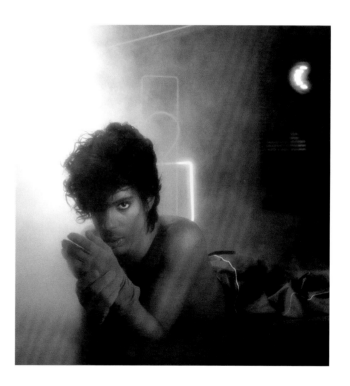

(opposite) Decades after it was taken by Allen Beaulieu, this photo of Prince at a dressing-room mirror was used on the cover of one of the first albums of unreleased recordings issued after Prince's death, *Piano & a Microphone*, in September 2018. *(above)* During this photo shoot for the *1999* album, Beaulieu captured the sultry and enigmatic allure of Prince that would define his image for much of his career. A different image from this session was used on the inside sleeve of the album.

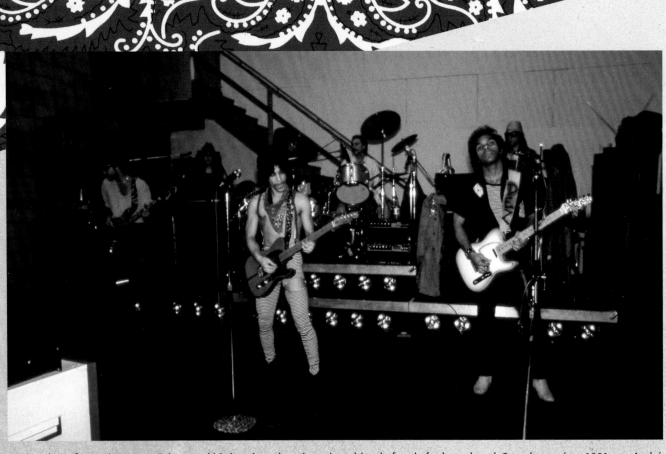

During these formative years, Prince and his band produced a unique blend of rock, funk, and soul. Seen here, circa 1981, are André Cymone on bass, Lisa Coleman on keyboards (behind Prince), "Bobby Z" Rivkin on drums, Dez Dickerson on guitar, and Matt "Doctor" Fink on keyboards.

"This is what he liked about me," said Beaulieu. "He didn't tell me this at the time, of course, he told me this later: 'You give really good instruction, very good art direction, and I loved your lighting. It just did something to me, instantly. You didn't say all those words to me that the other photographers would, like, *Yeah, yeah, yeah, that's great; keep going, that's beautiful, oh yeah!*

"I never said that. It was just very quaint. 'Move your shoulder, put your chest out.' It was more like that, more like helping him see himself better. That's what he connected with."

In Beaulieu, Prince also found a pal he could share his newfound success with.

"He'd make me buy the records for him," said Beaulieu. "He wouldn't buy them himself. He goes, 'Al, you do it, 'cuz if I do it, it's gonna look stupid.' He'd drive around the block, and I'd go into one of the record stores on Hennepin Avenue in Minneapolis. I'd go in and get the records and jump back in his Triumph Spitfire. We did that for both *Dirty Mind* and *Controversy* on the release dates. I'm loyal. That's what he liked about me."

It all started in March of 1978. As a freelance photographer, Beaulieu had carved out a good career, securing regular gigs with *Minneapolis–St. Paul* magazine and shooting department store fashion spreads. His magazine work included cover shots of local luminaries, politicians, celebrities, artists, and musicians. This time was also the dawn of the alternative media, with the *Twin Cities Reader* and *Sweet Potato* (precursor to *City Pages*) reporting on the scene—a scene that amounted to a small but vibrant cross-pollination of creative energies among original music clubs like Jay's Longhorn, Duffy's, Sam's, and the Capri Theater; independent art institutions like Ballet of the Dolls, Theatre de la Jeune Lune, the Guthrie Theater, and the Minnesota Dance Theatre; a budding community of independent record stores, record labels, and musical instrument

stores; and a concentrated milieu of colleges, universities, and art schools.

Commercial radio was homogenous and heavy on classic rock, with the only adventurous programming being pushed out by KMOJ-FM, the main source for funk, R&B, and soul music, and by specialty radio shows on KFAI-FM and the University of Minnesota's college station, KUOM-AM. All the while, the rumblings of the Minneapolis punk-funk-rock-and-soul sounds that would soon be heard 'round the world were being mined in basements and garages all over town. The so-called Minneapolis Sound had been building for more than a decade in the primarily African American neighborhoods of South and North Minneapolis. Out of that scene emerged the band Grand Central, with Prince on guitar and keyboards, André Cymone on bass, Morris Day on drums, and Linda Anderson (Cymone's sister) on keyboards. By late 1976, Prince left Grand Central to branch out on his own.

In the spring of 1978, having just released his debut album, *For You*, nineteen-year-old Prince was living with Cymone's family, and there on the wall of the home of Cymone's mother—the late, great matriarch of the Minneapolis Sound, Bernadette Anderson—Prince saw a stylish poster for the fourth annual "Shades of Blackness Fashion Extravaganza" (held on March 18, 1978, at the Nicollet Mall YWCA, with Ron Edwards and J. D. Steele). The poster featured two African American models bathed in an almost heavenly light. Prince, struck by the image, tracked down the photographer responsible for it: Allen Beaulieu.

"I actually did do 'shades of blackness,'" laughed Beaulieu, a genial bear and beloved member of the early Twin Cities music scene whose family hails from Cass Lake on the Leech Lake reservation in north-central Minnesota. Beaulieu graduated from Cooper High School in New Hope, played guitar in area garage bands, and studied painting, graphic design, and photography at the Minneapolis College of Art and Design. "For that poster I shot black people on a black background with black clothes. I literally shot what it said: shades of blackness. And that's what caught Prince's eye."

Around the same time, Al's brother Rick, also a musician and gifted graphic artist who attended MCAD with his younger brother, first hipped Al to this new star blasting out of Minneapolis.

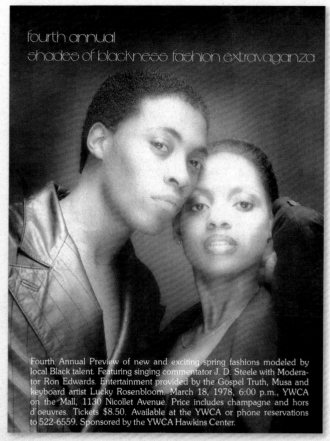

fourth annual
shades of blackness fashion extravaganza

Fourth Annual Preview of new and exciting spring fashions modeled by local Black talent. Featuring singing commentator J. D. Steele with Moderator Ron Edwards. Entertainment provided by the Gospel Truth, Musa and keyboard artist Lucky Rosenbloom. March 18, 1978, 6:00 p.m., YWCA on the Mall, 1130 Nicollet Avenue. Price includes champagne and hors d'oeuvres. Tickets $8.50. Available at the YWCA or phone reservations to 522-6559. Sponsored by the YWCA Hawkins Center.

Beaulieu's photograph on the "Shades of Blackness Fashion Extravaganza" poster from 1978 is the work that first caught Prince's eye.

"I remember my brother and I were at this bar, and 'Soft and Wet' came on," Al recalled, referring to the first single from the *For You* album. "My brother said, 'You know that musician is from here. You should photograph him.'"

When Prince ultimately did call, Beaulieu, accustomed to the singer's high falsetto voice from "Soft and Wet," remembered, "When I answered the phone, I was surprised there was this deep voice on the other end: 'Is this Allen Beaulieu?' I said, 'Yeah?' 'This is Prince.'

"You know, it was cordial. He said, 'How much do you charge an hour?' I go, '$150?' I was just spitballing. He goes, 'Okay, I want to book you for three days.' I go, 'Okay.'"

By this time, Prince had plenty of experience with photographers. The portrait on the cover of *For You* was shot by Joe Giannetti, whom Beaulieu had met as a young photographer and for whom he has great admiration to this day.

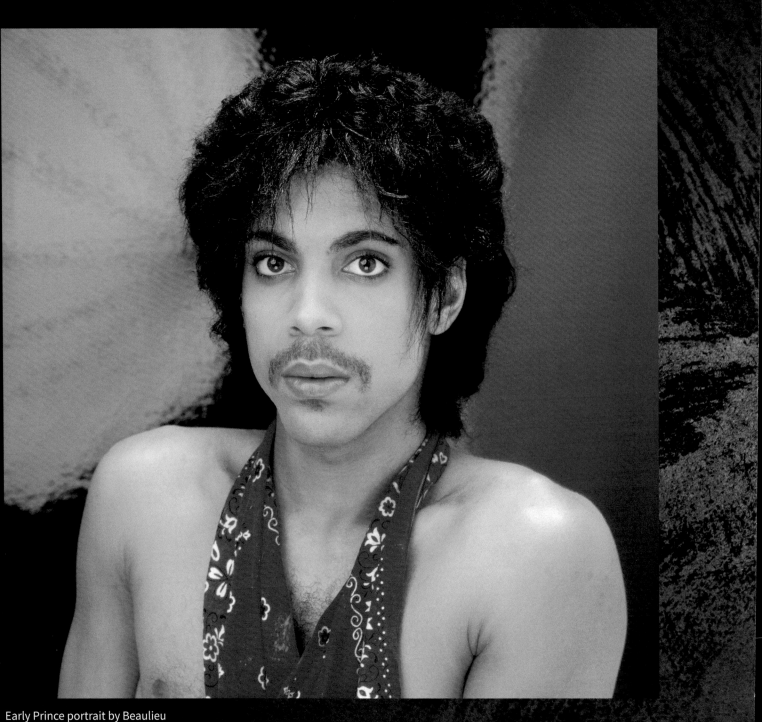

Early Prince portrait by Beaulieu

But other than signaling the first release by an amazingly gifted new artist who wrote all the material and played all the instruments, *For You* didn't make much of a commercial splash.

As a result, and as would become Prince's modus operandi for years to come, he was already gearing up for his next project, recording "I Wanna Be Your Lover," "Why You Wanna Treat Me So Bad?," "Sexy Dancer," and the rest of *Prince*, his second album, even as his months-old debut languished on the charts. Jurgen Reisch's cover portrait for *Prince* was fairly nondescript given the evocative, even provocative, subject and music within, leaving a somber-looking, elfin Prince and his budding sexy-mofo charisma to do all the work. But in Beaulieu, Prince recognized a photographer who could capture his supertemporal spirit and help translate it to print.

"He was looking for an artist like him," said Beaulieu. "One day he was explaining the second album cover [*Prince*] to his girlfriend at the time, Kim, and she said something about it, and he said, 'No, that album cover is art.' And I'm just saying to myself, 'I don't think that's art. That's kind of weird that he thinks that.' I believe what I showed him was art, or he saw it as art. After we worked together, he goes, 'Now I get it.'"

Beaulieu notes that he and Prince "didn't become instant friends or anything. I treated him very much like a client, and he treated me very much like a photographer."

The first photo shoot Beaulieu did with Prince resulted in the "red shorts and stars" images, which were promotional photos for the *Prince* album—or, the blue album, as he calls it.

To create the star effect, Beaulieu took a seamless black curtain and meticulously poked a galaxy of tiny holes into the fabric. He set up a bright strobe light behind it, and the bursts of light would appear through the tiny holes in the curtain.

"Prince had to wait through my resetting of the strobe light. I would walk around, flash it, recharge, flash, recharge, and he had to wait through twelve of those. Understand, Prince is in my studio; I shoot one shot, turn off all the lights so it's complete darkness for him and me, and all you could hear was the music. We played one song all night; I want to say it was 'Black Maria' by Todd Rundgren, because I'm a really big Todd Rundgren fan. It was hilarious. He was a pretty good sport about it.

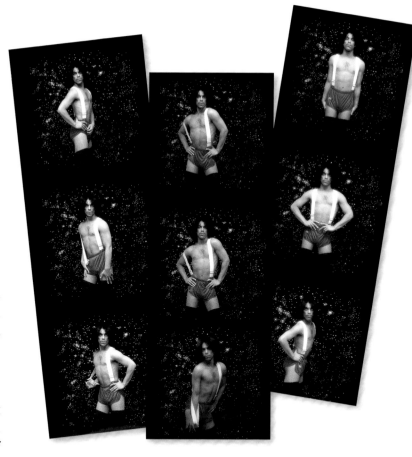

(above and following page) Taken during Beaulieu's very first photo session with Prince, the "red shorts and stars" image was used for a promotional poster for the 1979 album *Prince*.

"Later, I showed him the first sheet of the photos we did with the stars. They were just transparencies, and I've got this big light table you can view transparencies on, and he's looking at them, and he's going, 'These are really bad, these are really bad!' And I'm thinking, 'Oh man, I blew it. I get my one chance and I blow it.' And he goes, 'These are really *bad*,' and all of a sudden, I realize 'bad' is good! Okay, cool!"

Over the years, Beaulieu built a successful career as a music and fashion photographer, shooting from Minneapolis to New York and other ports, but it was that fateful strobe-light session that launched him into his role as Prince's go-to photographer for years to come.

The "red shorts and stars" photo landed in print ads and store windows all across the country. "That photo was in record stores three or four days after I shot it. That's how fast he got things done," said Beaulieu. "I remember walking down Hennepin, and it was in every record store. It's

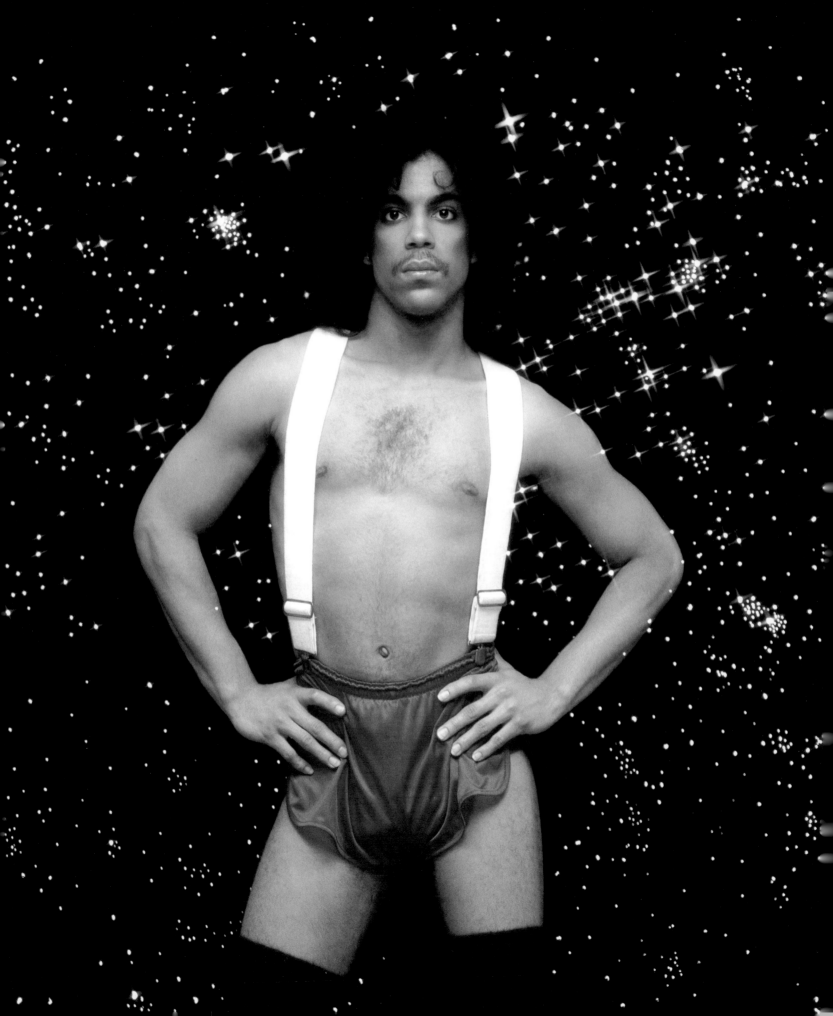

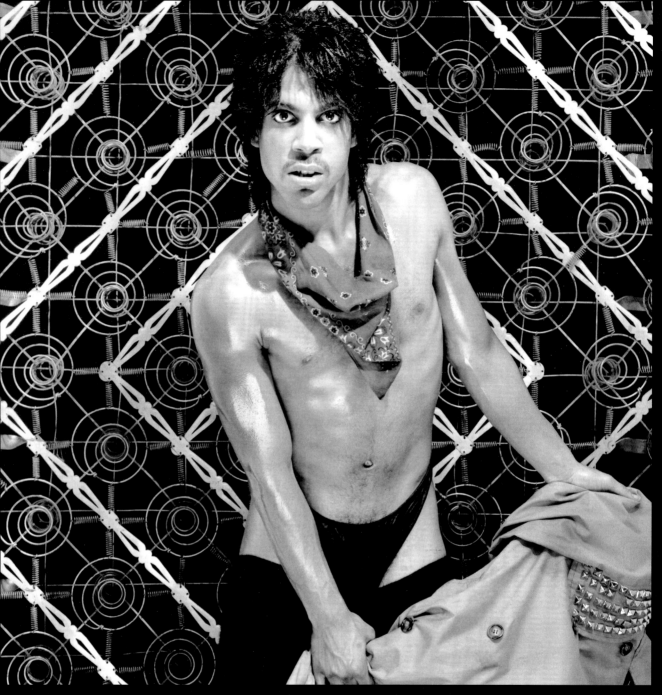

Outtake from the *Dirty Mind* cover session

really weird when you go across the country and you see your work everywhere."

While the photo he took was plastered in record stores nationwide, Beaulieu was working out of a small studio in downtown Minneapolis—across the street from First Avenue, the club that Prince would help catapult to national attention a few years later with the *Purple Rain* film. Beaulieu's setup was pretty bare-bones when he worked with

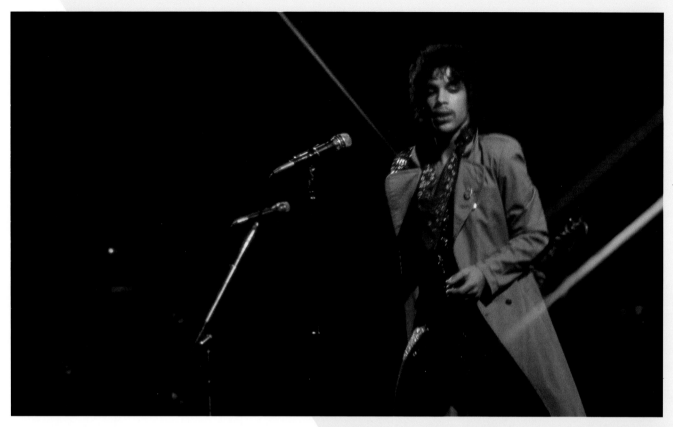

Prince always brought a fun, nasty, sexy attitude to his live shows, as seen here during the *Dirty Mind* tour in the spring of 1981.

Prince. "There was no makeup artist when we shot, ever. I had maybe one assistant, and he was only around for maybe one or two of the Time shoots or Vanity shoots. But all the shoots with just Prince and me was just Prince and me. We were creating an image. This is before he got really big. We were creating an image for people to latch on to."

That image would take a giant leap forward with the release of Prince's breakthrough third record, the deliciously tart and taut *Dirty Mind*—featuring Beaulieu's first-ever album cover photo.

Prince recognized that Al had a natural talent for capturing his subjects, and he also knew that, because Beaulieu worked as hard as he did, his new photographer friend was constantly in the creative flow and therefore fertile with ideas that could project the edginess of the new wave and now times. "Any photo I ever do, I have to see it in my head first, and then make it," Beaulieu remarked. "I don't know if everybody works that way—I doubt it; maybe that's what makes me unusual—but I gotta see it."

And that approach worked with *Dirty Mind*, which Beaulieu says Prince loved. "I had something I knew that he'd like, something I knew he'd been missing," said Beaulieu.

The *Dirty Mind* cover evokes a certain raw angst and superhero sexuality, while the exposed bedsprings suggest desperate lovers and well-worn mattresses on hot summer nights, as Prince practically howls with carnal freedom. The rise of the moral majority and the beginning of the Reagan-Bush-Thatcher eighties was underway, and Beaulieu's cover portrait ushered in a fierce new politically savvy artist amidst growing global conservatism—a sexual-spiritual dynamo comfortable in his own skin and wearing stockings, garters, and G-strings, not to mention his "Are you gay? No, are you?" dance floor philosophy.

Fueled by nasty, fun, and beautiful breaths-of-fresh-sexy-air songs like "When U Were Mine," "Uptown," "Dirty Mind," "Sister," "Head," and "Partyup," *Dirty Mind* was released in October 1980. Take it from one who knows, one whose skinny little white ass was dancing to Prince along

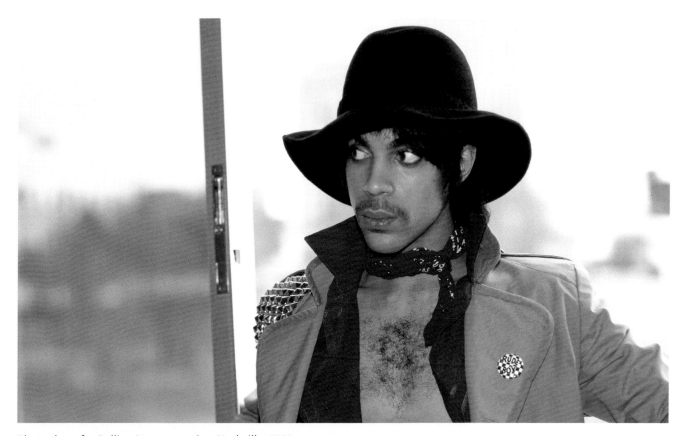

Photo shoot for *Rolling Stone* magazine, Nashville, 1980

with all the other just-baptized citizens of Uptown, that beautiful utopia where all God's creatures get together and get along, *Dirty Mind* was nothing if not a quick balm for the repressed and horny masses here, there, and everywhere. So sexy, so welcome, so necessary: Discriminating dance floors across the world erupted in throbbing synthesized p-funk-rock-n-shockedelica; radios roared with its revolutionary songs of freedom; pearls were clutched, lips were kissed, love was made, babies were born, funk was funked.

Later that year, *Rolling Stone* magazine was scheduled to review *Dirty Mind* and needed a photo to go with the piece. Wanting to be taken seriously, or perhaps punking on the mainstream media, Prince told Beaulieu he wanted a *"Playboy* Interview"–style portrait to go with the review, "where they're not looking at the camera but they're looking away. That was my instruct," the photographer recalled.

So, Beaulieu was dispatched to Nashville, where Prince was on tour promoting the album.

"Actually, *Rolling Stone* had sent a photographer, and I guess Prince didn't like him. Kicked him out," said Beaulieu. "So, Prince calls me and says, 'I want you in Nashville by tomorrow because I want you to do the pictures. A ticket will be waiting for you at the airport.'

"So I fly out there—I'd never been on a plane before—take a cab to his hotel, get his room number, go up there, and there he is. I brought my 35 mm camera gear. I shot him just like the *Playboy* Interview photos, where he's looking off. And sure enough, they ran a huge photo in *Rolling Stone*. So that was cool. I loved that." Beaulieu had scored his first photo credit in *Rolling Stone*, for which he would go on to do countless assignments with artists from all over.

Beaulieu's photo accompanied Ken Tucker's rave review in the February 19, 1981, issue. Tucker championed *Dirty Mind* as "maybe the most generous album about sex ever made by a man," and concluded, "In a time when Brooke Shields' blue-jeaned backside provokes howls of shock and calls for censorship from mature adults, Prince's

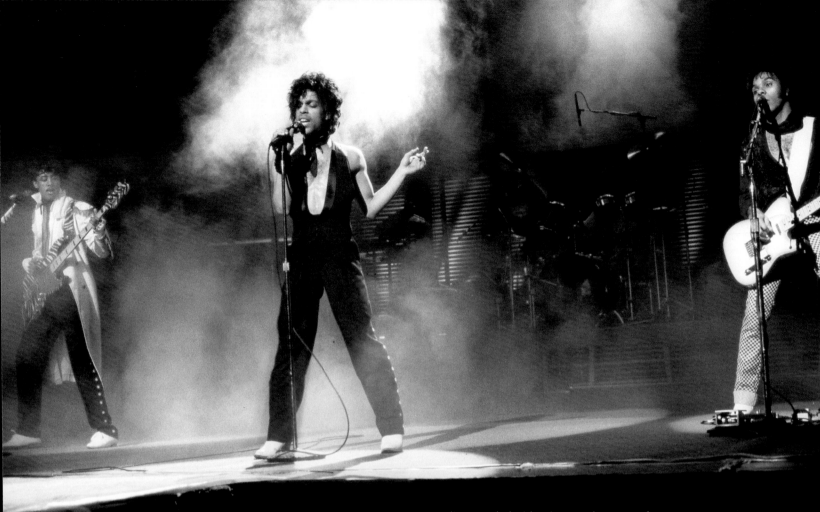

Beaulieu traveled with Prince on three tours from 1979 to 1983. The photographer perfected his concert-shooting skills while Prince perfected his own musical legacy.

sly wit—intentionally coarse—amounts to nothing less than an early, prescient call to arms against the elitist puritanism of the Reagan era. Let Prince have the last word: 'White, black, Puerto Rican/Everybody's just a-freakin.'"

Quickly going beyond private studio sessions and hotel-room portraits, Beaulieu was on his way to a wild ride with Prince. "He wanted me to come on the road with him," said Beaulieu. "I told him, 'I'm a studio cat. I gotta have lights where I want 'em. I need you to stand right here and let me design lighting around you. I'm a studio guy. A *studio cat*. And to take me from that, on the road, where you're dancing around? I don't think I can do that.' He said, 'No, you'll get it.' I went, 'All right, I'll try it.'

"The first concert, I think I shot ten rolls. I got them processed right away because I wanted to see what I was doing, and there was nothing. I'm thinking, 'I'm gonna get fired.' I go to Prince and say, 'I got nothing. I told you. I'm no good at

it.' He said, 'You'll learn.' I'm like, 'Okay, that's weird.' At the next concert, I talked to the other photographers about how to shoot it, and one guy told me to move with the movement and let the shutter do the work—and it did. So the second night, I actually got some stuff. Not great stuff, but some, and from there I kept going. But it was never truly *me*."

Slowly but surely, as they shared adventures and projects together, Prince and Beaulieu grew to be friends.

"Prince and I became very close," he said. "And I don't know how we became close; I really have no idea. There's that line when you like somebody and then there's that line when you love somebody. Now, I don't know when that happened. For me, falling in love is like falling asleep. It's a little bit at first, and then it's all at once. I don't know how other people do it, but we became really good friends."

As they started spending more time together, both in and out of the studio, Beaulieu learned something else

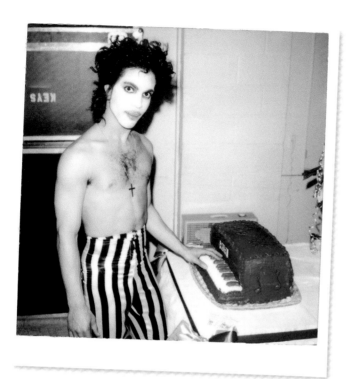

about his new friend: "He was a horrible driver. He had this little Triumph sportscar, and I had this huge van. One time he picked me up for a shoot at his house, and he's driving, but he's going on the side of the freeway, on the shoulder, and it's rush hour. He would drive on the side of the road, and it would freak everybody out. Eventually they took his license away. So then he'd call me at like ten o'clock at night and go, 'Al, come pick me up and we'll go to First Avenue.' By this time he's getting big, and I'm going, 'Listen. We're not going in together, for one. You go in, I'll park, and then we'll meet up at the end of the night and I'll drive you home.' That was fine with him because he had enough friends and

(left) Beaulieu spent many years developing a friendship with Prince and captured rare, behind-the-scenes moments, such as this party for Prince's birthday, held at a rented warehouse space in suburban Minneapolis. *(below)* Prince's fashion sense was always evolving, along with his music.

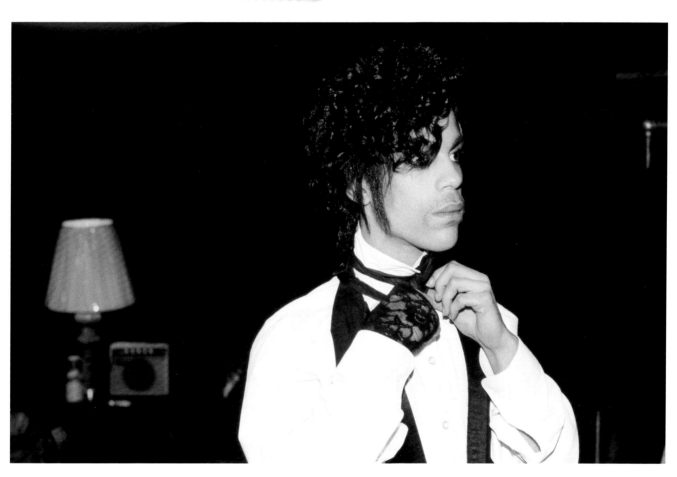

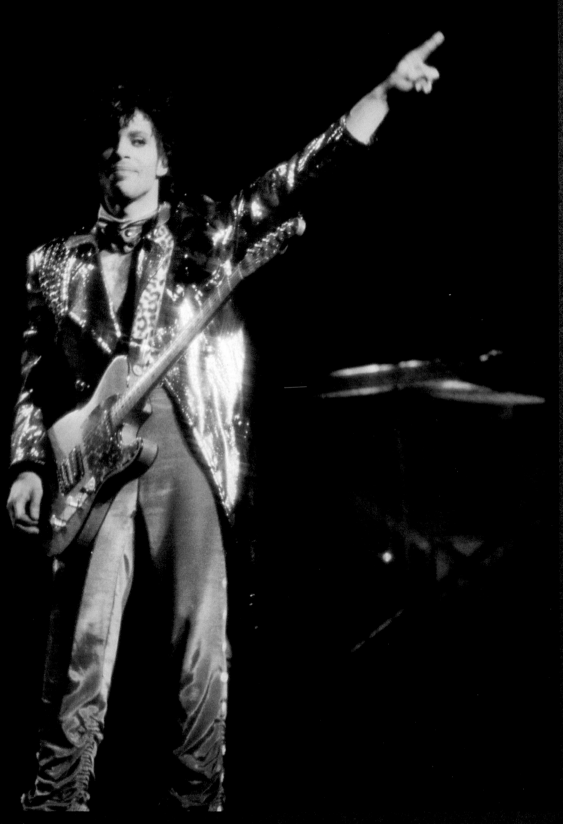

Prince onstage during the *1999* tour

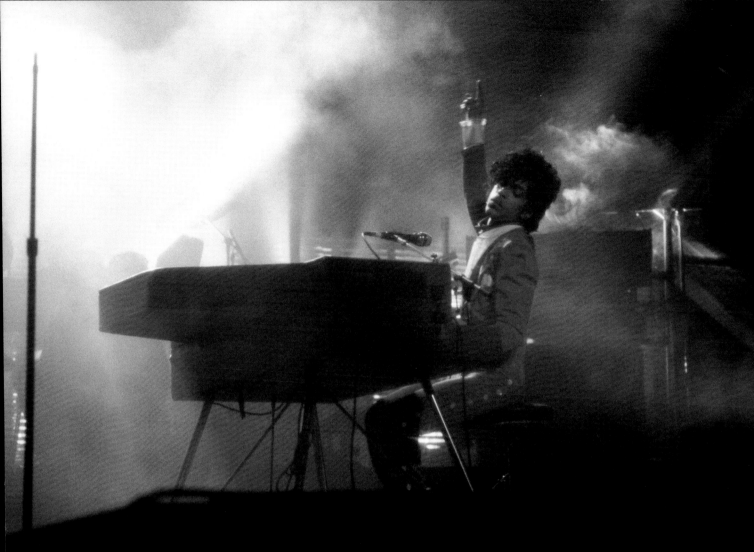

Prince at the piano during the *1999* tour

all that stuff. André [Cymone] would be down there and a lot of his friends. I mean, I didn't know a lot of his friends back then. I got to know some, not everybody.

"The really cool thing was that, you know, I had Prince in my van at the dawn of everything, and now it would seem crazy. It would be unheard of. There'd be bodyguards everywhere and blah blah blah, but back then it was just me and him.

"The first time I was at his house [in Chanhassen, Minnesota] was to shoot the *Controversy* album cover," Beaulieu continued. "He was like, 'Al, you have to come shoot at my house because I don't want to go anywhere.' So we shot *Controversy* there."

Released on October 14, 1981, *Controversy* was another great leap forward for Prince, both musically and image-wise. In Beaulieu's cover photo, Prince is wearing the same trademark trench coat that he donned for *Dirty Mind*, but this time he's actually wearing a shirt underneath—not to mention a vest and tie as well. That inching toward an impression of respectability and seriousness is underscored by the newspaper headlines floating behind Prince, revealing the political consciousness that continued to merge into the funky sexuality of his music.

Fueled by the "Our Father"–sampling title track and such pop-funk gems as "Let's Work," "Do Me, Baby," "Sexuality," "Ronnie, Talk to Russia," and "Jack U Off," *Controversy* would be Prince's first platinum-selling album. And he was just getting started. The tour supporting the album was a marathon party that lasted from late November 1981 through mid-March 1982, hitting nearly sixty cities and selling out venues across the nation. Prince was also spearheading a number of side projects during this period, like

the Time, fronted by his friend and former bandmate Morris Day, and the all-girl trio Vanity 6. Allen Beaulieu was by his side through it all.

But save for some more promotional shots and the interior photos for the *1999* album, the *Controversy* cover shoot was both the high point and the beginning of the end for the partnership between Beaulieu and the man who would be The Kid in *Purple Rain*.

The double LP *1999*—released just one year after *Controversy*—was Prince's commercial breakthrough. Motored by hit singles "Little Red Corvette," "Delirious," and the hit title track, *1999* was Prince's first top-ten album on the Billboard chart, the fifth-best-selling album of 1983, and Prince's first true hit record; he also earned his first Grammy Award nomination, for "International Lover" in the best male R&B vocal performance category.

The commercial and critical success didn't mean that Prince had played it safe with *1999*. Prince told the *Los Angeles Times*, "my goal is to excite and provoke on every level. . . . Most music today is too easy."

Things weren't getting any easier for Beaulieu, whose own career was blossoming alongside his friend's. "In the end, I was doing a lot of stuff," he sighed. "I was working for *Rolling Stone*, I was doing Prince's albums, I was doing the Time album covers, and I did Vanity 6. I was on tour with him, shot the tour posters—three for Prince, two for the Time, and one for Vanity 6—plus buttons and shirts and all sorts of merchandising. And it was all in such a short, compact period of time, from 1979 to the end of 1984, when *Vanity 6* came out."

The photographer's growing portfolio and rising profile didn't sit too well with Prince. "By *Dirty Mind*, I was getting really good with the live stuff, too, and he kind of noticed it. I think that's why he knew when Earth, Wind & Fire called him to get my number, it was kind of over between us. I know how Prince thinks. He goes, 'You're mine. I'm not giving Earth, Wind & Fire your number. You're my secret.'" He told Beaulieu to start using a pseudonym. "He had the Jamie Starr pseudonym for his production stuff, and he wanted me to change my name, too. He said, 'You're on too many things. You're on my album covers; you're on the Time's album covers; you're on Vanity 6 album covers.'

"In fact, he didn't even credit me for *1999*. My name is not on that album cover. And I'm thinking, 'That's an insult.'

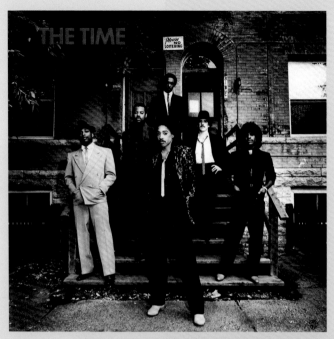

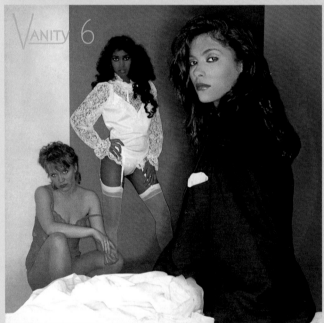

Beaulieu began photographing album covers and other work for the Time and Vanity 6, which helped bring the photographer greater exposure but also led to some tension with Prince.

I just wanted 'photography by,' and he wouldn't do it. There was a party for the release of *1999*, and I asked him why he didn't credit me, and he just rolled his eyes. That's how mad

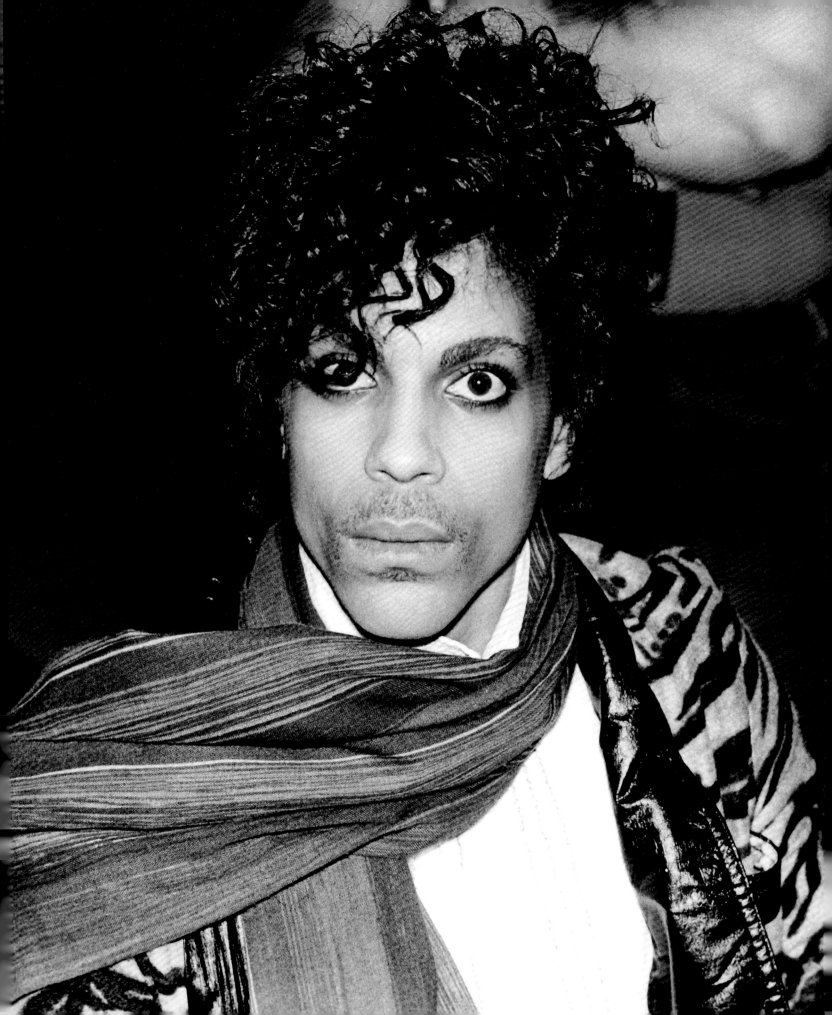

he was that Earth, Wind & Fire called. He just got paranoid. Stuff happens.

"That was pretty much it. He booked me to do the Time's *Ice Cream Castle*, he booked me to do *Purple Rain*—but it turned out not to be. If I had done all those things, I would've been famous, but I wasn't. That's why I claimed the term *almost famous* way before that movie came out."

Nearly forty years later, does Beaulieu have regrets about how it all ended?

"I wish I would've been more involved in his life, and maybe I should've been, and I think I could've been, because I was actually on the inside at one point," he said. "Maybe I took it hard at the end."

His friend Prince has been dead for almost three years now, and Beaulieu looks back fondly on his time spent with His Royal Badness.

"I think it was amazing that Prince picked me. I have no idea how it stuck, or how things happen," he said. "But I was with him for a long time and did a lot of projects. The last tour I did with him, which was *1999*, was the richest tour. It was a big success, and he was selling out shows. By then,

I was feeling pretty cool because, you know, I'm with the coolest band that I know of. I was very proud of Prince for his success, and I was so grateful that he brought me along. I felt like I was one of the cool guys even though I knew I really wasn't! They made you feel cool even when you're not."

In many ways, as with so many musicians, artists, photographers, and writers, Prince helped make Beaulieu's professional dreams come true.

"I wanted to be Richard Avedon; I wanted to be a fashion photographer," Beaulieu said. "I actually told Prince that, and he ended up working with Avedon for a *Rolling Stone* cover, with him and Vanity. I asked him how it was working with Avedon, and he said, 'You're better.' I went, 'Yeah, right.'"

Jim Walsh is a writer, columnist, journalist, and songwriter from Minneapolis and writer of the liner notes for the 1995 ⚥ album The Gold Experience *and author of the book* Gold Experience: Following Prince in the '90s.

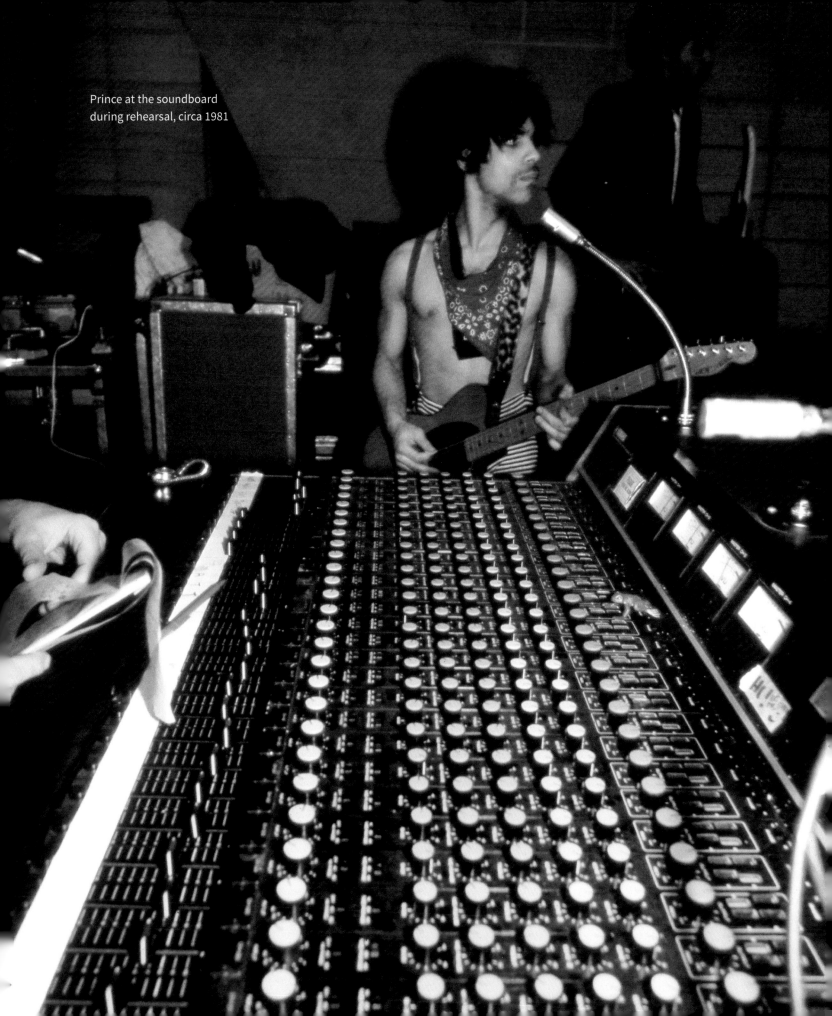

Prince at the soundboard
during rehearsal, circa 1981

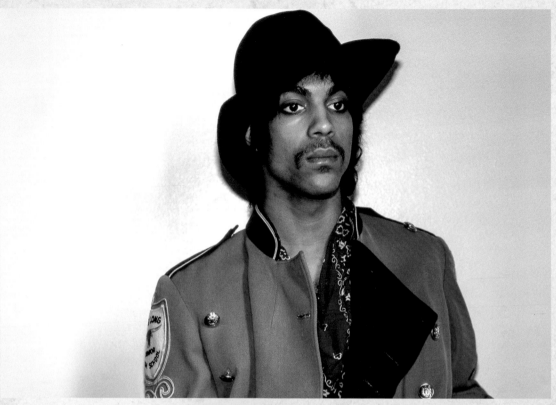

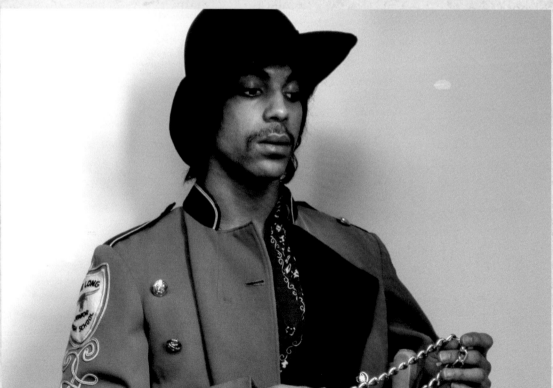

While Prince was on the road with the *Dirty Mind* tour, Beaulieu went to Nashville to shoot portraits of him for an album review in *Rolling Stone*.

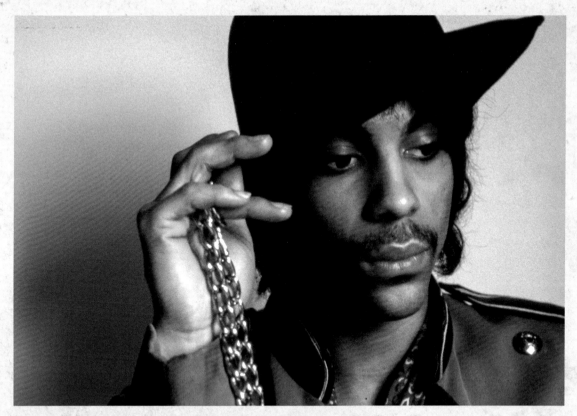

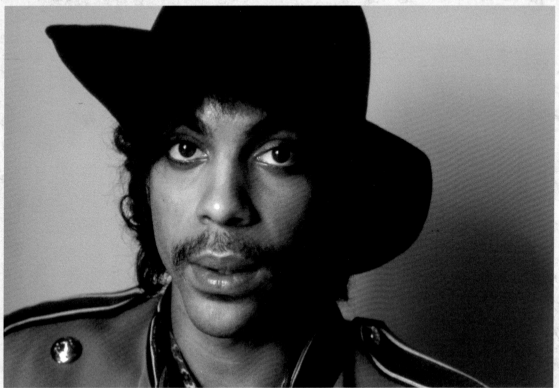

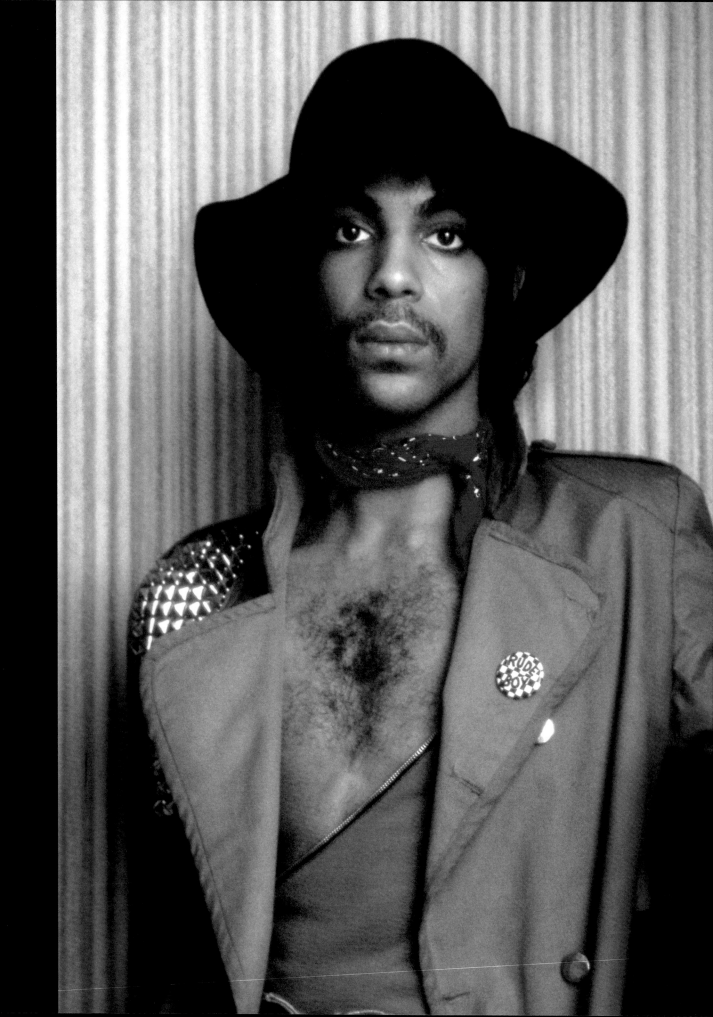

SHOOTING *DIRTY MIND*

Dirty Mind was Prince's third album, and his third in less than three years. The album signaled the young artist's continuing musical evolution, and its cover art reflected the ongoing redefinition of his image.

Dirty Mind was also the first album cover shot by Allen Beaulieu. "He called me up in my studio and said, 'Hey, Al, it's Prince. How'd you like to do my next album cover?' I said, 'Are you kidding? I'd love to do your album cover!' That was my dream, to do an album cover. It was just unbelievable! I asked him, 'When do you wanna do it?' You know, I thought it would be months away and I'd have plenty of time to work on backgrounds and whatever. And he goes, 'Well, I have to have it done by next week.' I go, 'Next week?!?' And he says, 'It's okay, I'll explain to you what I want over the phone.'"

That would be a typical process between them; Prince would describe what he wanted before they shot it. And Beaulieu consistently was able to meet the musician's vision, always in the short time period he expected. For *Dirty Mind*, Prince told him, "I want to be shot on a bed."

Beaulieu thought, "Okay, I've always wanted to do an album cover, so I guess this is what I'm gonna do." But the photographer began to have some reservations. "All I could think was, 'This is my first album cover, and I'm shooting a black man on a bed! That's not going to work.' I thought about it a little while and decided, wouldn't it be cool to get bedsprings that actually make a pattern? I thought, 'I'll put Prince on that. It's Prince on a bed, right?' So, I went to a junkyard and found this bare-bones box spring, just the steel springs. I paid $25 for it, put it in my car, and took it to my studio. I lit it up a little bit, and it looked interesting, pretty cool."

Now he just had to find out what Prince thought of it. "He comes into my studio, and it's late, of course—he always wanted to work late—he showed up at my studio about ten or eleven. It was just me and him, since I didn't have an assistant at the time. It was a small studio. He comes in, and I asked him, 'What do you think of the background?' He said,

'It looks all right.' He didn't seem really excited one way or the other, but I thought he must like it, otherwise he'd say something. So we went with it."

Prince's first two album covers had been basically headshots, although on the inner sleeve of *For You* he posed naked with his guitar, and the back cover of 1979's *Prince* showed him nude riding a Pegasus. He stepped up his wardrobe—relatively speaking—for *Dirty Mind*. Sure, he's shirtless and wearing a thong, but he also has his soon-to-be-trademark trench coat, as well as a bandana around his neck. Adorned with studs on one shoulder and a "Rude Boy" pin on the lapel, the coat brings punk and new wave–ska elements into the hyper-sexual ensemble.

"I photographed Prince in front of the bedsprings, in black and white and in color," Beaulieu recalled. "We shot about twenty rolls of black and white because he really wanted a black-and-white cover, and I shot about ten or

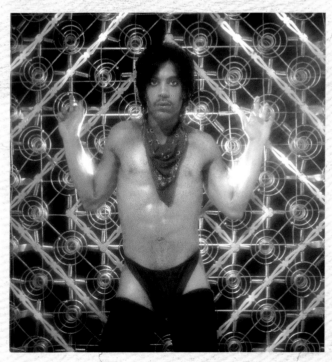

A color outtake

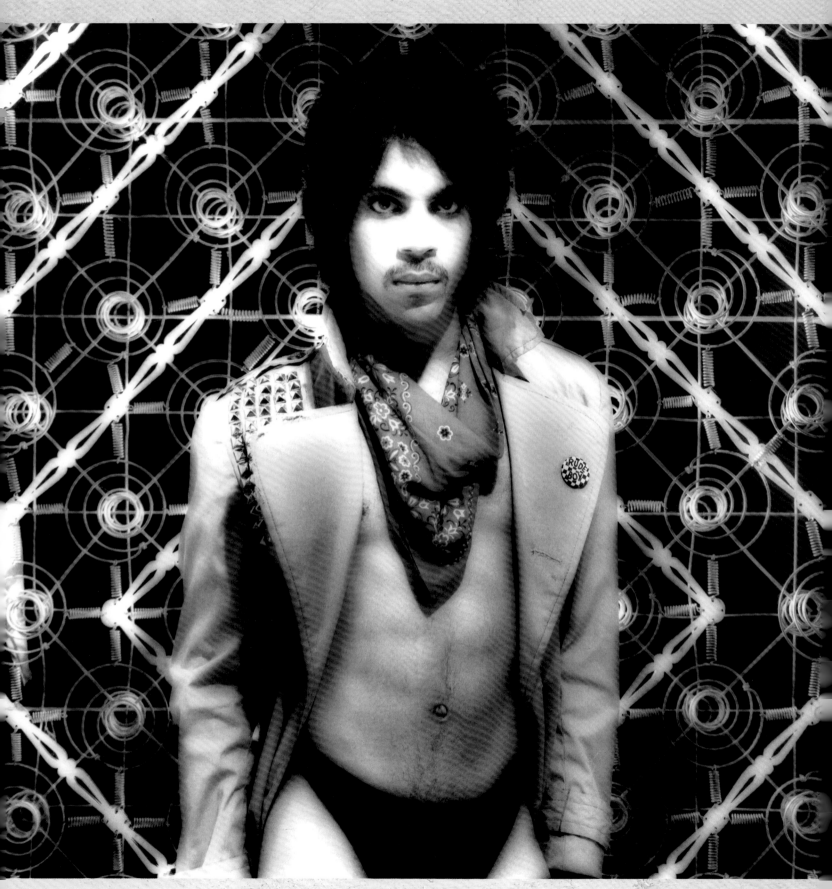

The winning photo from the *Dirty Mind* cover shoot

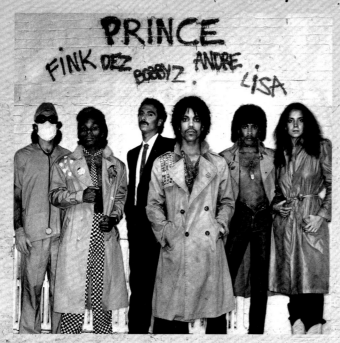

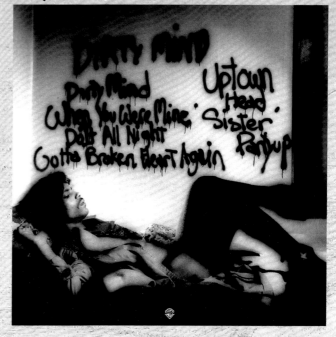

Inside paper sleeve from *Dirty Mind*

Dirty Mind back cover

fifteen rolls of color that we used in other things, for advertising and posters.

"And, yeah, he loved them. He picked the black-and-white one, and sure enough, that was the album cover."

Standing in front of the springs, Prince has a serious but suggestive gaze that fixates the viewer. The image offers an intimate, simple representation of Prince's patented sexuality. Sensual but raw, Prince's look creates a sense of voyeurism as well as arousal for the viewer.

A week after the bedspring session, Prince came back with the band for a group shot that would illustrate the inner sleeve of the record. "He wanted to spray-paint my walls, so we did that," Beaulieu said. "He spray-painted 'Prince' and then the name of each member of the band."

For the album's back cover, they went to the apartment of Prince's girlfriend at the time, Kim, and Prince got the more literal representation of him on a bed that he had initially wanted for the front. Beaulieu shot Prince on Kim's bed underneath the album's song titles, which Prince spray-painted on the bedroom wall. "He meticulously wrote out all the song titles in red spray paint. And he did it really well; it was just perfect. There was side A and side B, and he just put up the names of the songs. It fit perfectly. He knew intuitively how to do that.

"I thought when the album came out it was really something." ◉

As Prince and his photographer were getting to know each other better, and as Prince continued to explore new looks and refine his image, he would telephone Beaulieu and set up impromptu photo shoots in the studio. The sessions typically started late, at ten or eleven at night, and would last a few hours. Beaulieu would shoot five to ten rolls of film and go to the camera shop the next morning to get them processed. The results further reveal Prince's ongoing development of a sexy yet coy persona in the early years.

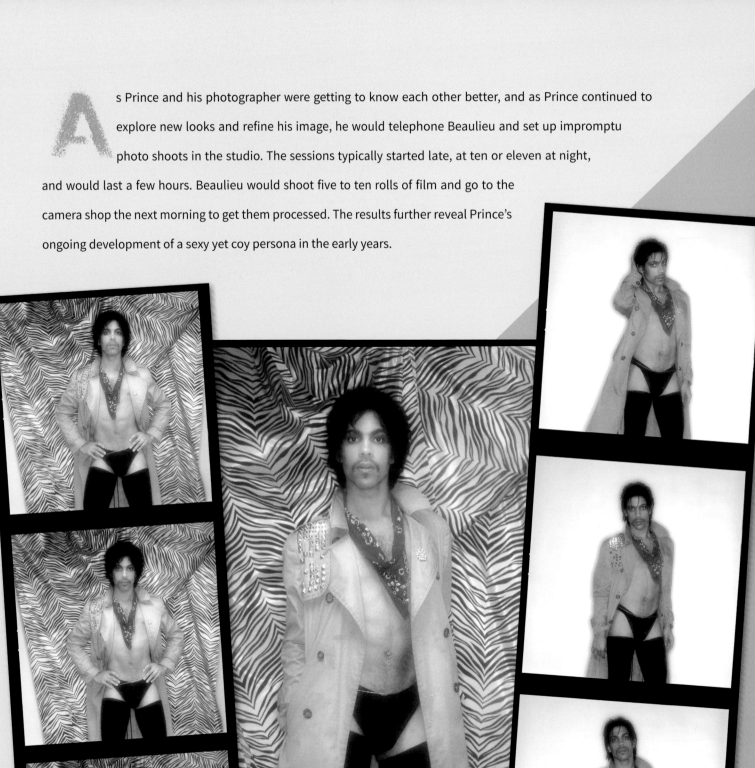

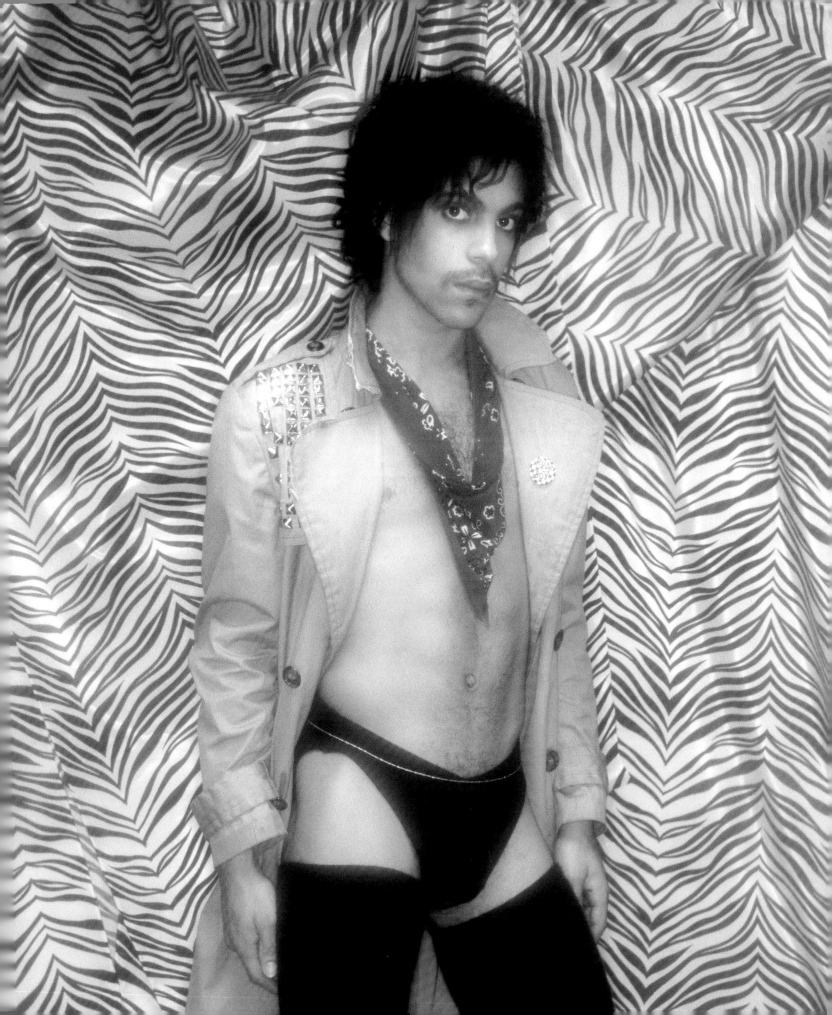

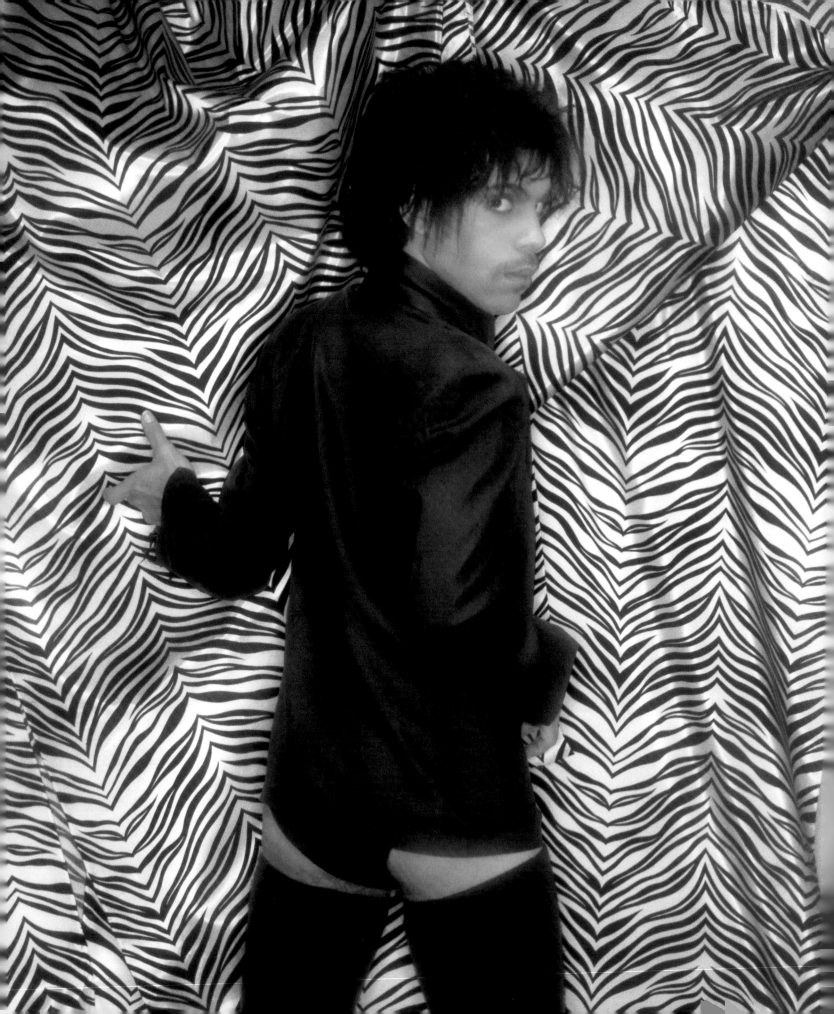

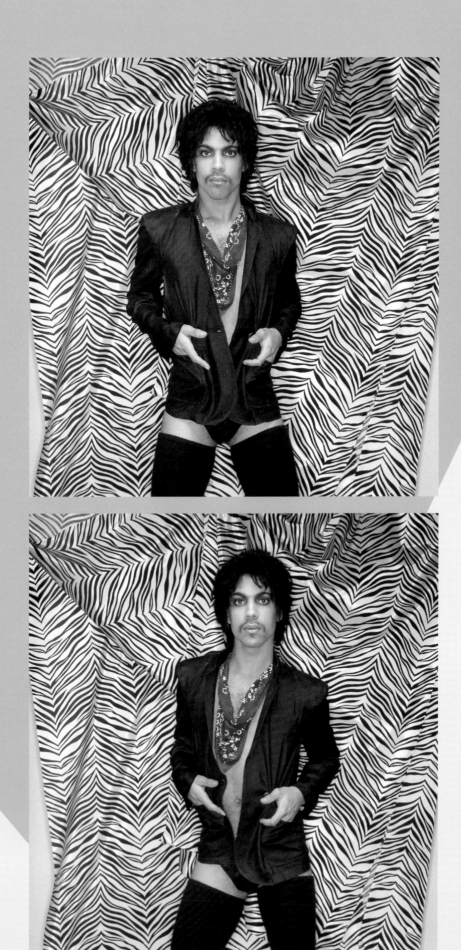

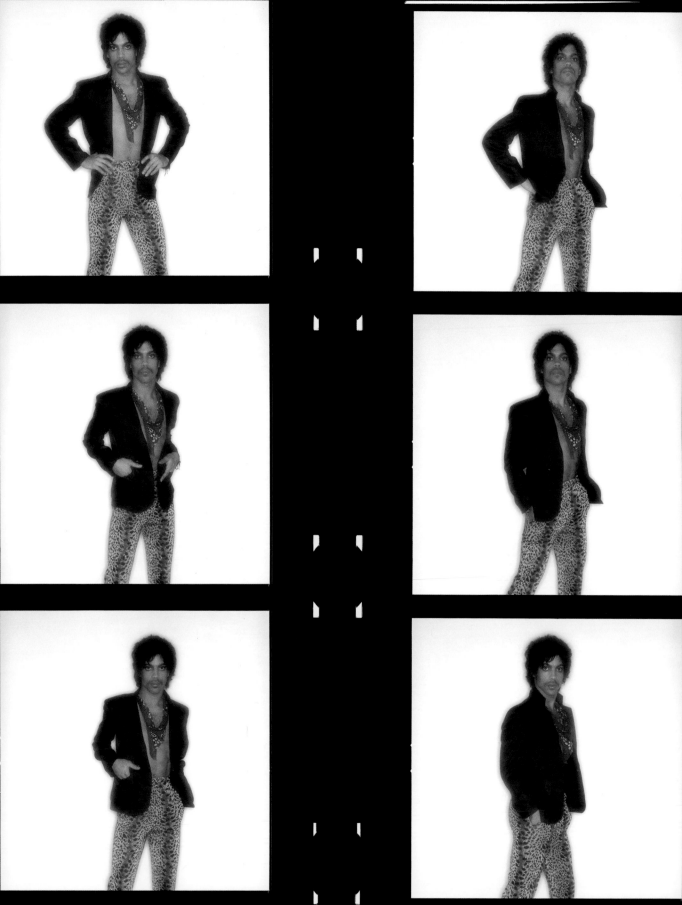

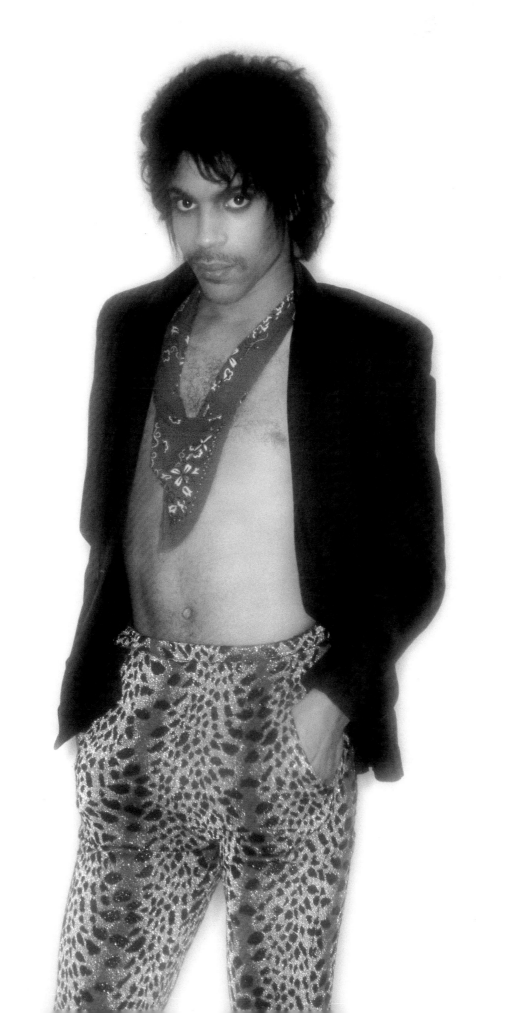

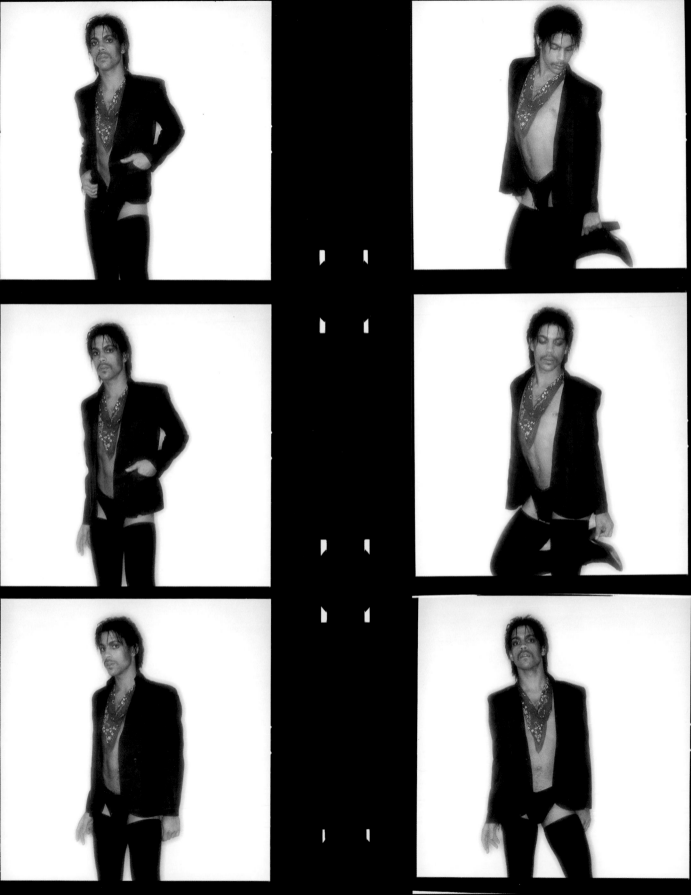

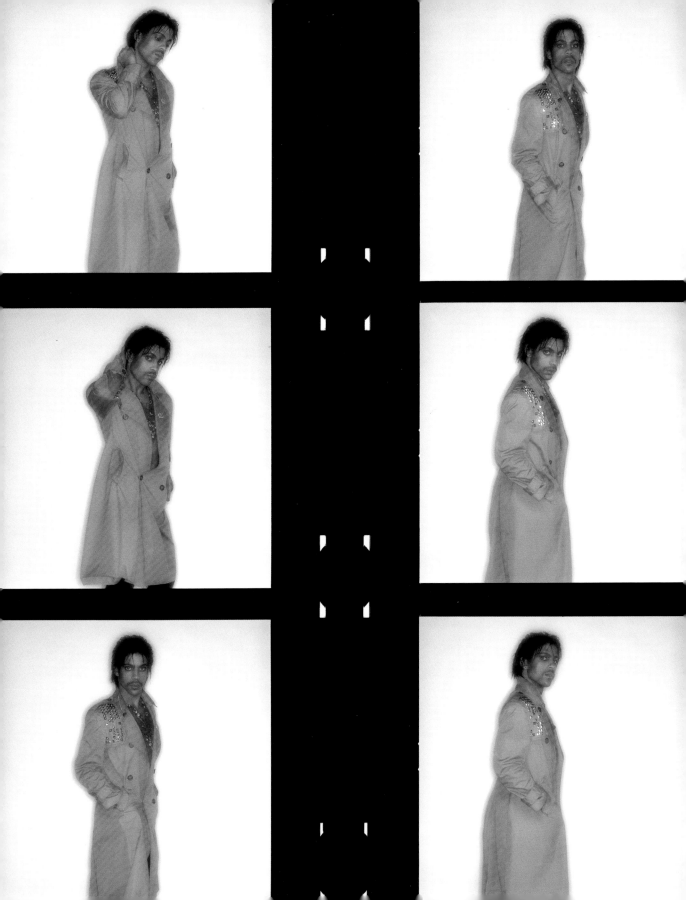

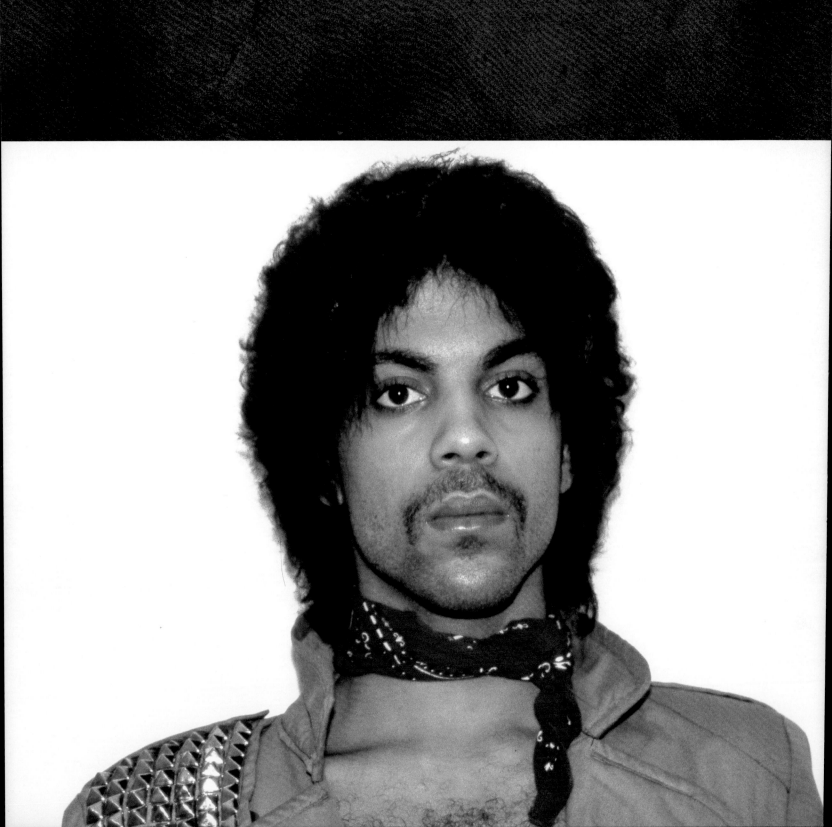

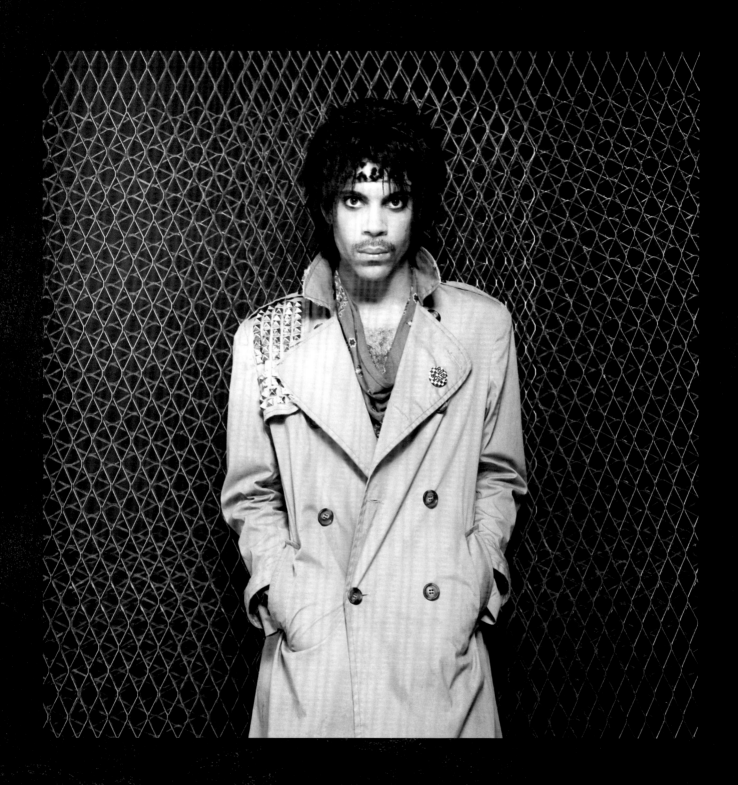

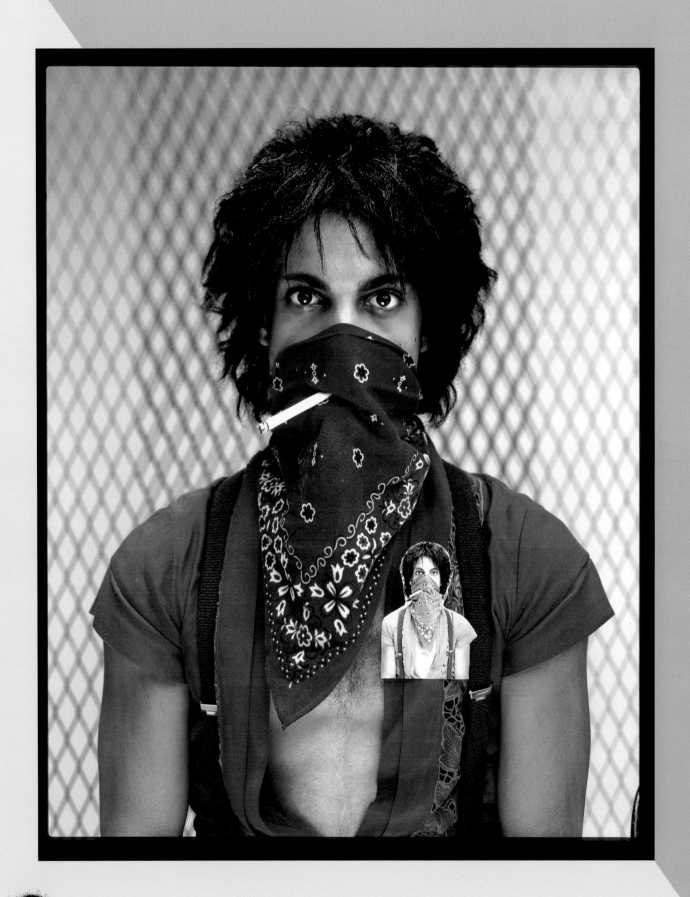

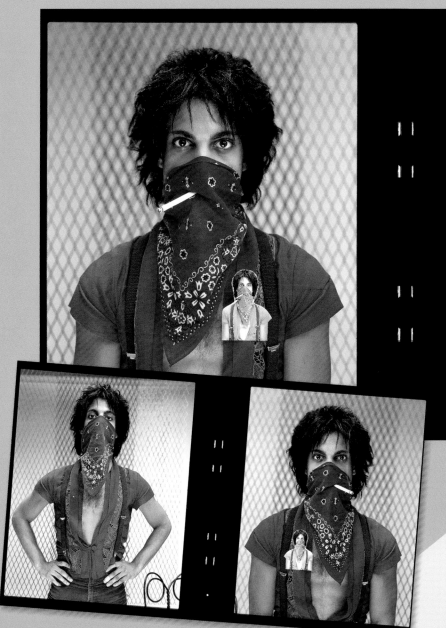

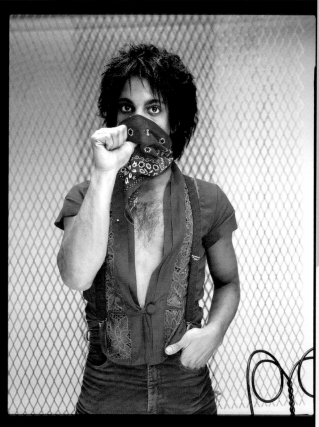

ccasionally, Prince would reveal his playful side. One day he stopped by Beaulieu's studio to check out the images from the previous night's shoot. The photographer was working on a color test for another client, trying out some 4x5 large-format film, and Prince offered to be his model. Pulling his familiar red bandana over his nose and mouth, the musician posed with a cigarette dangling from his bandana-covered lips and with his thumb in his mouth, showing his humorous side in front of Beaulieu's camera.

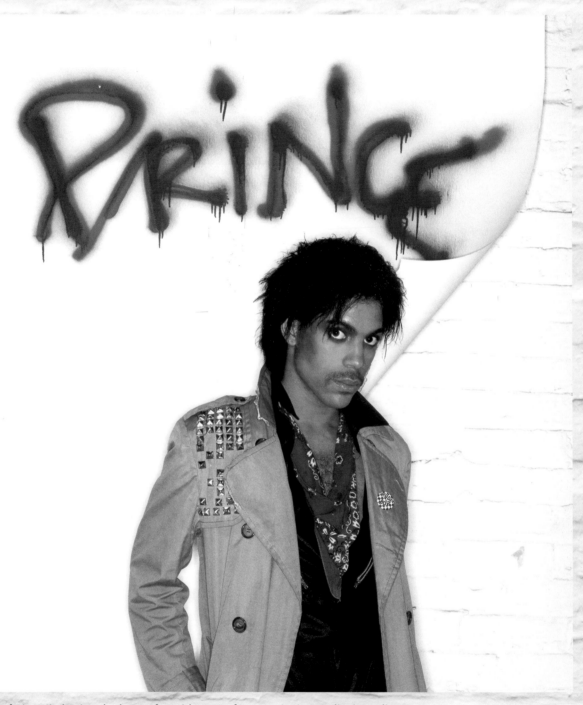

Around the time of *Dirty Mind*, Prince had some fun with a can of spray paint in Beaulieu's studio.

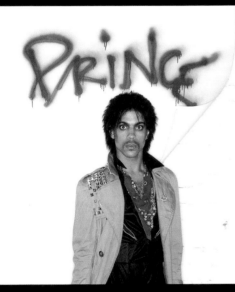
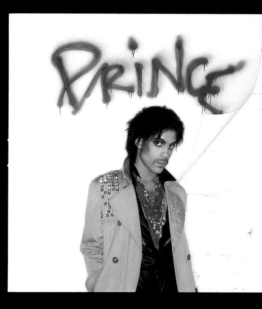
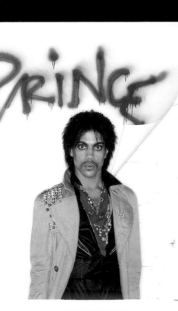

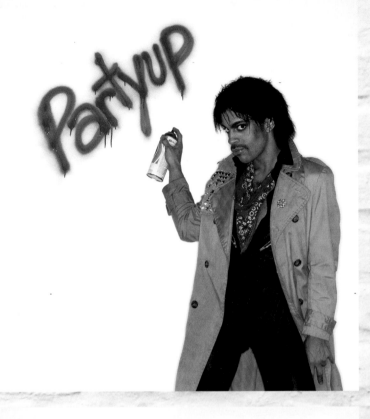

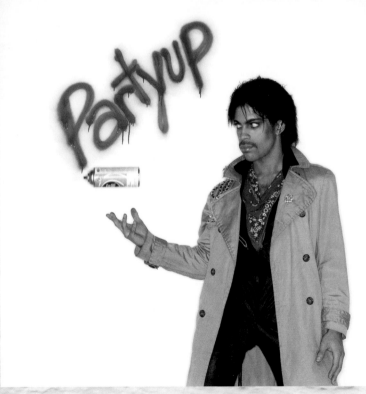

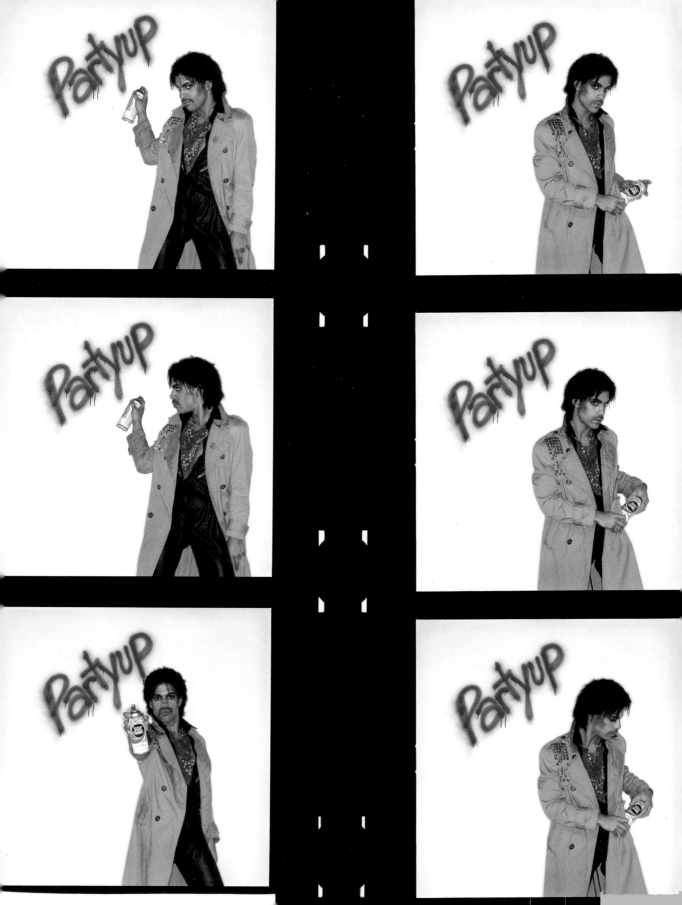

DIRTY MIND

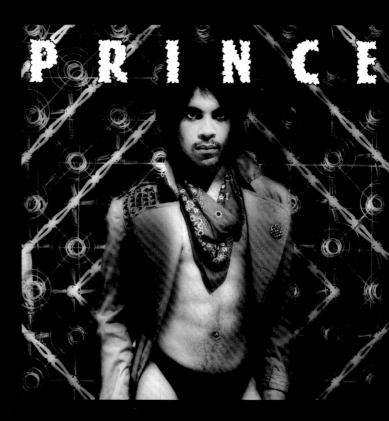

PRINCE

By Eloy Lasanta

Dirty Mind was a departure, the first of many, from what people expected from Prince. Coming off the success of *Prince*, his second album, he changed many things about his image and his music—and it took everyone, including his fans, by surprise. All the disco sounds and late-seventies flavor of his previous endeavors were gone. He brought in a new band that included men and women, blacks and whites—a mixed group for a new decade. The album featured songs cowritten by Prince with Morris Day, André Cymone, and Doctor Fink. Prince still performed most of the instruments for the recording, however, other than Lisa Coleman's vocals on "Head" and Doctor Fink on synthesizer on both "Dirty Mind" and "Head."

People started to wonder: Who, or what, is Prince? Some journalists during the *Dirty Mind* era wrote entire articles on the subject. Was he black or white? Straight or gay? A patriot or some kind of commie? The album marked the start of Prince as an enigma—an artist who kept his followers wondering what his next off-the-wall act would be, and left the naysayers scratching their heads.

Prince's new image direction was, of course, against the wishes of his record label, Warner Bros. He kept the Speedo but added an amazing trench coat and became a hyper-sexualized version of himself. Prince had been a powerhouse in 1979, dominating club and radio play, but the stark shifts in tone, content, and overall presentation in 1980 left his audience taken aback and divided.

Recorded during May and June of 1980 and released on October 8, *Dirty Mind* sold about half as many copies as the previous album, *Prince*. Prince wasn't topping the charts as he had before. But none of that seemed to bother him. He had worked hard to build his audience to the point where he could experiment more and deliver the messages that *he* wanted to put out there. He released songs like "Uptown," preaching about equality among people, and "Partyup," an anti-draft song. *Dirty Mind* is also where the more overt sexual material began creeping into the music, with songs like "Head," "Sister," and "Do It All Night" pushing the envelope of what music fans expected, what record stores would carry, and Prince's own creativity. ●

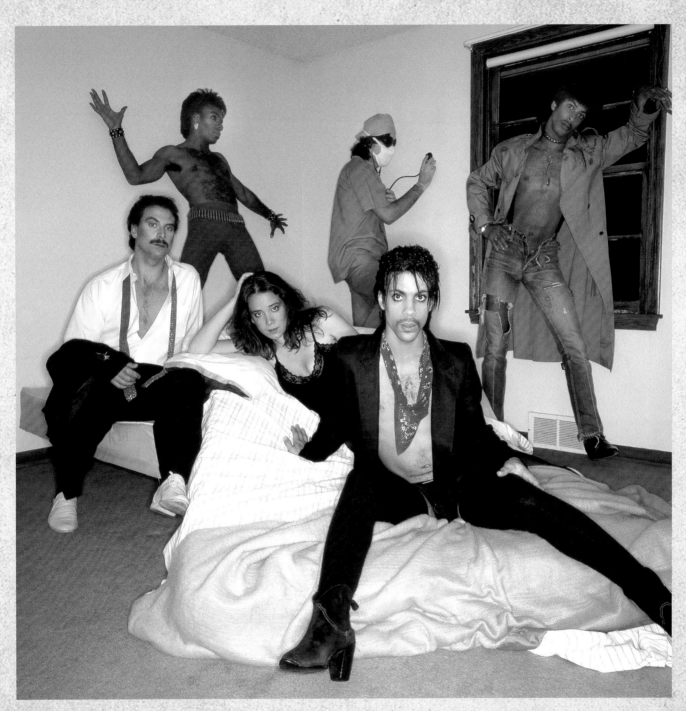

Promotional photo of Prince and the band, taken at Prince's house in Chanhassen

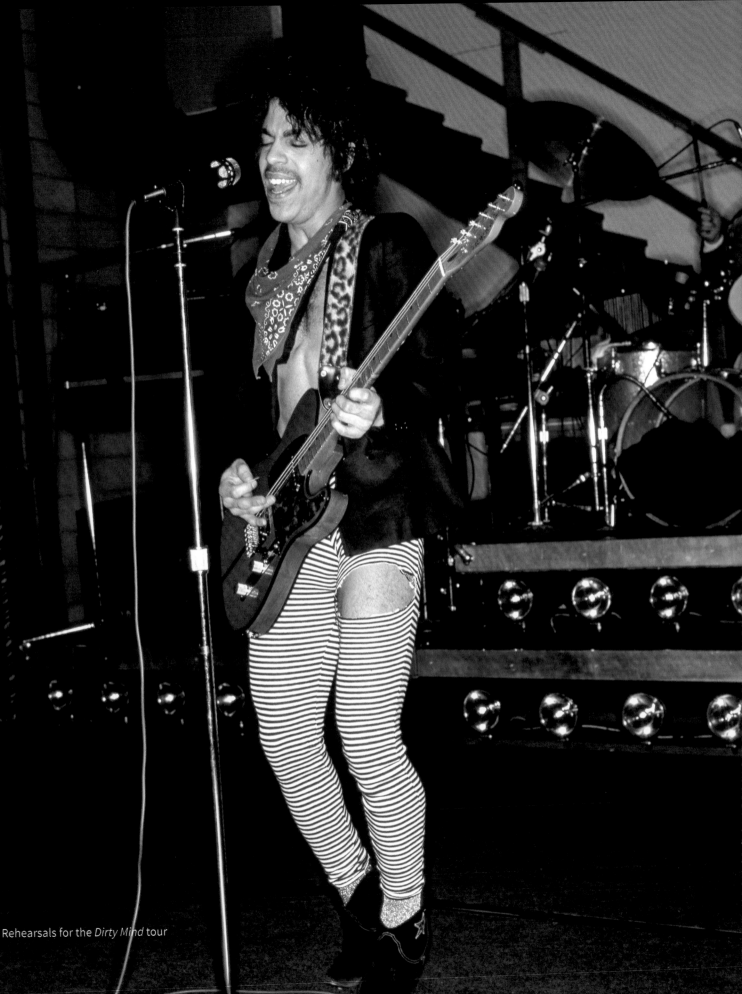

Rehearsals for the *Dirty Mind* tour

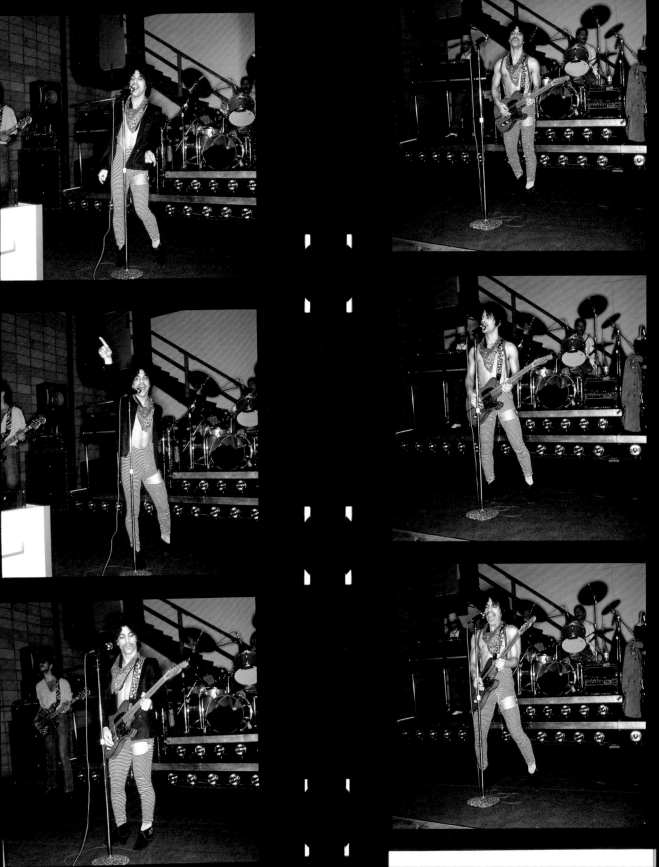

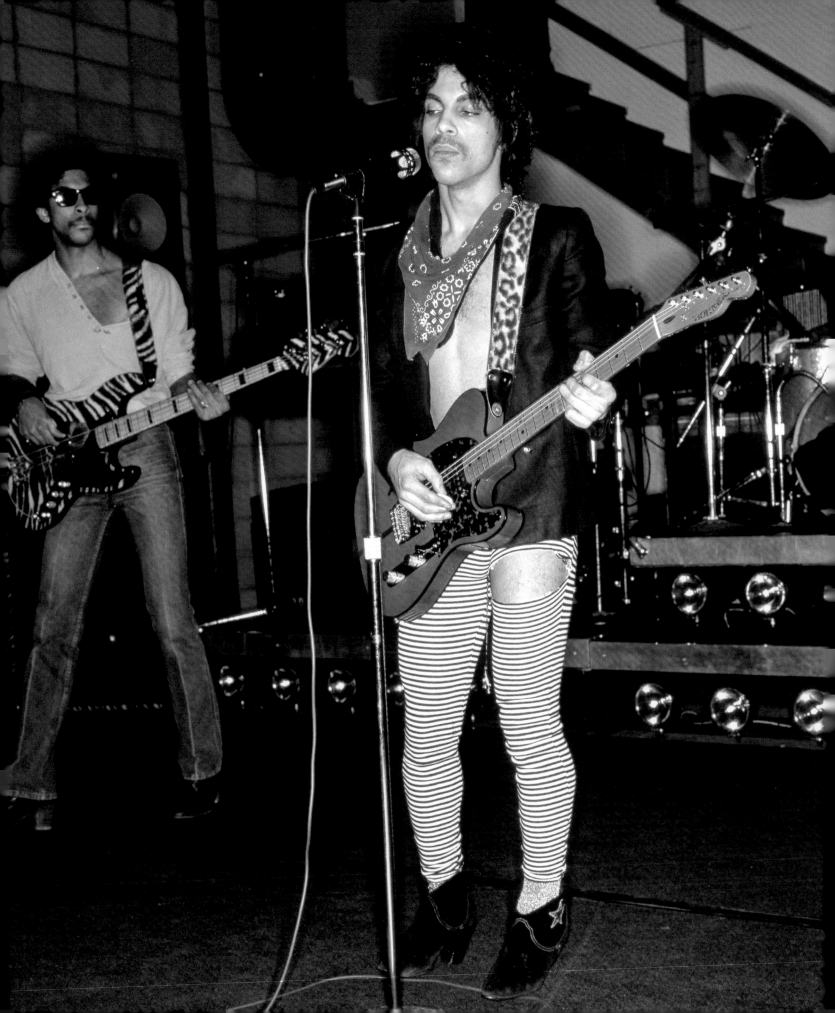

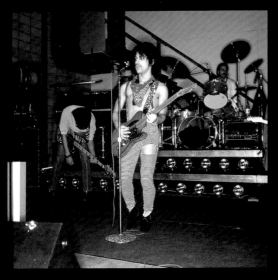
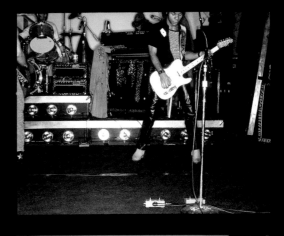
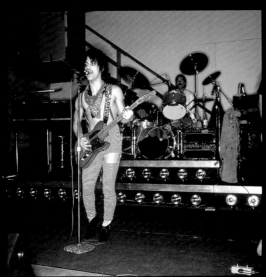
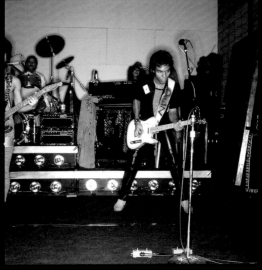
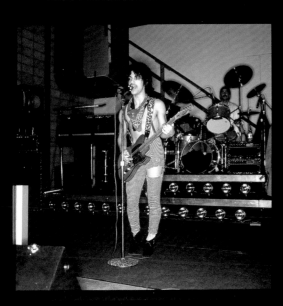
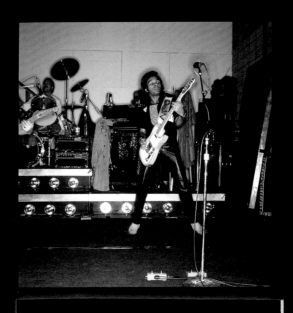

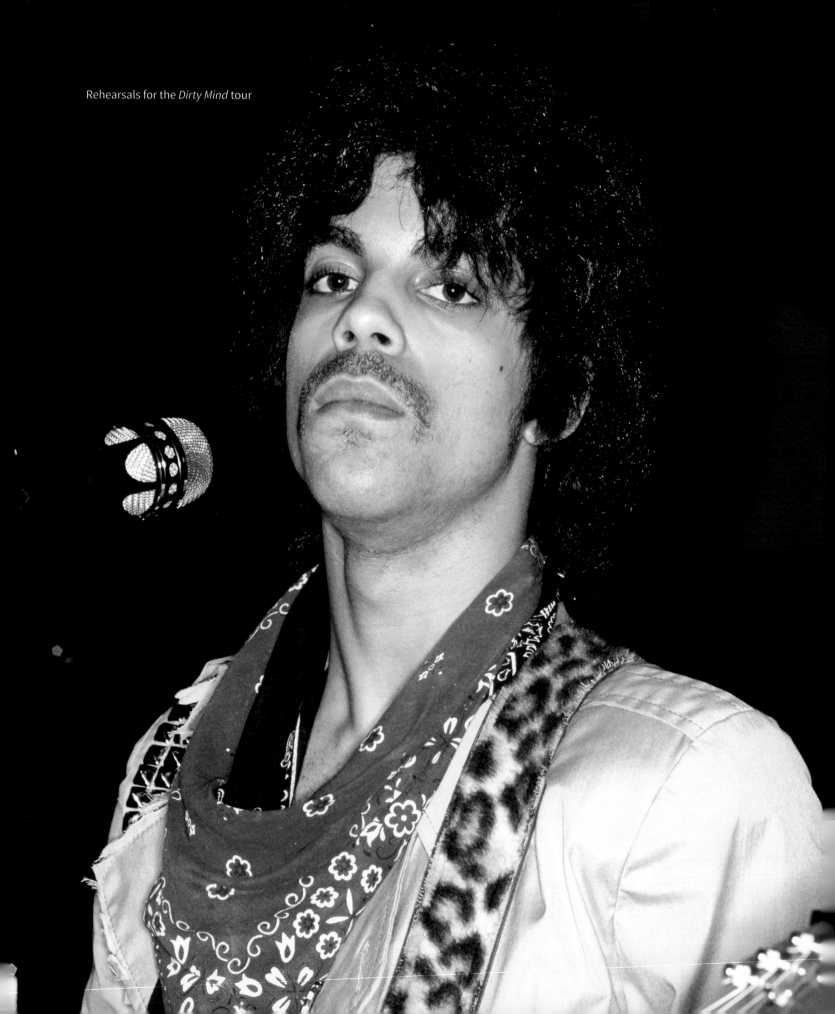

Rehearsals for the *Dirty Mind* tour

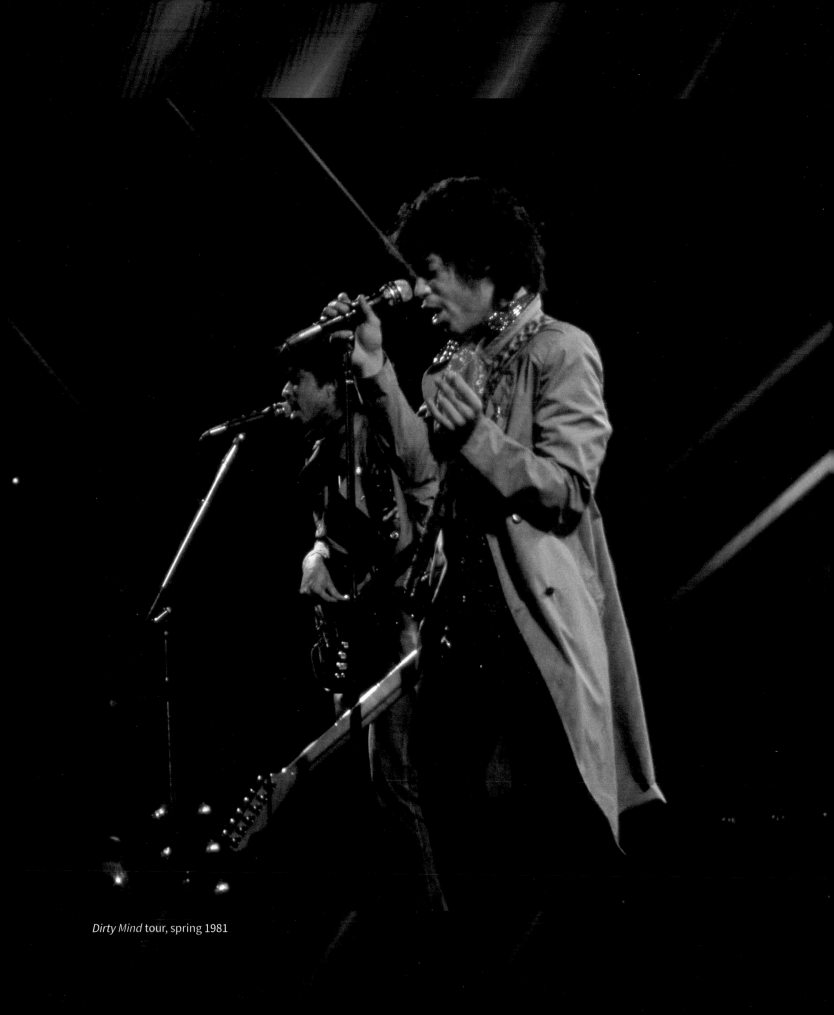

Dirty Mind tour, spring 1981

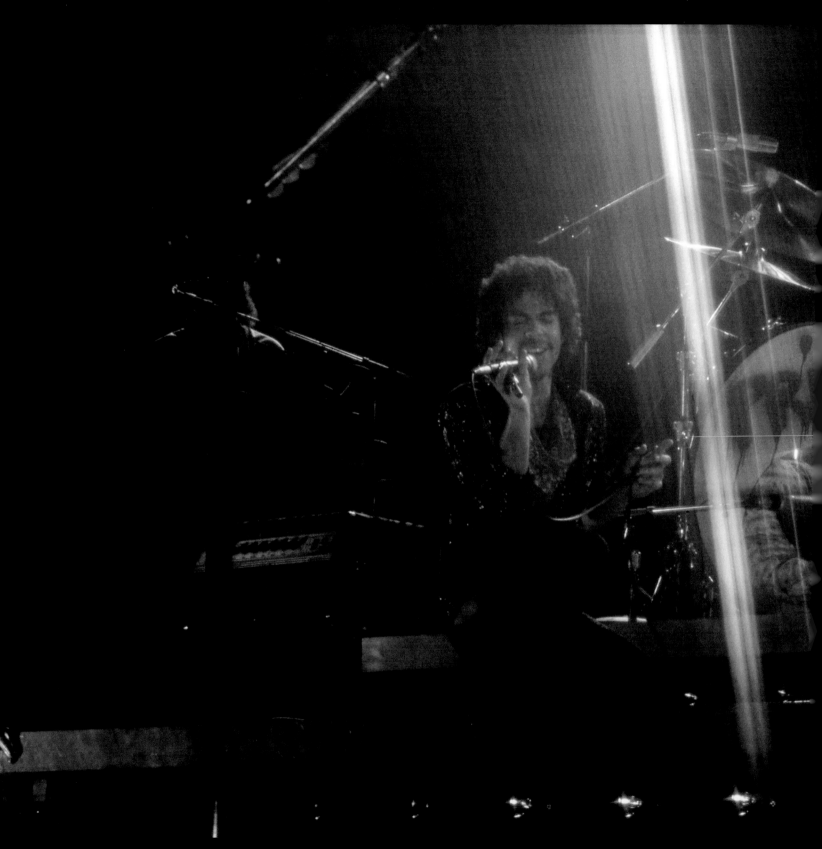

Dirty Mind tour, spring 1981

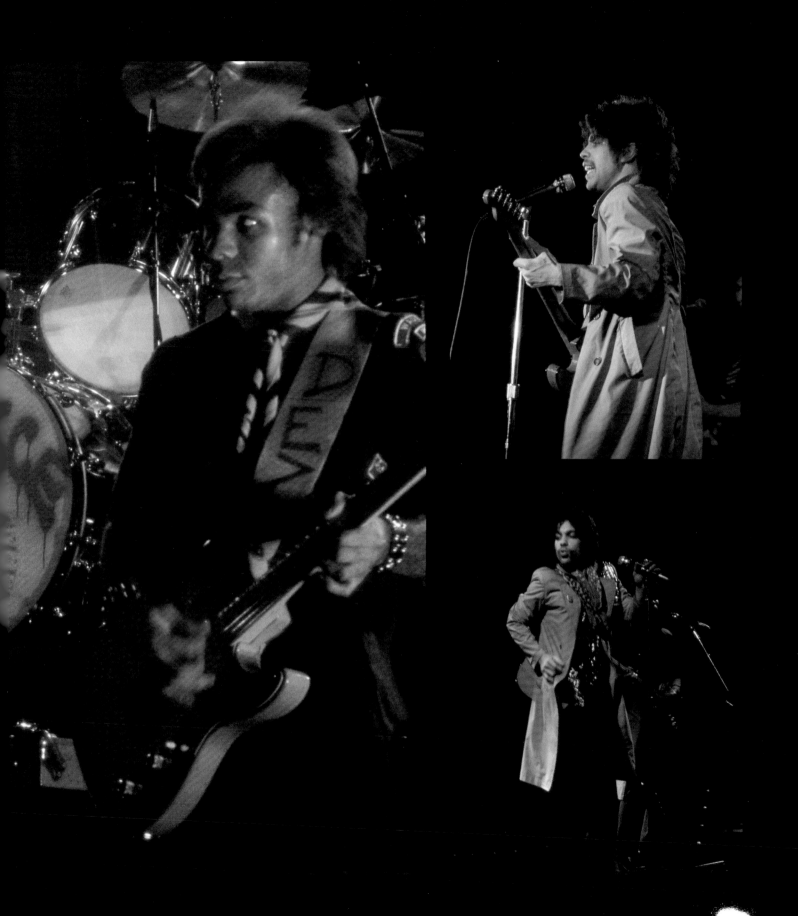

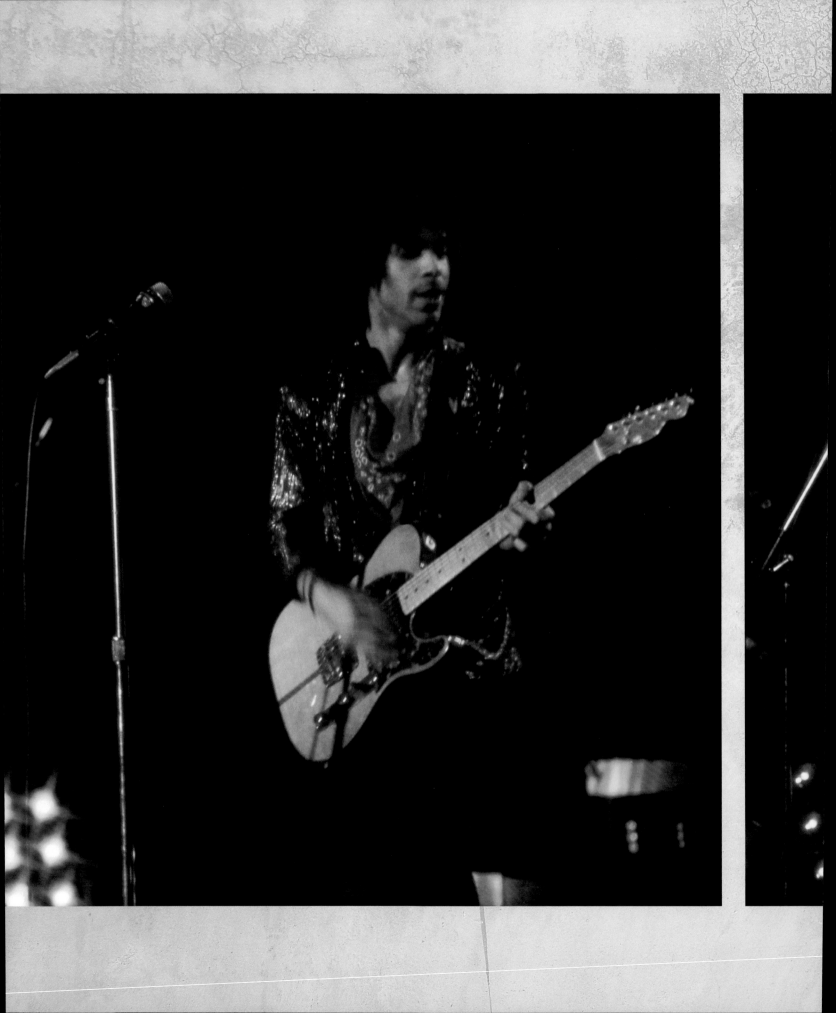

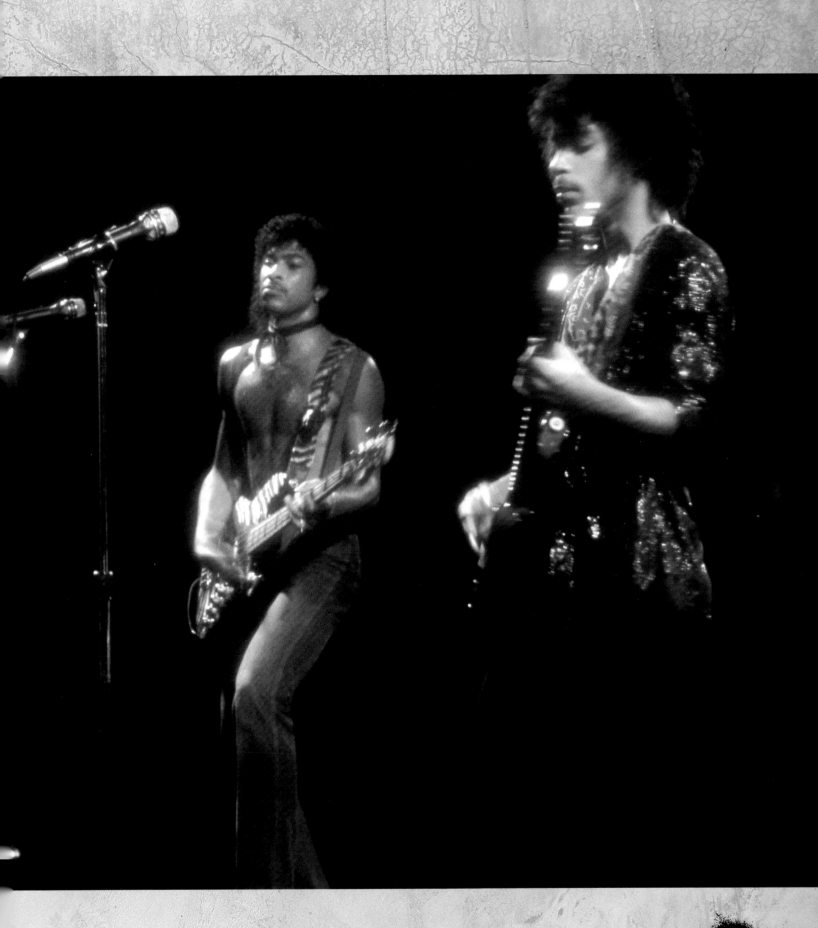

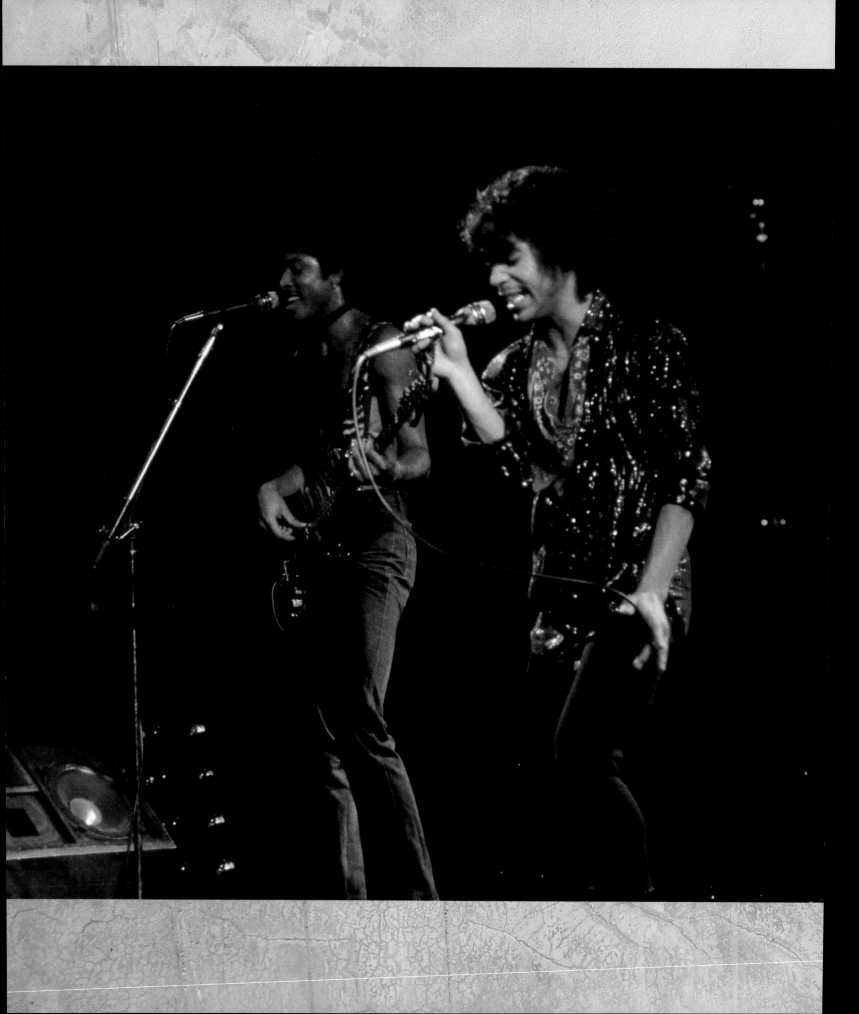

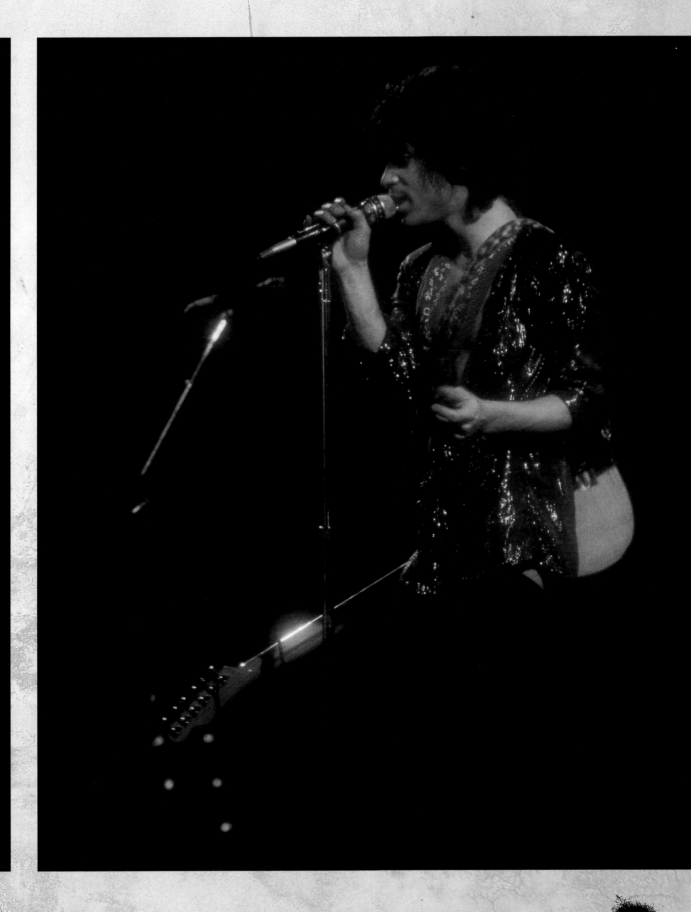

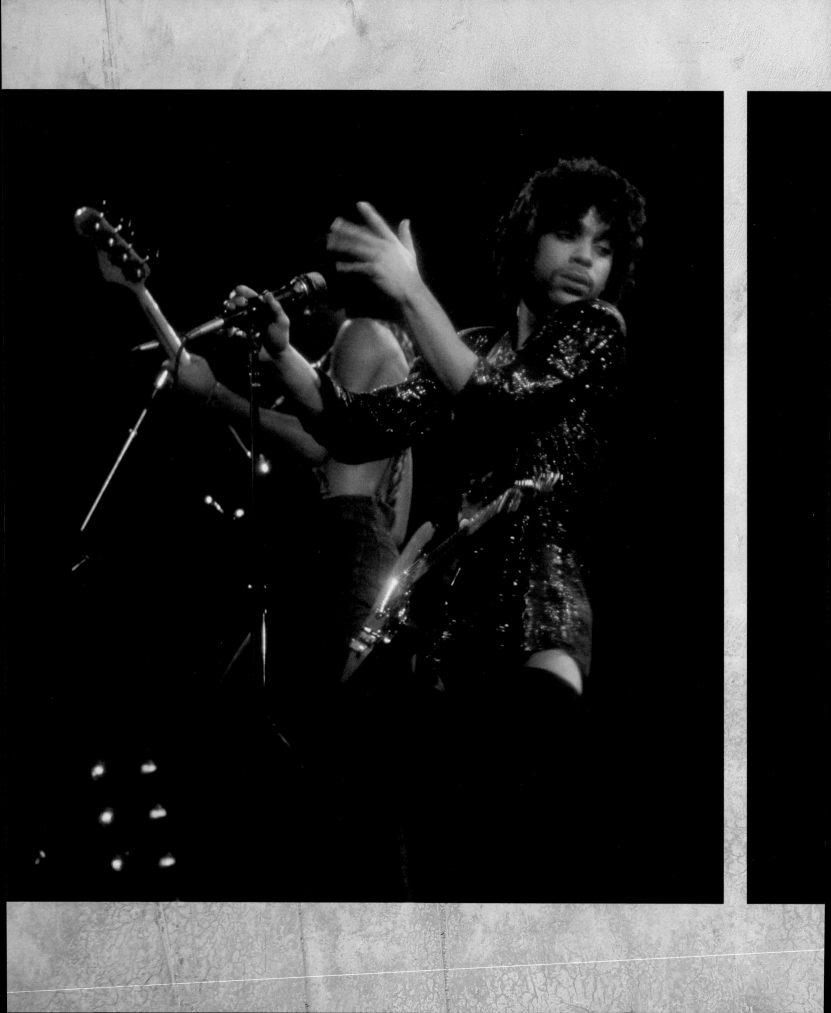

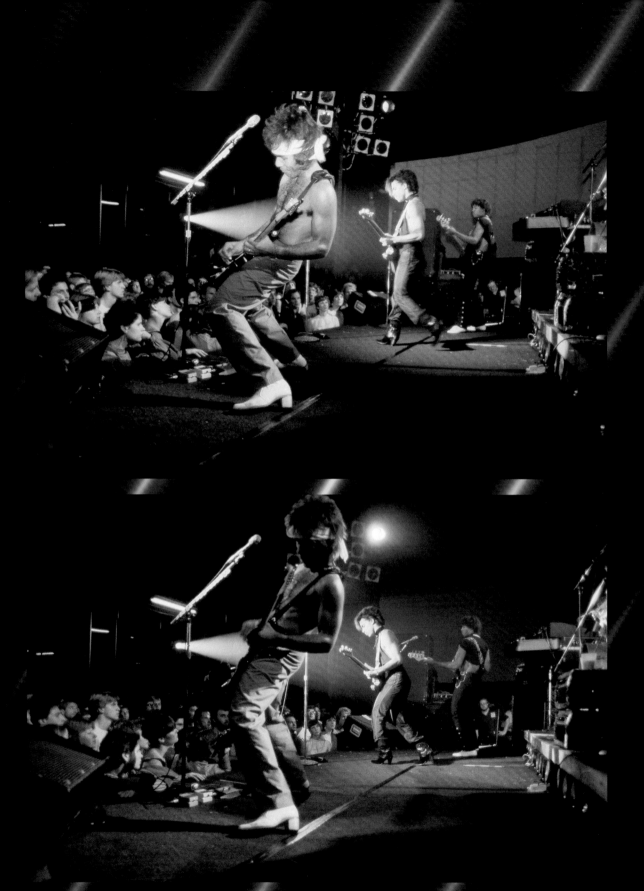

Prince's first-ever performance at First Avenue (then known as Sam's) in Minneapolis, March 9, 1981

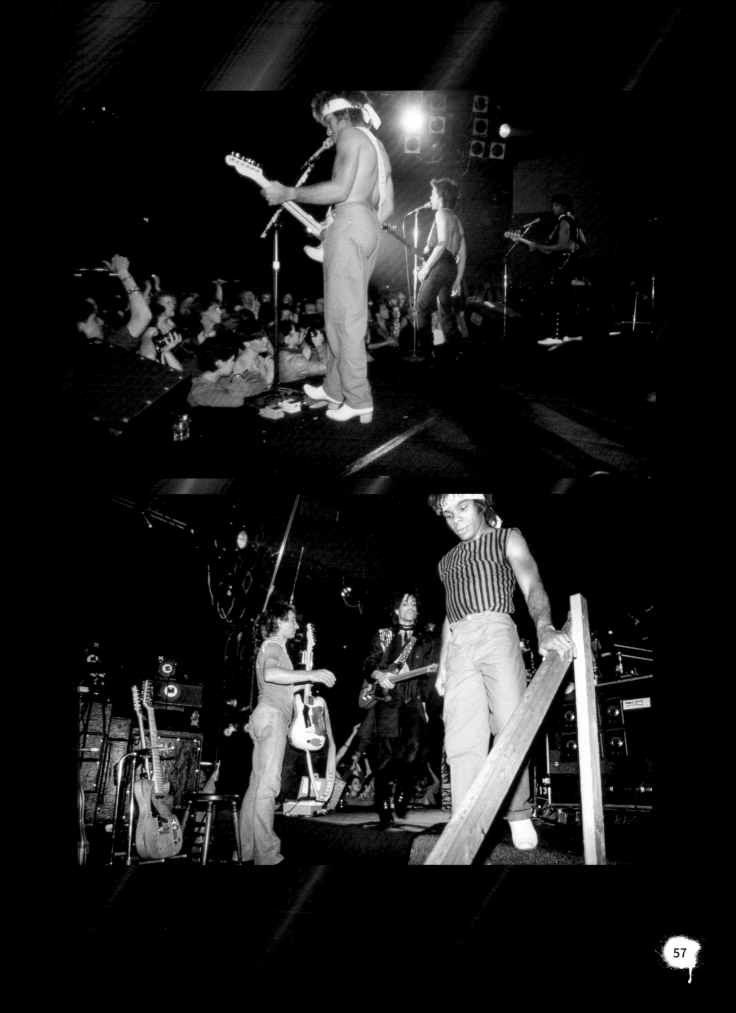

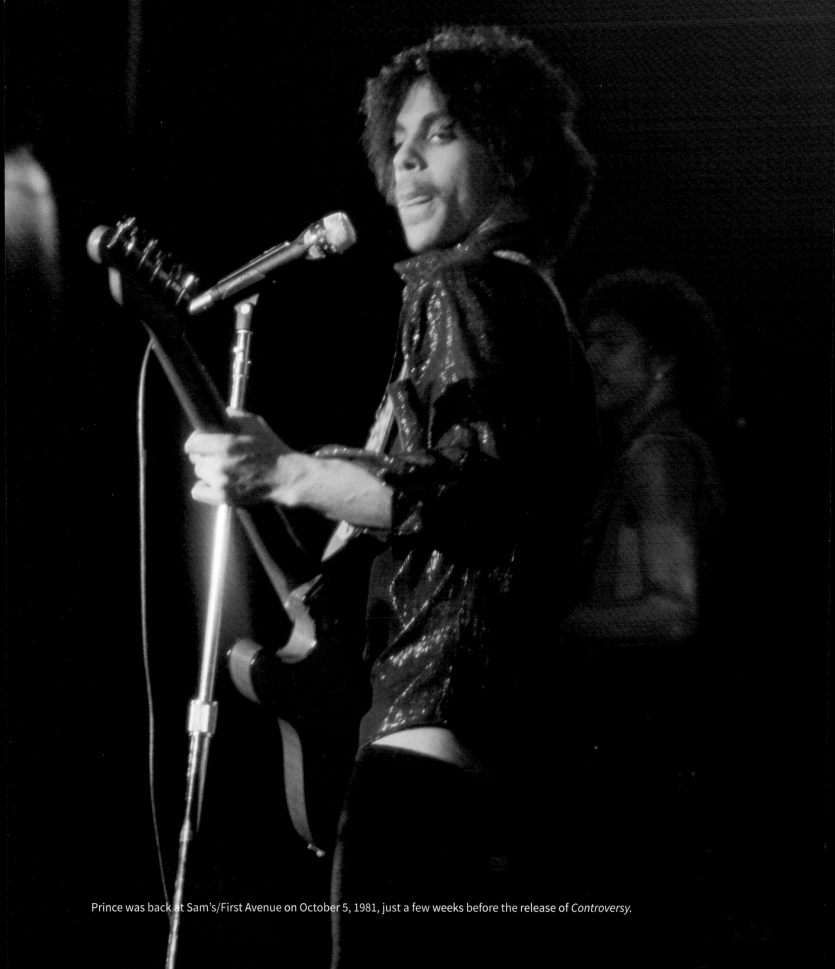

Prince was back at Sam's/First Avenue on October 5, 1981, just a few weeks before the release of *Controversy*.

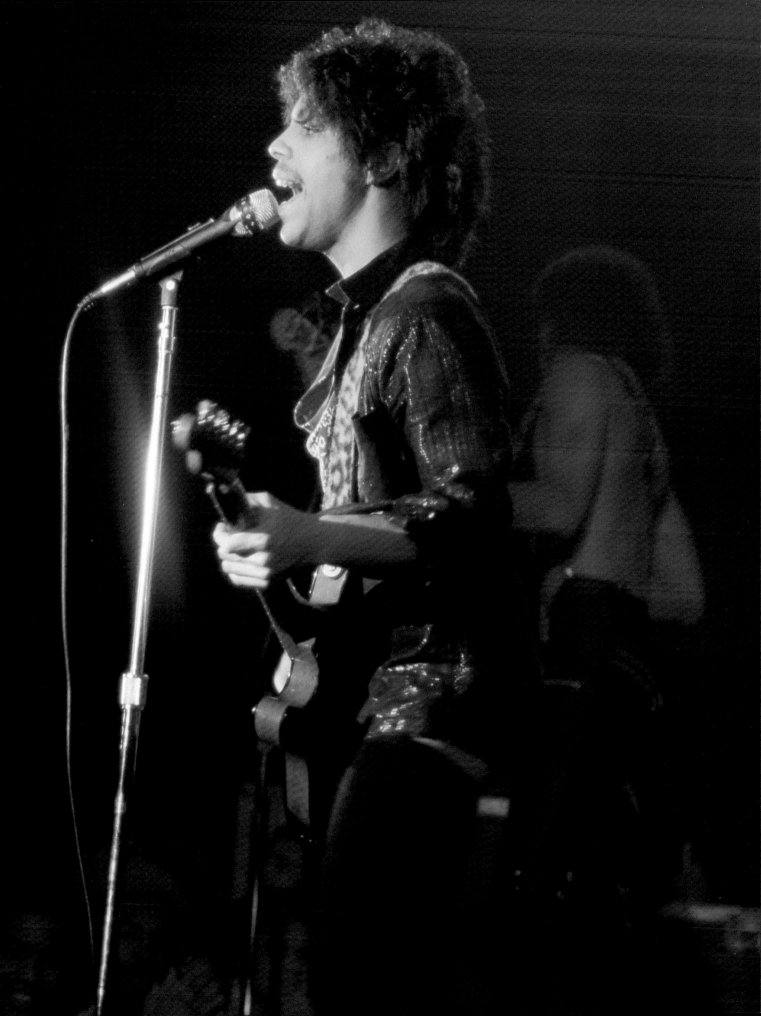

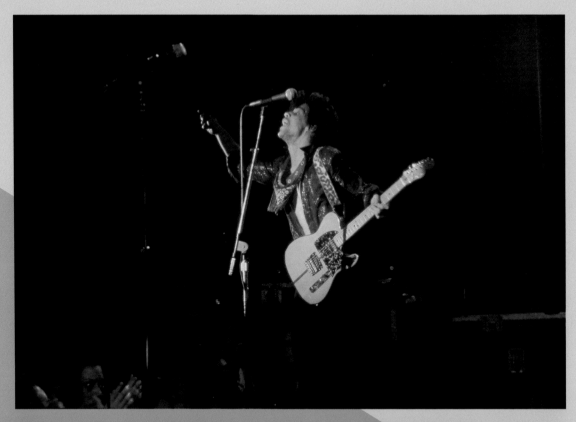

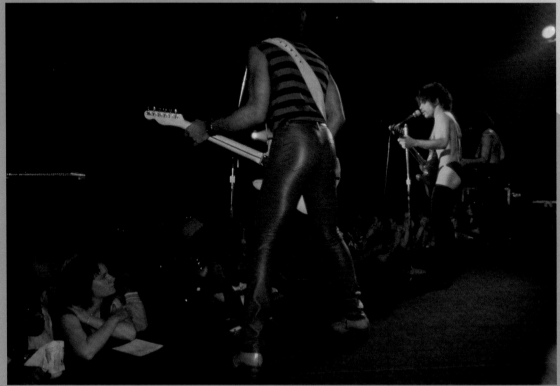

Concert at Sam's/First Avenue in Minneapolis, October 5, 1981

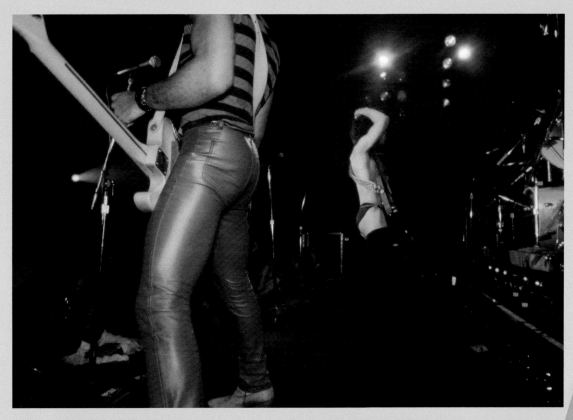

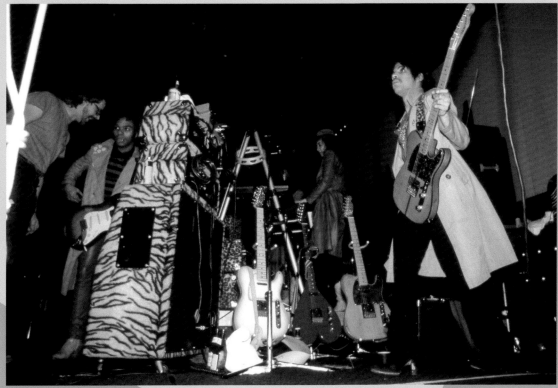

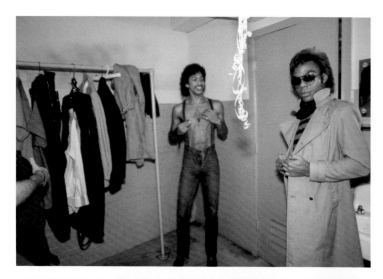

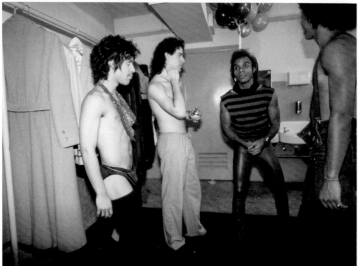

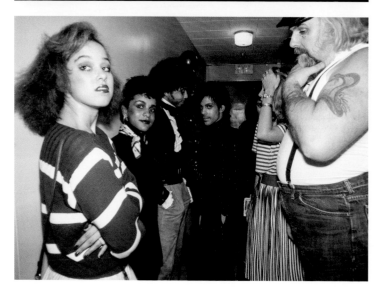

Backstage, *Dirty Mind* tour

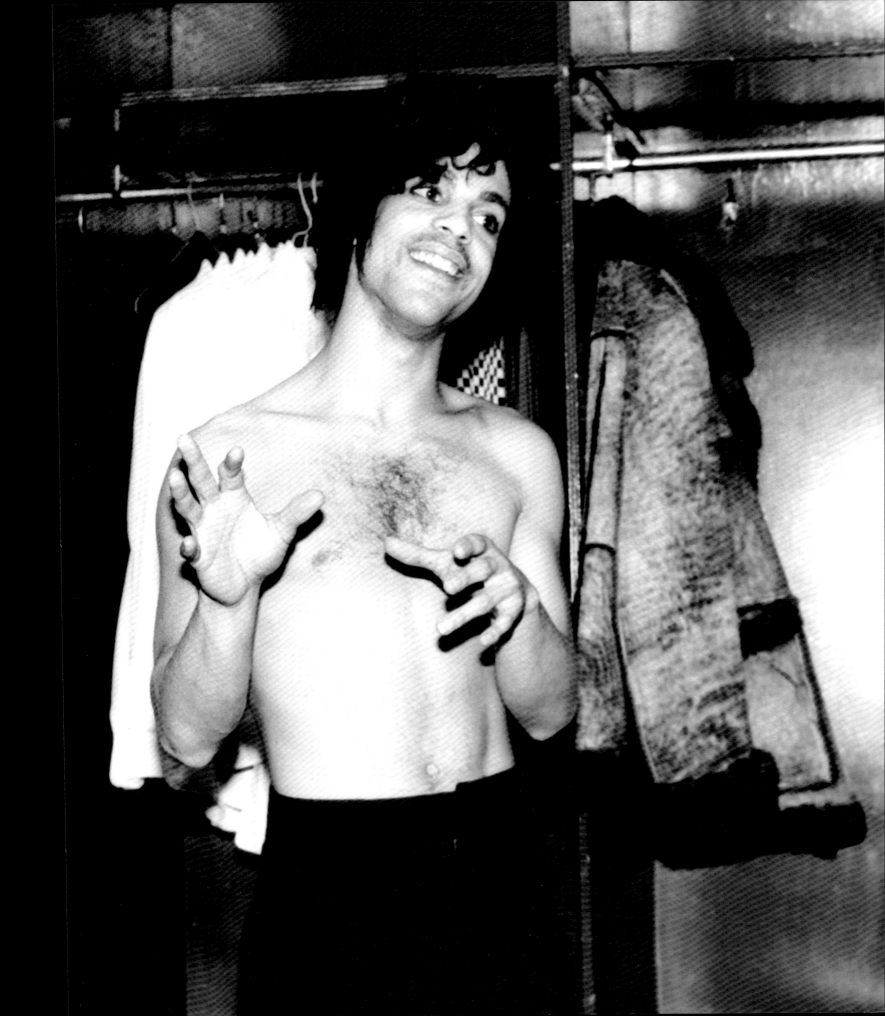

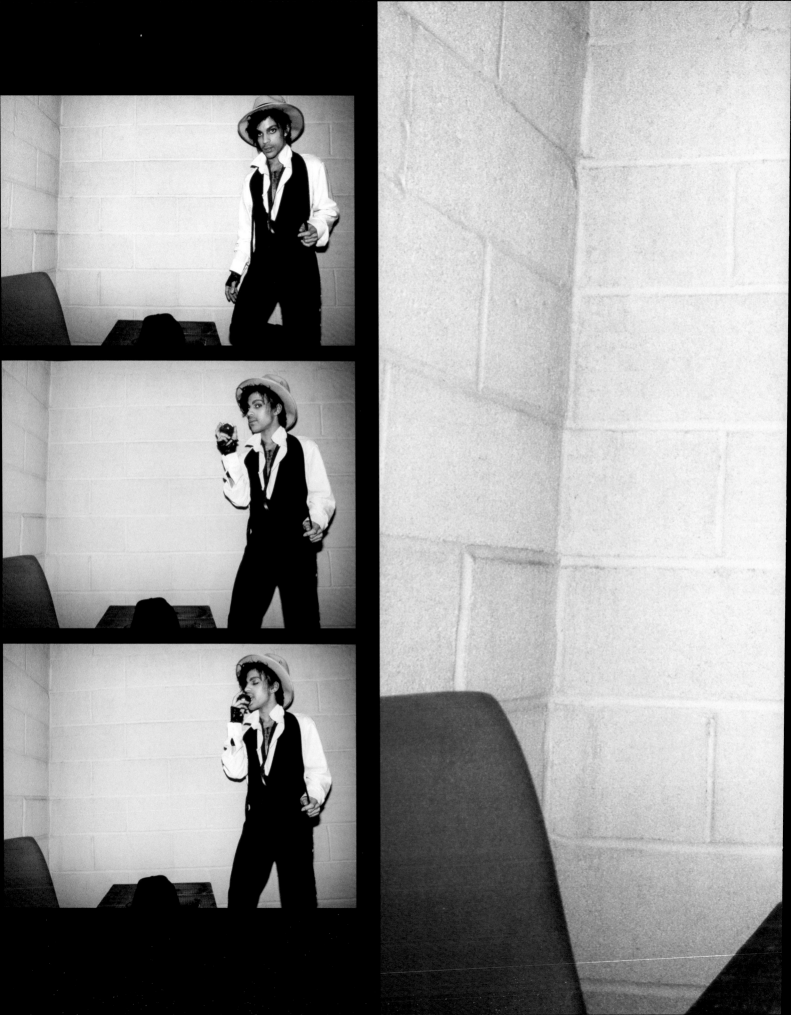

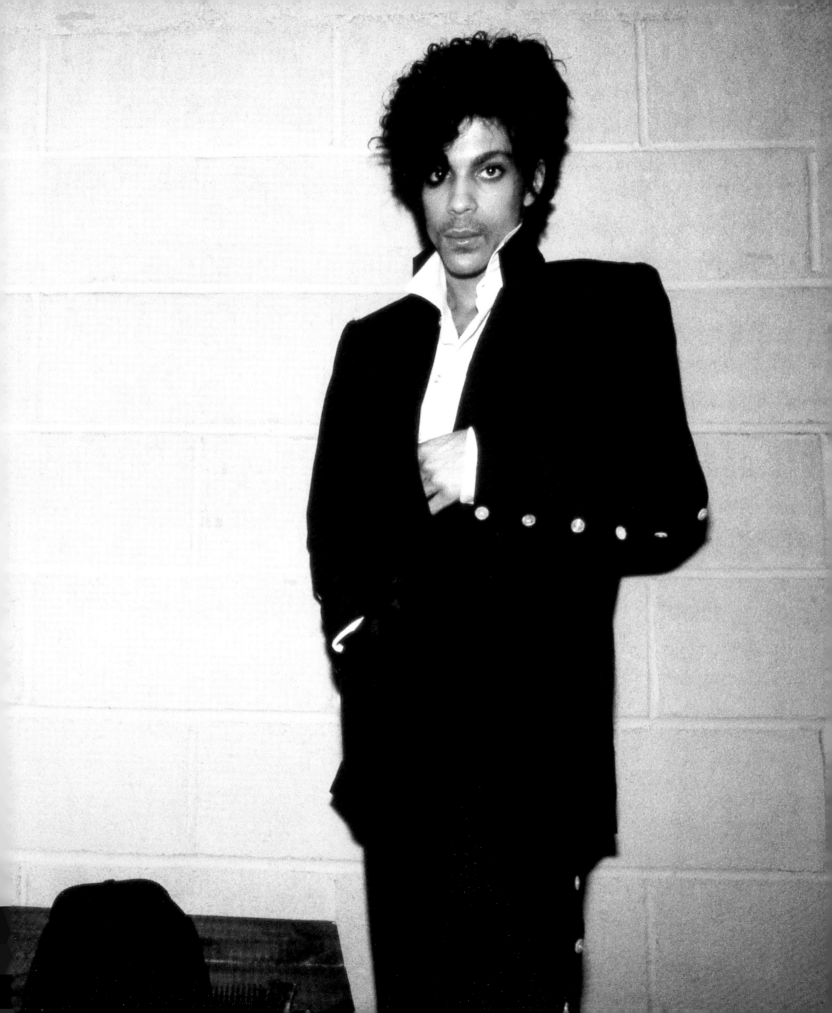

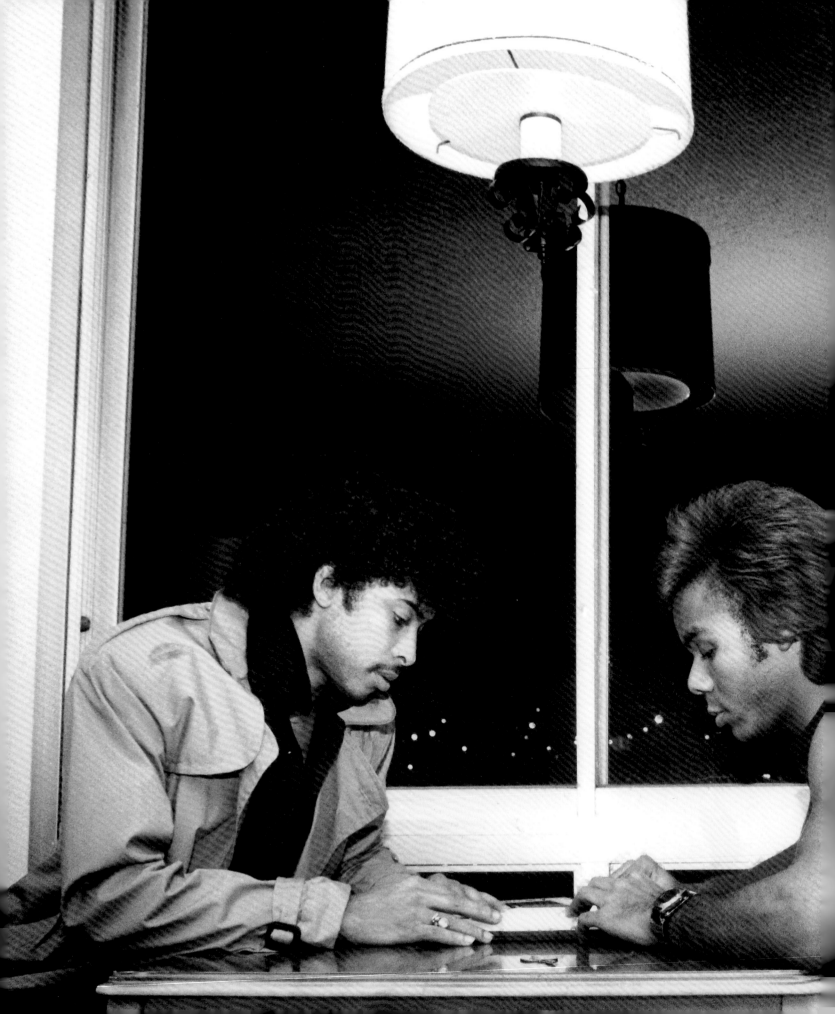

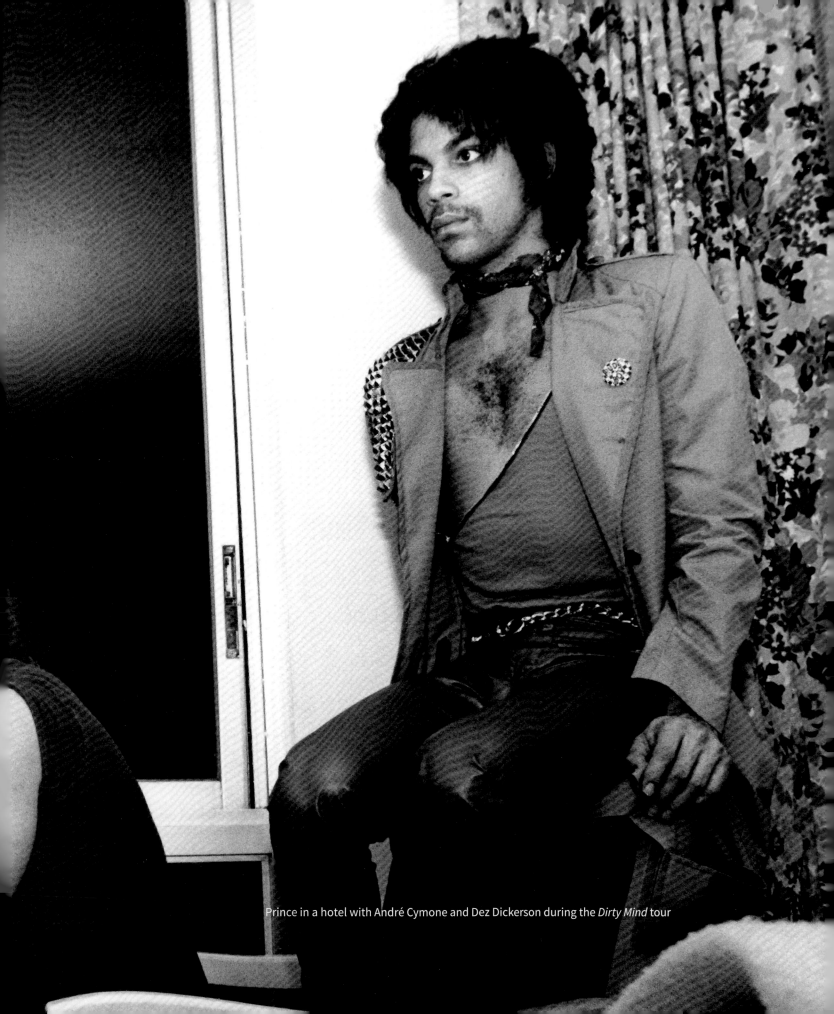

Prince in a hotel with André Cymone and Dez Dickerson during the *Dirty Mind* tour

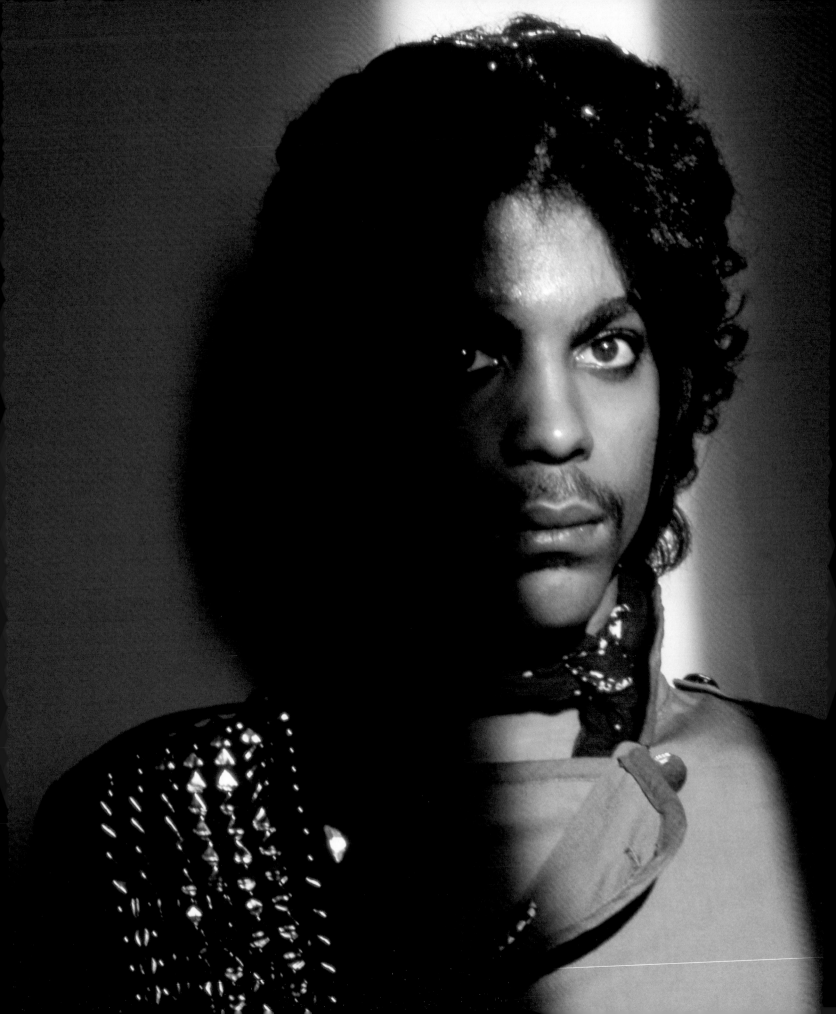

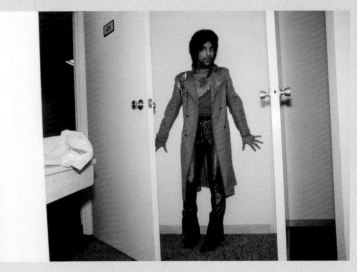

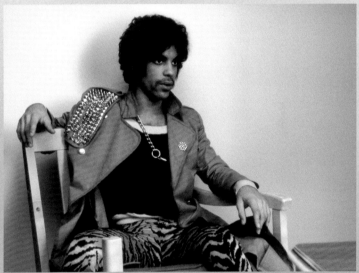

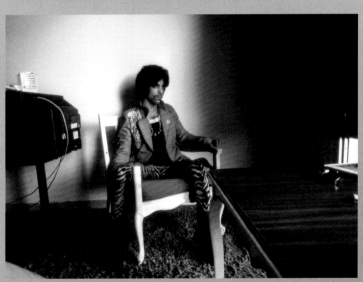

On the road, in a hotel, Anywhere, USA

Shooting Controversy

Prince's fourth album, *Controversy*, was recorded and released at a time when Prince was ramping up his activity and side projects. In addition to being on the road with the *Dirty Mind* tour early in the year, he produced and arranged the self-titled debut album of the Time, which was released on July 29, 1981—featuring a cover photo shot by Allen Beaulieu.

So, when it came to shooting a cover photo for his own upcoming release, Prince needed his photographer/friend to drop everything and get to work.

"The last thing he would do is the album cover, because he was so into the music part," said Beaulieu. "Like, the album was due a week ago, and Warner Bros. is going, 'We need the art *now*.' He called me after the third time they

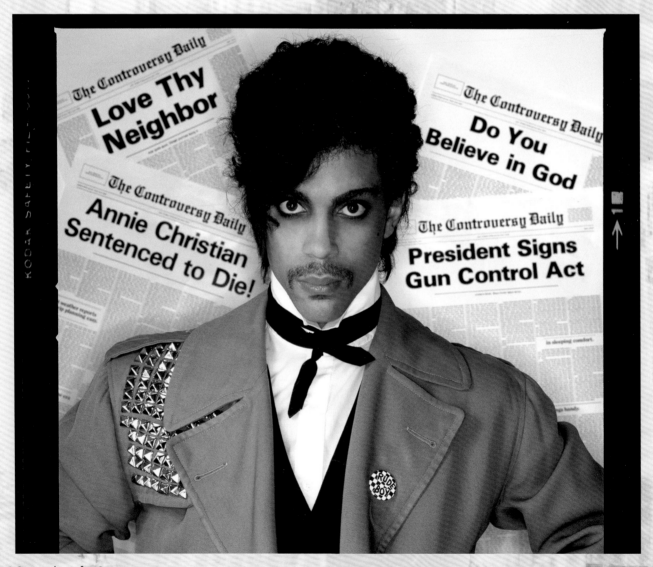

Cover photo for *Controversy*

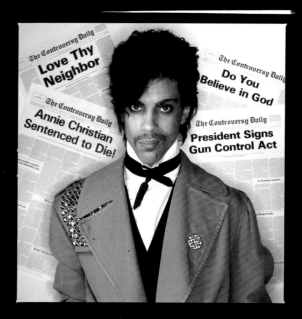

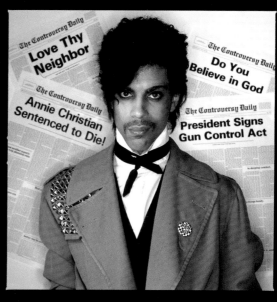
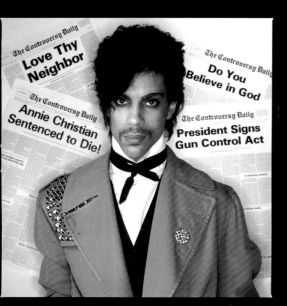
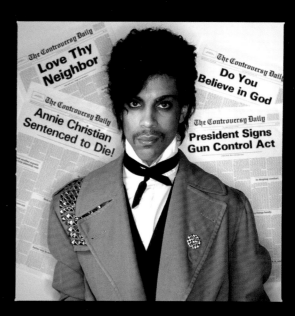

called him. He said, 'Al, I needed this yesterday, so you've got to figure it out.'"

The concept that Prince wanted for *Controversy*'s cover was a tough one for Beaulieu. "I was really having a hard time with it. Prince called me up and said, 'Al, what I want you to do is to shoot me on a newspaper.' All I could think of was newspapers at the bottom of a parakeet cage or something. I couldn't get a visual in my head. It was my brother [Rick] who said, 'You should come up with a newspaper, *The Controversy Daily*.' That's all I needed, some imagery to go with.

"So I called Prince back—and it's weird that I got ahold of him, because he was constantly changing his number to try to throw off fans—and I said, 'Hey, my brother suggests we make it like *The Controversy Daily*, and we can have the song titles or whatever, but I just need headlines.' I told him I would make the paper and we'd use that. He asked, 'Can you do that in one day?' I said, 'Yeah, I can do it in one day, but I need the titles right now.' He wasn't prepared for the question, but right off the top of his head he says, 'Love Thy Neighbor, Do You Believe in God, Gun Control, Joni Mitchell,' all that."

Beaulieu went to a typesetting place near his studio to make the stat of the paper. "We made it in one day; they promised one-day service. I had this girl help me who was a key-liner at Donaldson's department store. I can't remember her name, and she never got any credit on the album, but she made *The Controversy Daily* and put the headlines in. The copy was just dummy copy.

"We tried to get all the headlines in, but Prince's head was going to be too small. I wanted to do what Prince wanted, first and foremost—'You want all these on the cover, and I'm here for you, but we need to make this a real album cover'—and we'd taken tons of Polaroids, and none of them looked album cover-y to me."

Beaulieu loaded all his equipment and the newspaper stats into his car and drove out to Prince's house for the shoot. When he got there, he told Prince he had cut the newspaper down to four headlines for the front of the

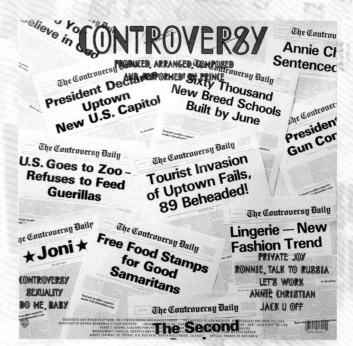

(above) Back cover of the *Controversy* album, showing more headlines from *The Controversy Daily*. *(opposite)* This photo, taken in the shower at Prince's Chanhassen home, was included as a limited-release poster insert with the *Controversy* album.

album. "He goes, 'You're asking me a lot, Al.' I say, 'I know, but go with me on this. I need just four headlines.' He walks over and goes, 'Okay, here's the four I want. Set it up.' If you look at the album cover, you can see where I cut and pasted to get it down to just the four headlines.

"The other hard part of shooting that album cover was that I wanted the copy of *The Controversy Daily* to be slightly out of focus, but I wanted this much of Prince showing. So, he's in focus, and the stories are out of focus.

"When I saw it, I knew we had it. When I showed him the first Polaroid—it was the first shot—we knew it: that's the album cover. How amazing is that? We did forty rolls after that, but we had it on the first shot. When he saw the first Polaroid, he goes, 'This is it. I feel it in my heart.' And I knew it as soon as I pulled it. As soon as I looked through the glass, I knew we had it." ◗

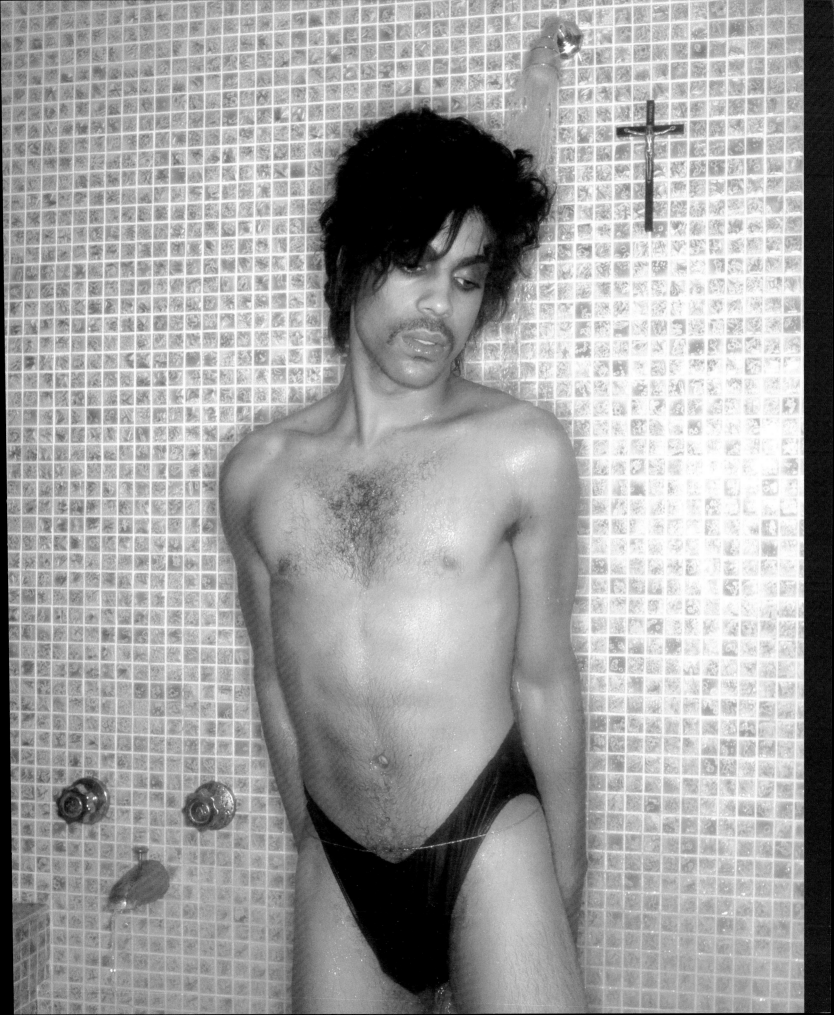

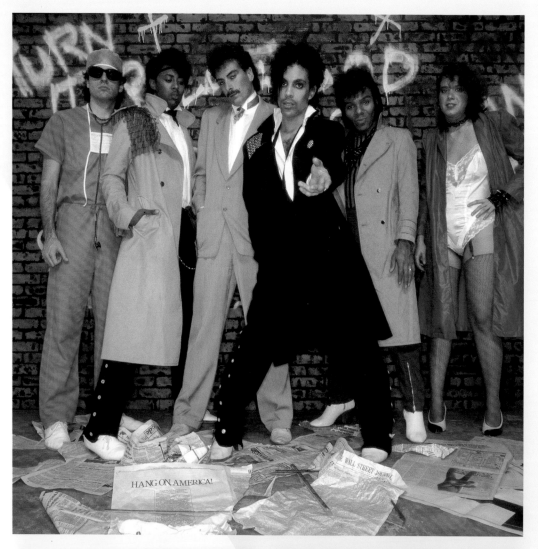

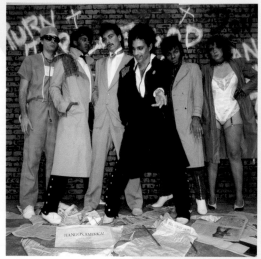

Promo photo for *Controversy*, taken in Beaulieu's studio

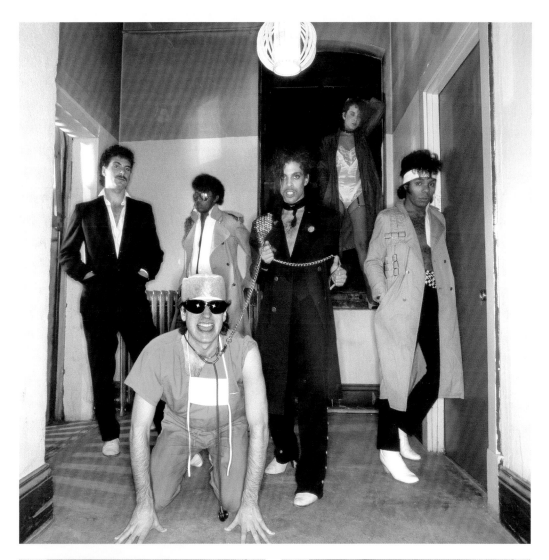

Another *Controversy* promo photo. The orange door on the right leads to Beaulieu's studio.

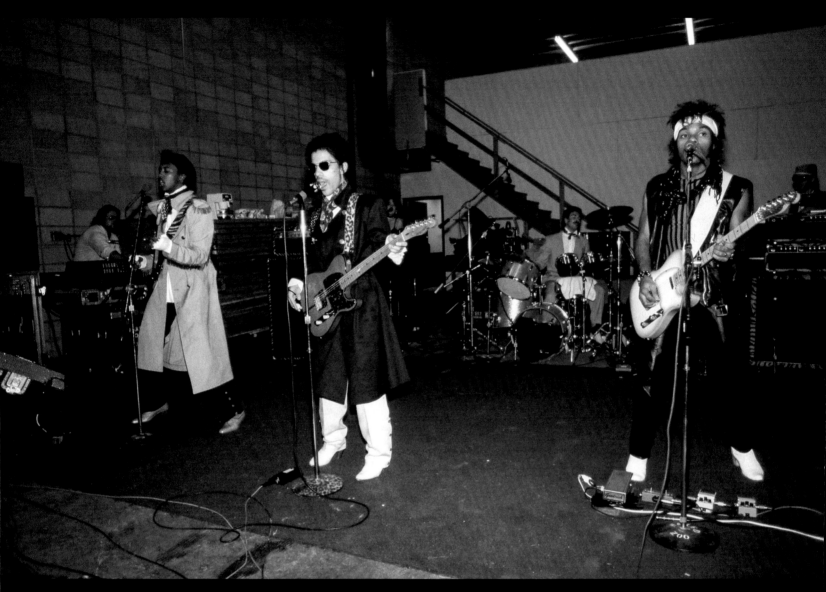

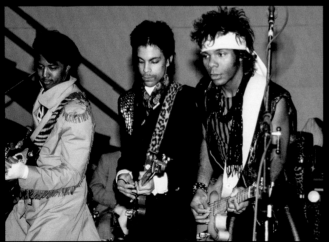

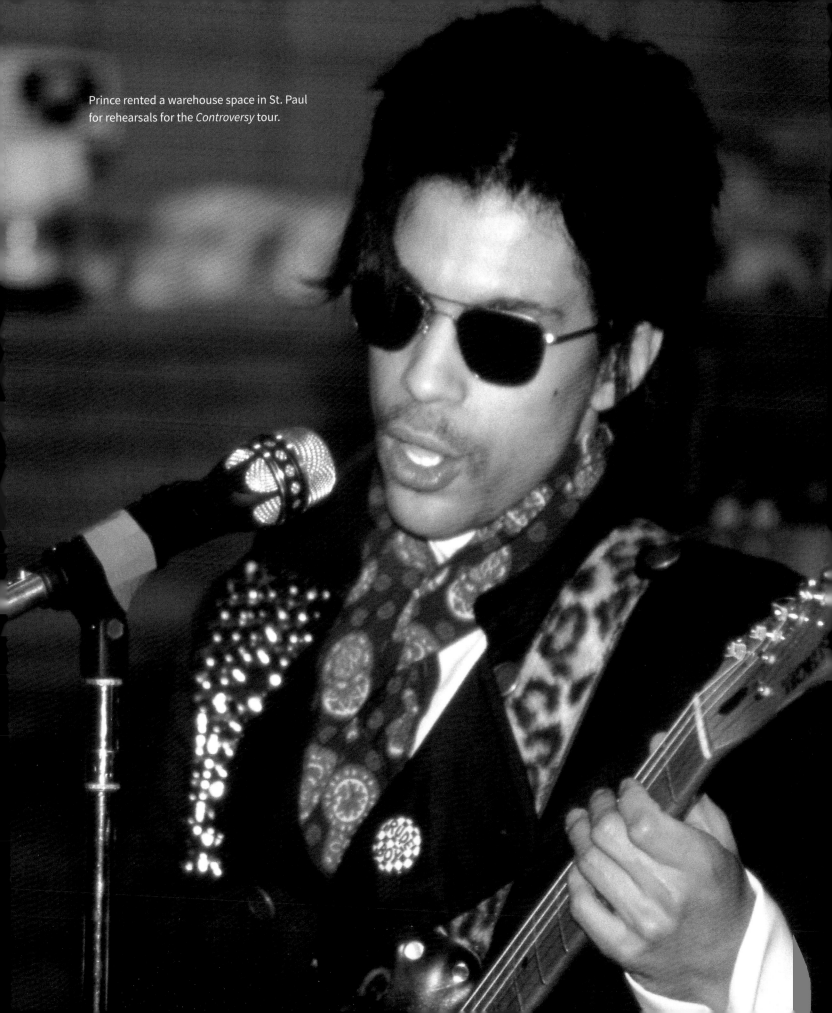

Prince rented a warehouse space in St. Paul for rehearsals for the *Controversy* tour.

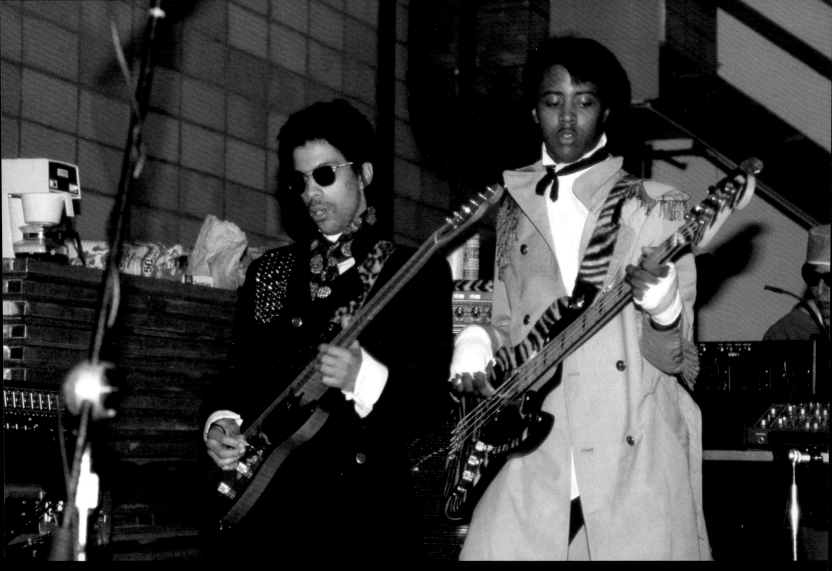

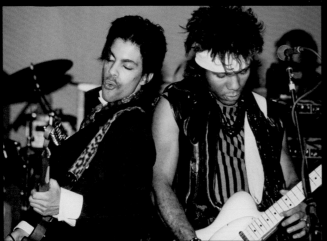

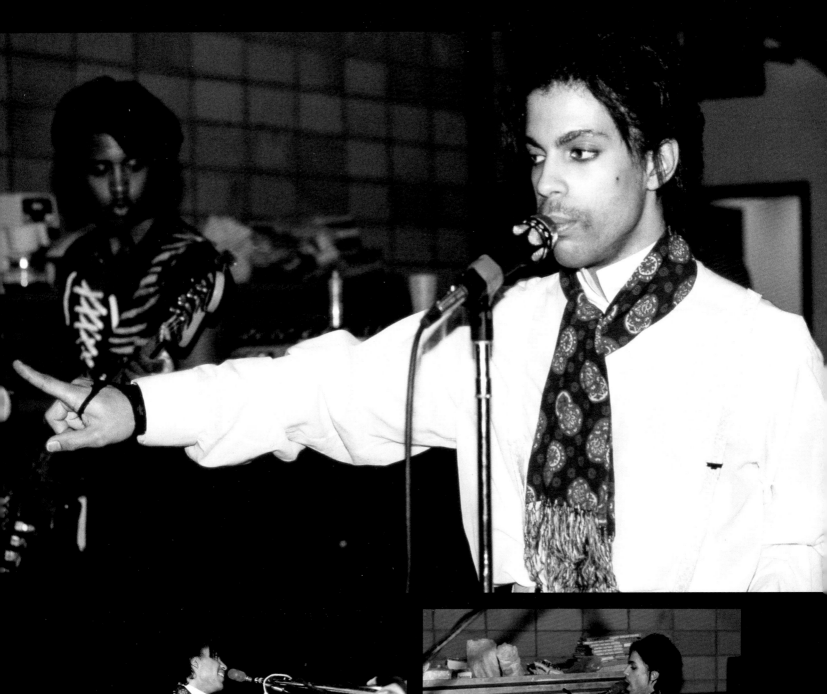

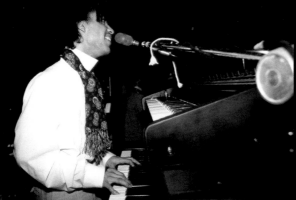

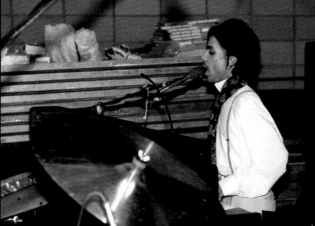

L.A. Blues

By Jim Walsh

In the fall of 1981, Prince and the Revolution were preparing to head out on the four-month *Controversy* tour. Prince had honed his live chops by then. After a short headlining tour on the heels of the release of *Prince* in late 1979, he joined up with Rick James's *Fire It Up* tour in February 1980, serving as the supporting act for forty-two dates in forty cities. Seven months later, Prince was on the road again with the *Dirty Mind* tour, which kicked off in December 1980 and concluded in April 1981.

The band was in top form, *Controversy* was in the can, and all concerned were ready for the album's October 14 release date when Prince accepted Mick Jagger's invitation to open the Rolling Stones' two-gig stand at the Los Angeles Memorial Coliseum as part of their *Tattoo You* tour. But on October 9, 1981, 94,000 Stones fans couldn't be bothered with Prince. They threw bottles, food, and racist slurs at the diminutive singer and his band, who stopped partway through their fourth song, "Uptown," amidst a stadium's worth of boos. Prince walked offstage, the band finished the song, and Prince reportedly cried after the gig.

Allen Beaulieu, who made the trip with his cameras in tow, recalled that the shows were held on Friday and Sunday, since the University of Southern California Trojans had a football game at the Coliseum on Saturday. "It was a huge stage, and I was shooting on the stage. I had a good sightline, actually.

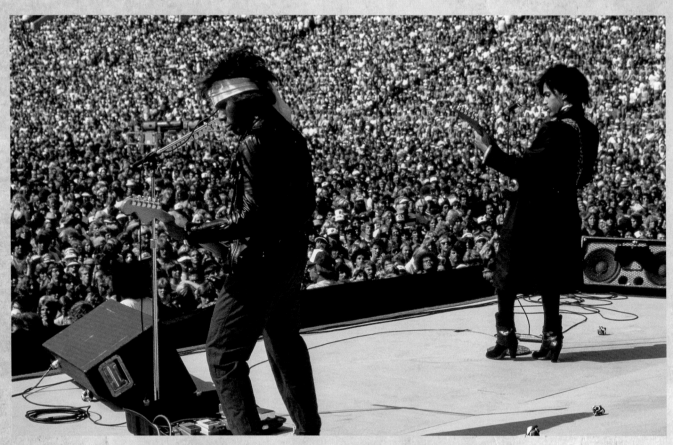

The band's performance opening for the Rolling Stones, in front of a huge crowd at Los Angeles Memorial Coliseum in October 1981, did not go as well as planned.

"For the Friday show, Prince came out in a trench coat and bikini briefs," Beaulieu said. "First song he did was 'Jack U Off,' and that didn't go over too well with the bikers in front. You put this black kid in front of the Rolling Stones—you put any black guy in a trench coat and bikini briefs in front of a bunch of bikers at noon—it was a bad situation. People were booing him, throwing trash and bottles at the stage. It was not pretty."

Prince played for about fifteen or twenty minutes, and then he just walked off the stage. "He was pretty upset by what happened," said Beaulieu. "He actually flew back to Minneapolis right away. He was backstage for maybe fifteen minutes, then he and [bodyguard] Big Chick went home. The rest of the band and I stayed in Los Angeles. After Prince, it was George Thorogood, then J. Geils, and then the Rolling Stones came on about nine o'clock."

The second concert was still scheduled for Sunday.

"We didn't know what was going to happen," Beaulieu said. "Saturday was a day off, and I couldn't get news from the band or management. It didn't look like Prince was coming back. I know Mick Jagger called him and tried to get him back. The way I heard it later, Dez Dickerson is the one who talked him into coming back. So, he came back for the Sunday show, and he changed the whole set, doing more like a 'greatest hits' set. It didn't really matter, though. They still booed him. These people were there to see the Rolling Stones. They'd been lined up since six in the morning. Again, you're putting a black person in a trench coat and bikini briefs and high-heel boots at noon—it was just the wrong thing."

It was a tough moment for the young star, who was still only twenty-three years old. "I think he was embarrassed. Prince had never been treated that way in his life."

Fortunately, he got over it, and Prince continued to assert his place among the greatest live performers the world has ever seen.

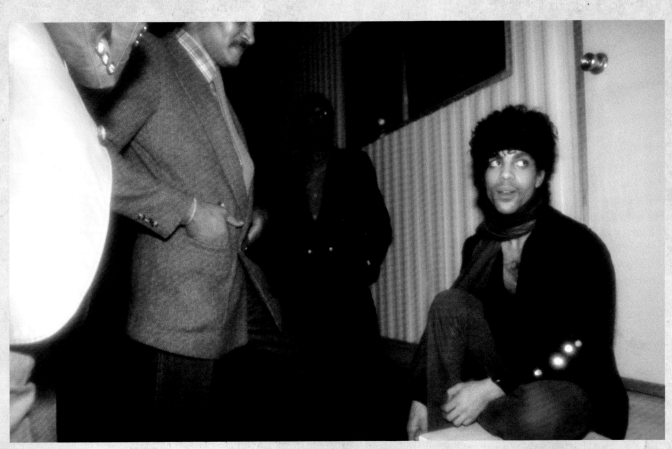

The poor reception from the Rolling Stones fans in L.A. hit Prince hard.

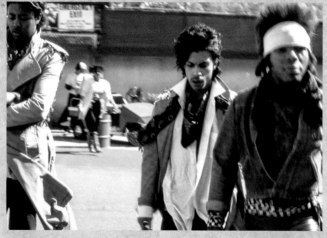

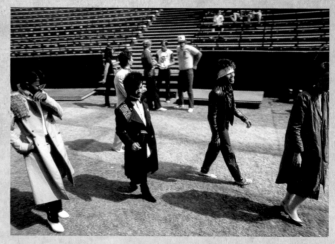

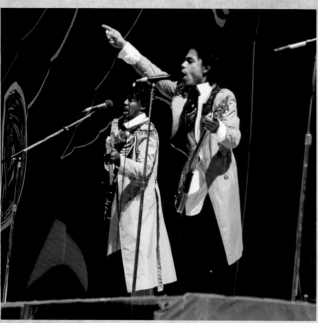

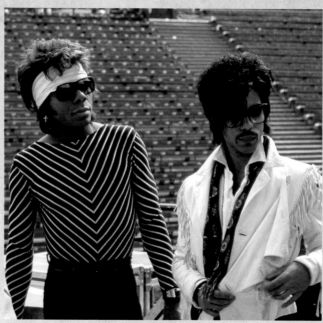

"These photos of the Rolling Stones show make me feel like I'm seeing lost pictures of the *Titanic* at the bottom of the sea. It was such a chaotic moment in this story. It had the makings of greatness, the greatest news ever.

"Can you imagine? You're a drummer, a young kid from Minneapolis working with a young kid from Minneapolis, and you get the call: You're going to open for the Rolling Stones! There's nothing bigger. It was such a crazy, exciting moment. . . .

"It's festival seating and people are crammed in like sardines to get up front, and now it's time for Prince?!? He walks out in the trench coat and frankenfurter outfit, and he's spinning around and dancing with his ass hanging out. It's driving everybody wacky. They didn't get it, they didn't know what was going on. They were shocked and appalled. It created a combustion of human anger that I'd never experienced. I was in tears, and Prince was frightened to death.

"It was such a shock to the band. The rehearsal we'd put in for months and months, and the expectation for the album to be the next new punk, new wave conquering thing. The wings fell off that day, and we crashed back to earth."

—*Bobby Z*

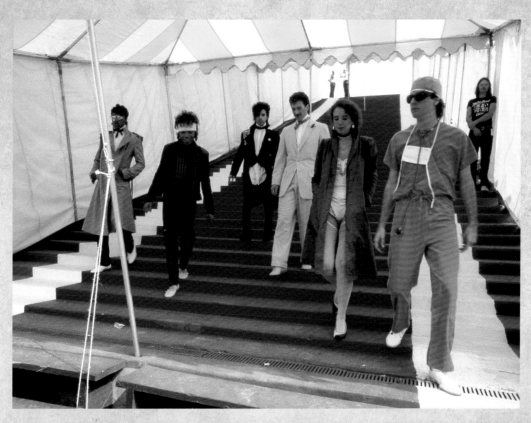

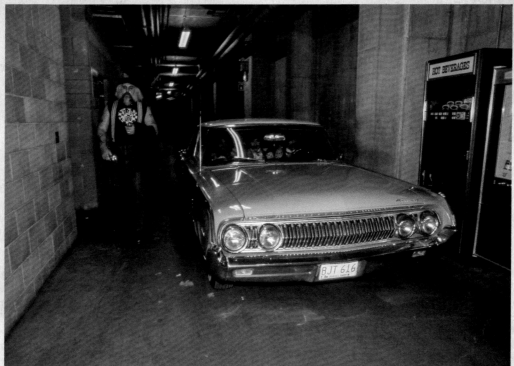

Prince and the band driving through the corridors underneath L.A. Coliseum, while Prince's bodyguard, Big Chick, walks alongside

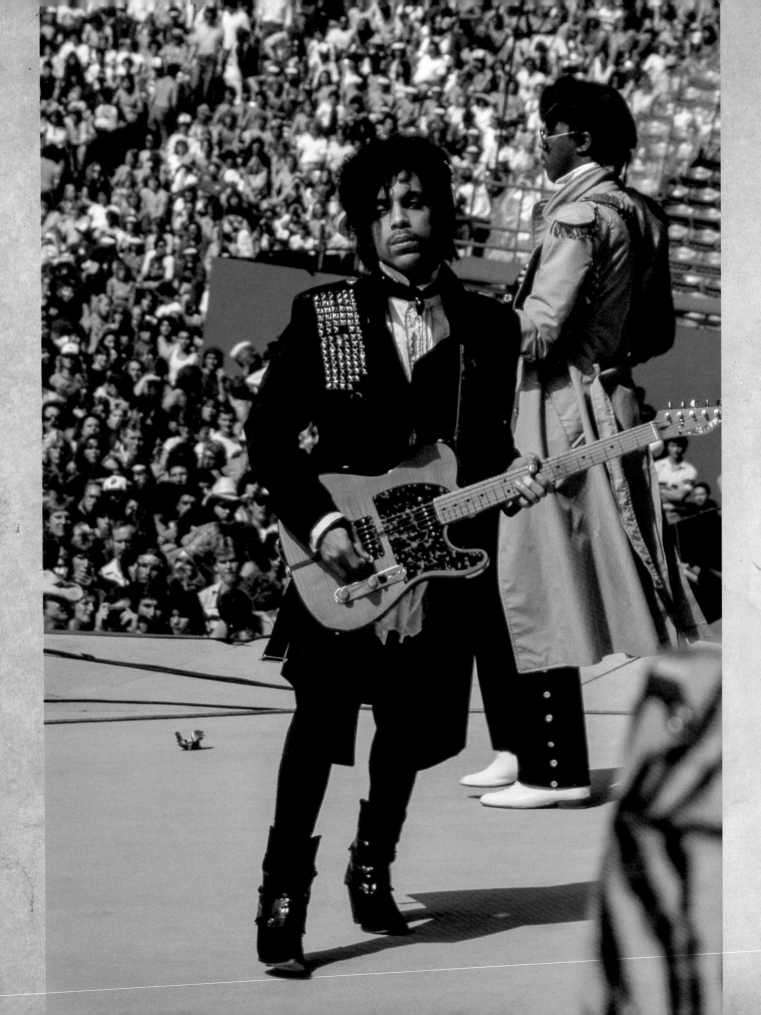

Controversy

By Eloy Lasanta

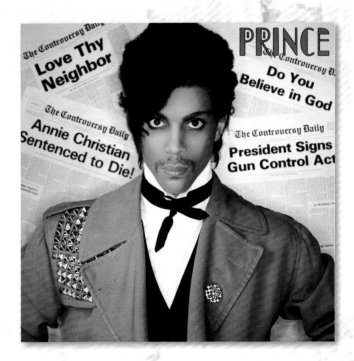

Released on October 14, 1981, almost exactly a year after *Dirty Mind*, *Controversy* was Prince's fourth album, and it came during an extremely prolific period for the artist. In late 1980, he took off on the *Dirty Mind* tour with the lineup that would eventually become the Revolution; the tour, which had a three-week run in December and then picked up with a second leg in March and April, hit about twenty-five cities, mostly in the East and South. Prince wrote the majority of *Controversy* while on the road, and he launched the Time with Morris Day in 1981 as well.

For the album cover, Prince attempted to bring a bit of polish and respectability to his image, as he traded in the bandana and bikini briefs of *Dirty Mind* for a button-down collared shirt, a vest, and an untied tie to complement the purple trench coat and "Rude Boy" button from the previous cover. The headlines behind Prince calling for "Gun Control" and to "Love Thy Neighbor" set the tone, informing potential buyers what they were in for. Yes, there was still a fair helping of s-e-x, but *Controversy*'s new material also focused on political messages. It also incorporated influences from the new wave movement coming through in the early 1980s, mixed with Prince's existing punk and funk grooves.

Controversy was released to positive reviews, as it felt almost like an extension of *Dirty Mind*, a revision of sorts, and thus connected with fans who were into the previous album. Of course, while *Dirty Mind* only reached gold status in record sales, *Controversy* sold a lot more and hit platinum.

Blender magazine's Keith Harris described *Controversy* as "Prince's first attempt to get you to love him for his mind, not just his body," and that's pretty accurate. Sure, "Do Me, Baby" conveyed a lot of sexuality as a single, but songs like "Controversy" and even "Sexuality" carried political messages that were a breath of fresh air to radio listeners and record-store customers. "Let's Work," the second single released from the album after the title track, didn't do as well on the charts, but it became a fan favorite that Prince performed to get the party started even late into his career. ●

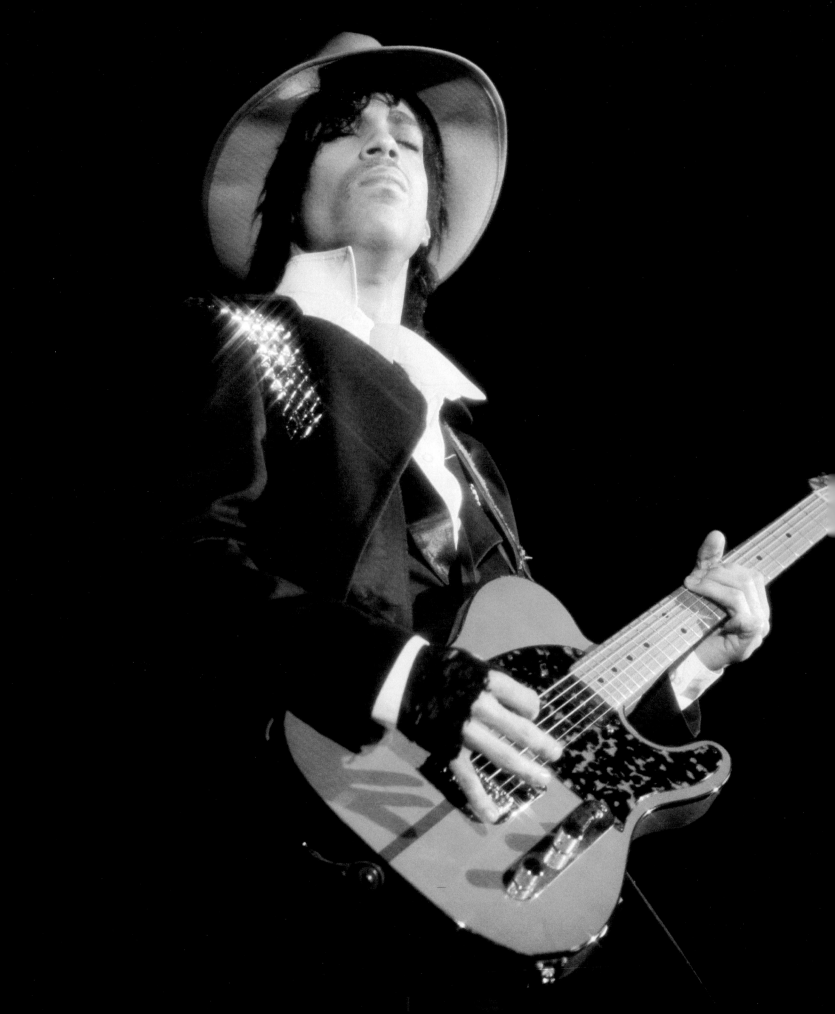

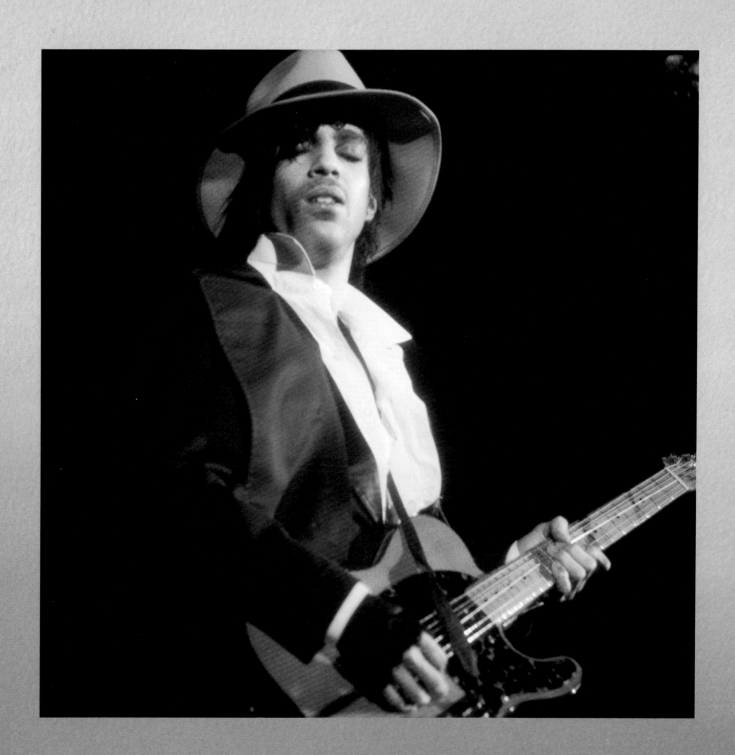

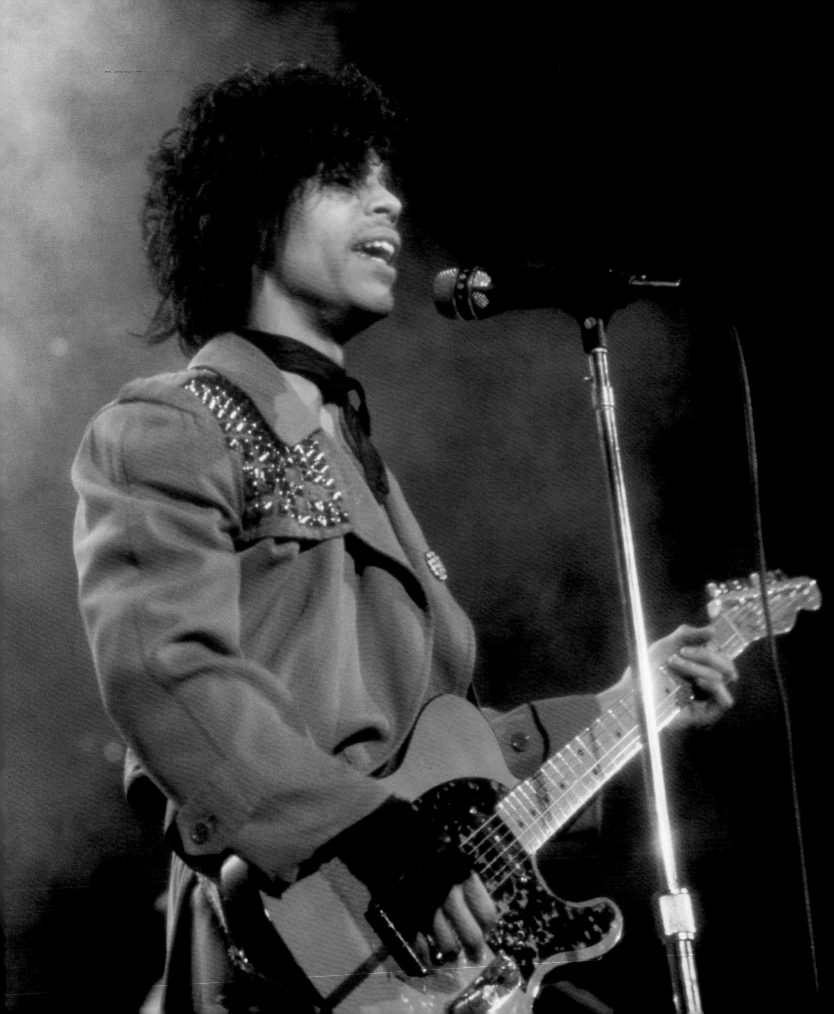

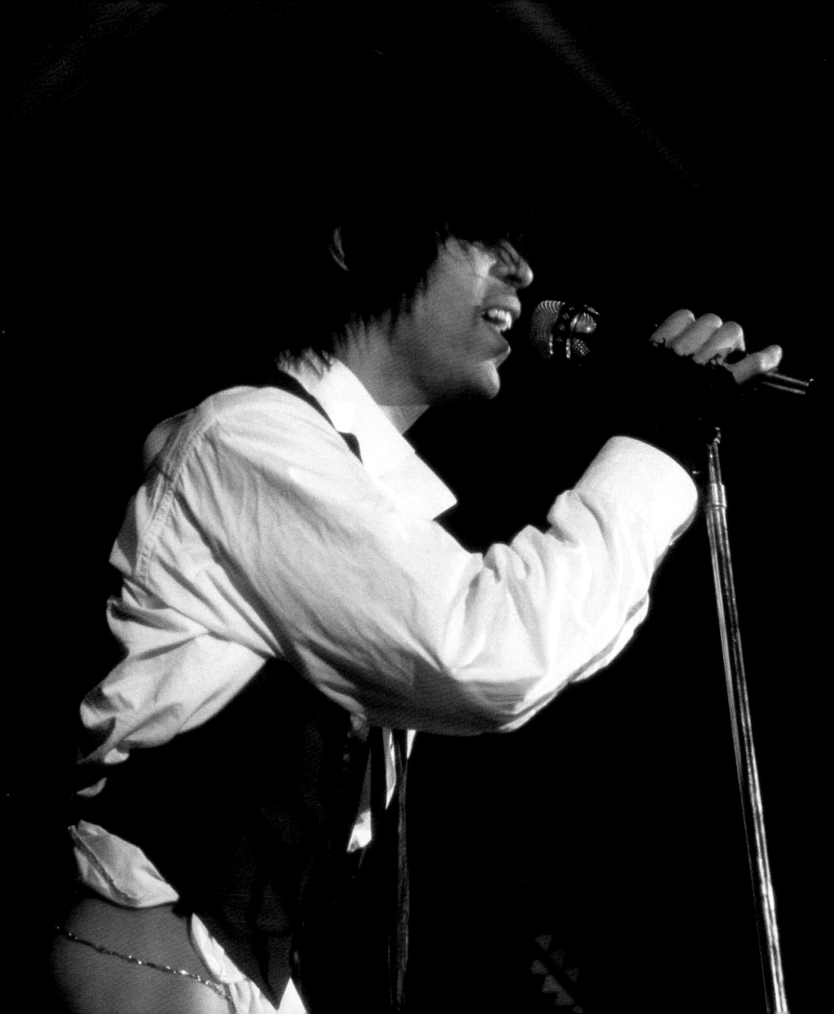

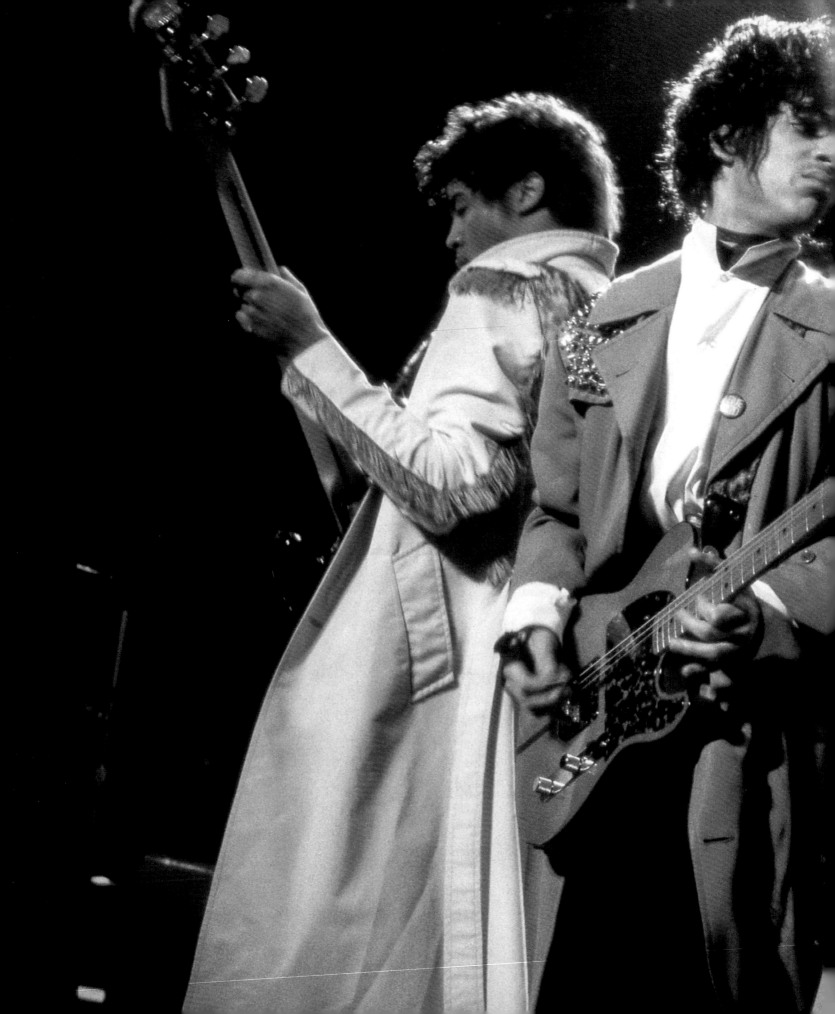

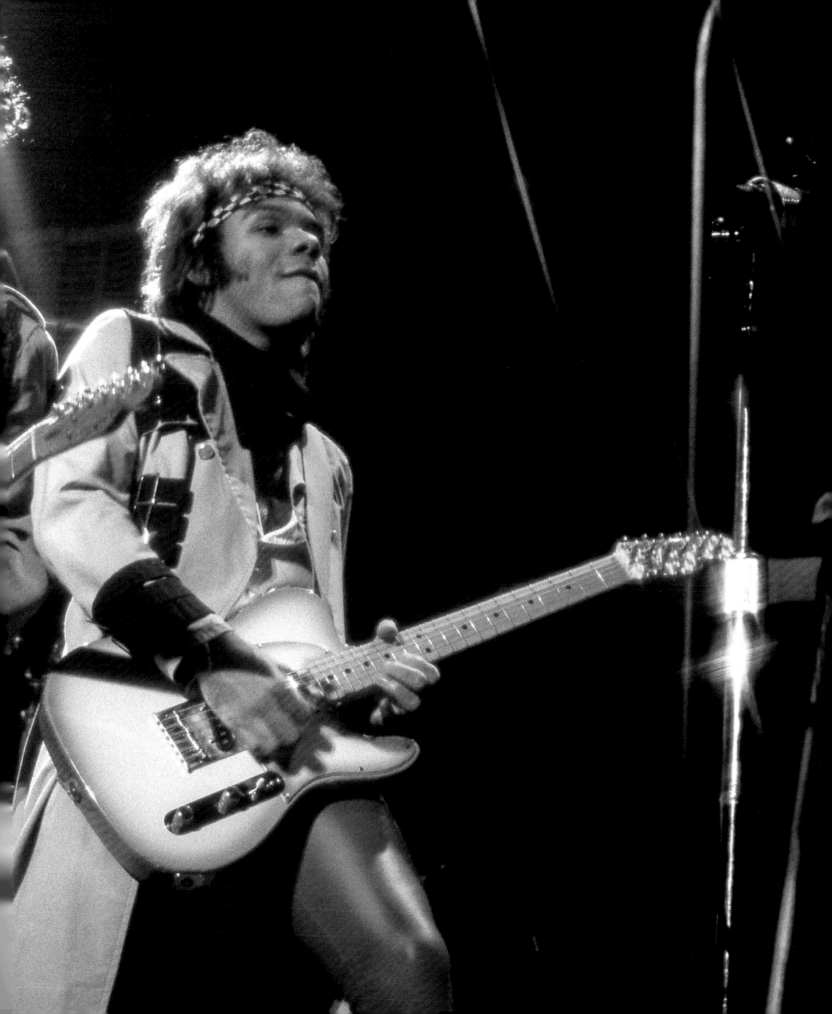

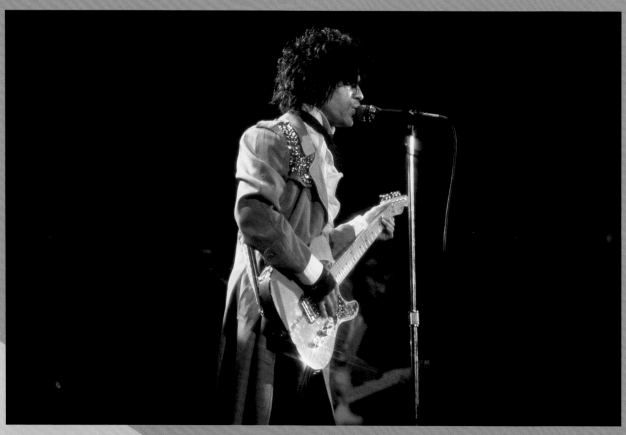

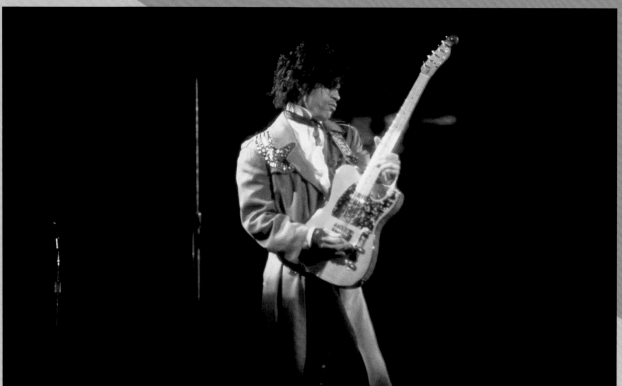

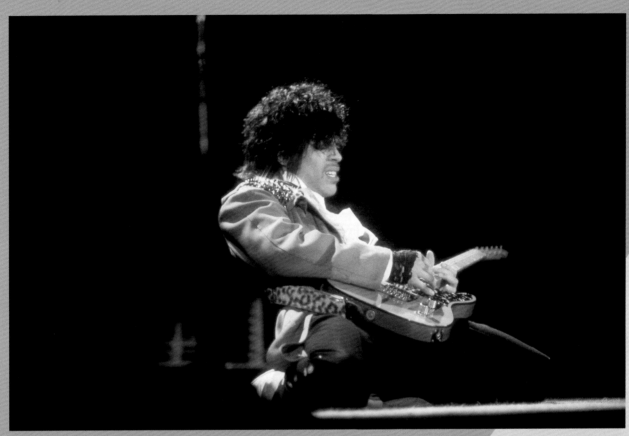

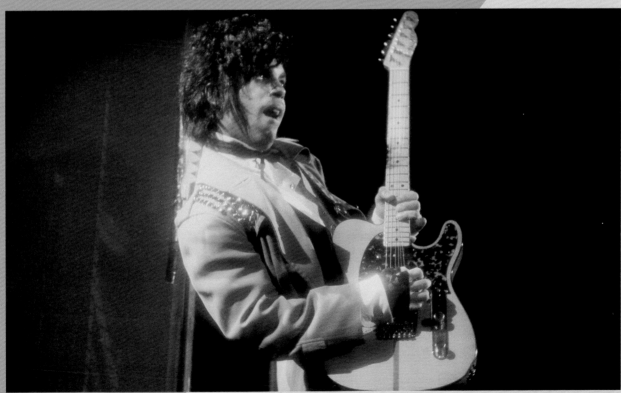

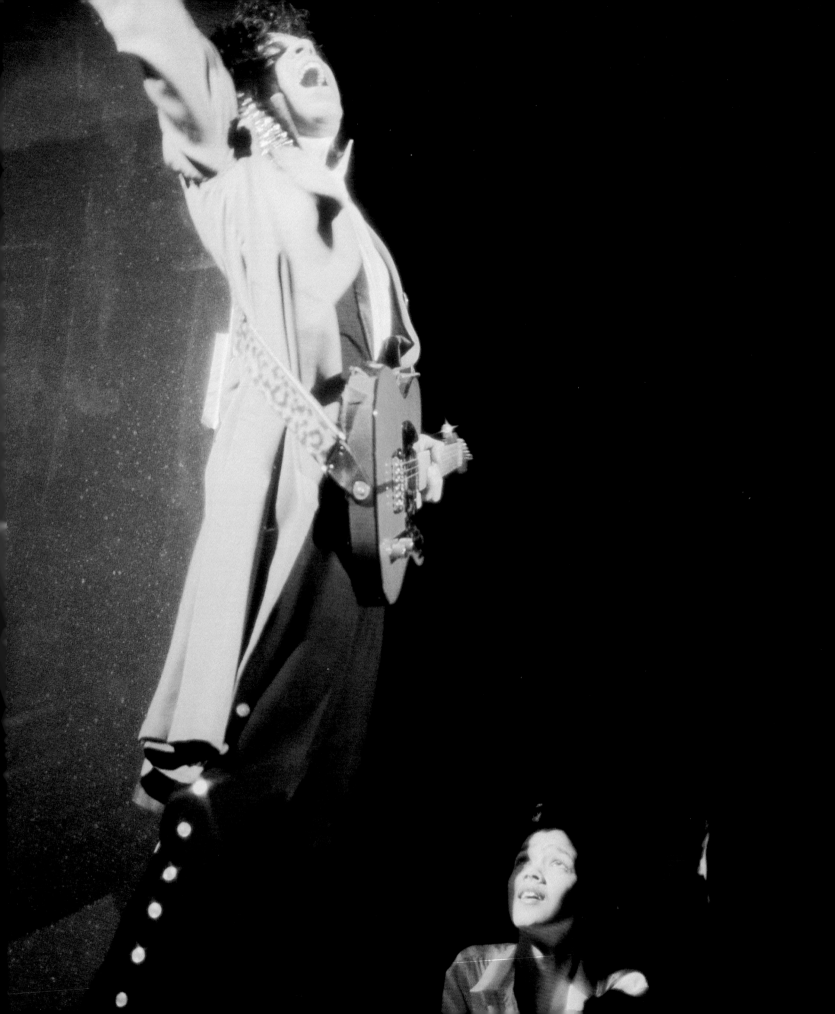

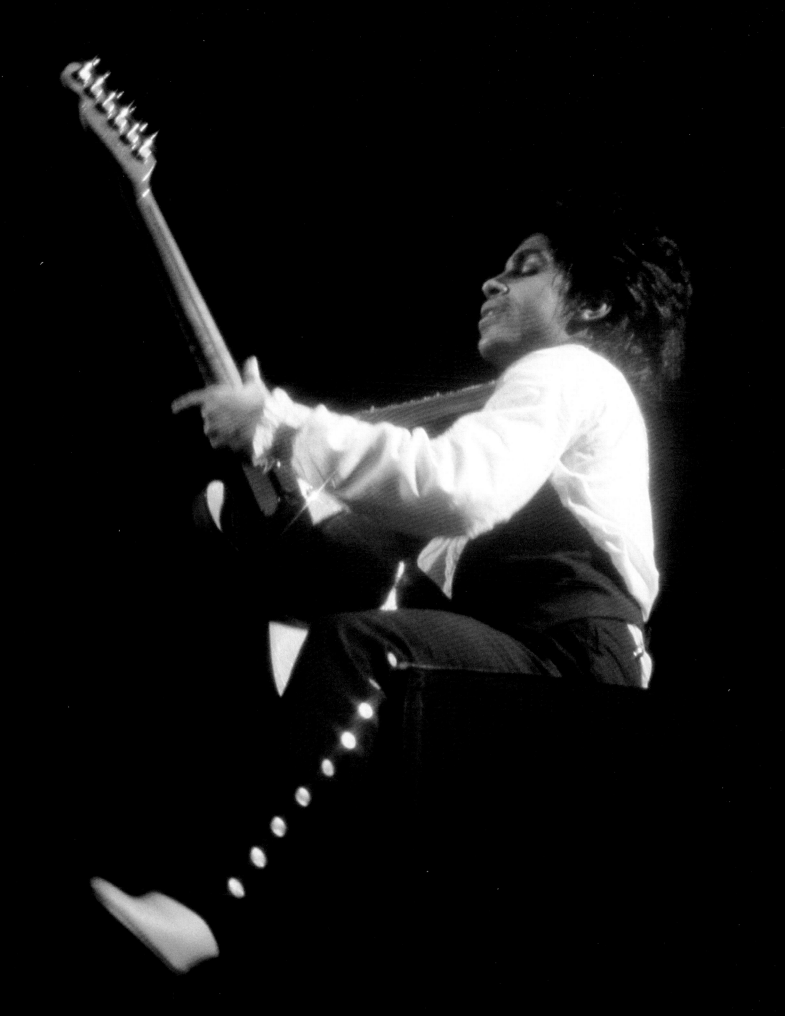

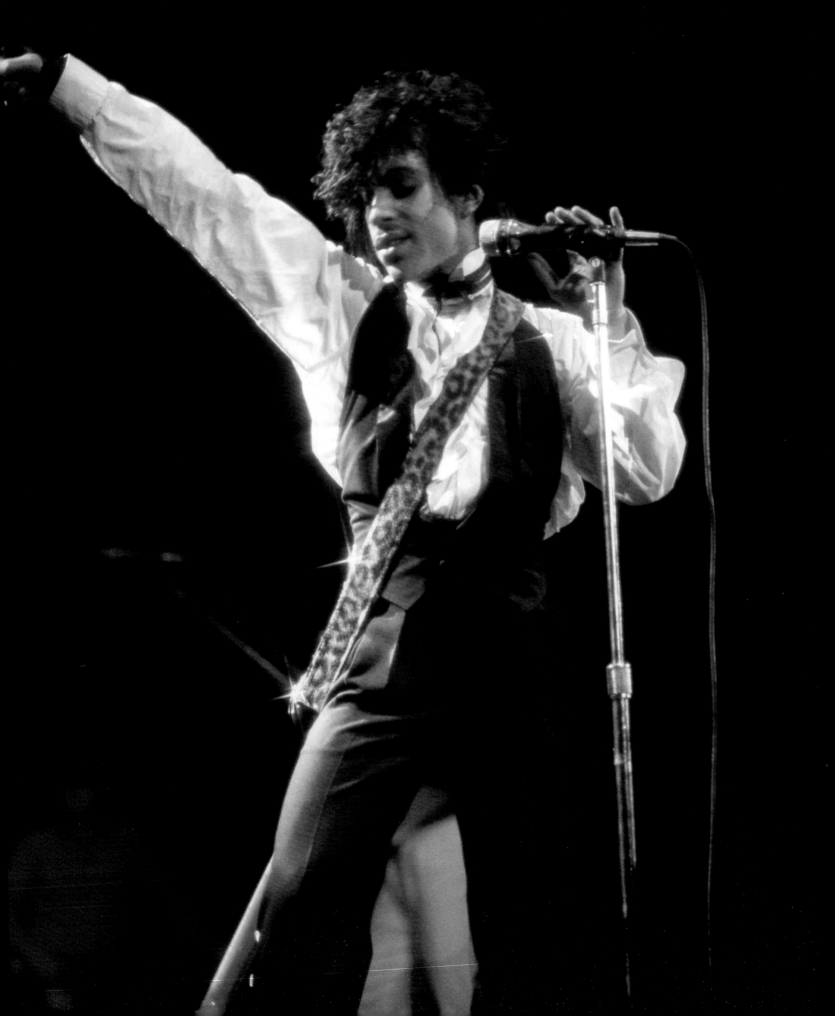

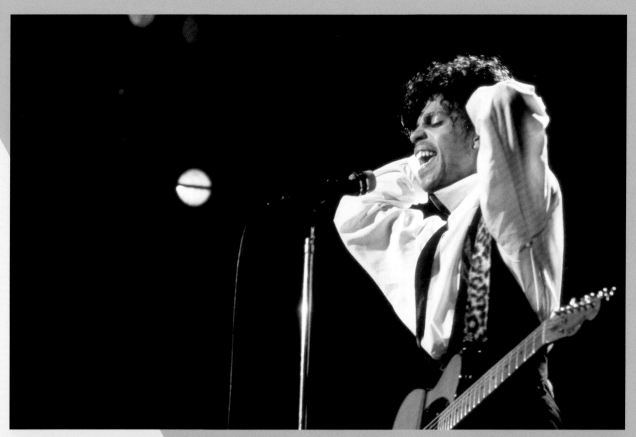

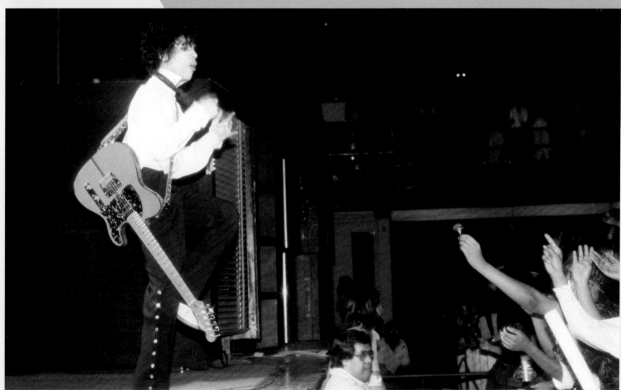

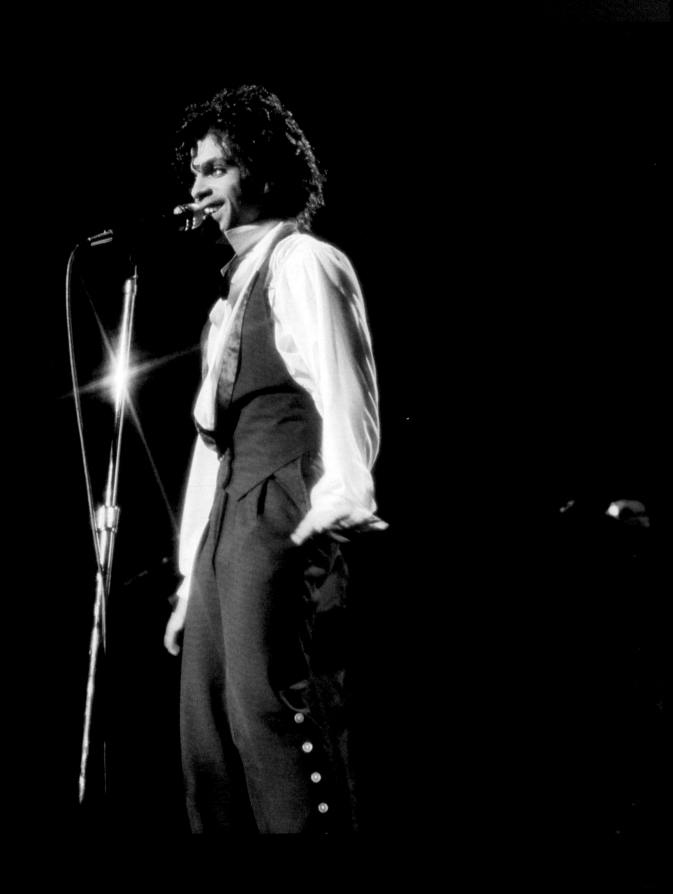

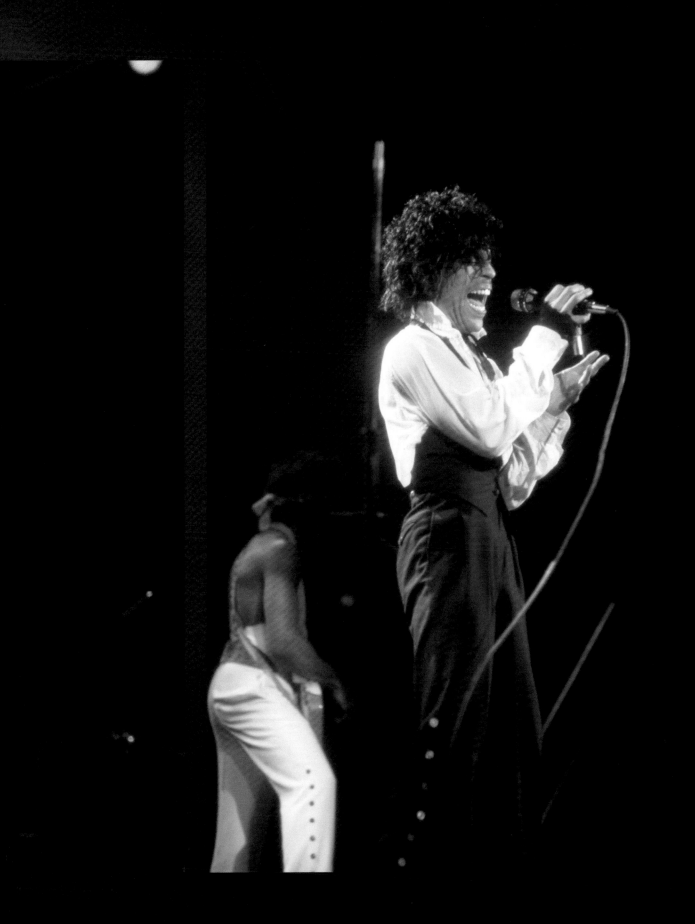

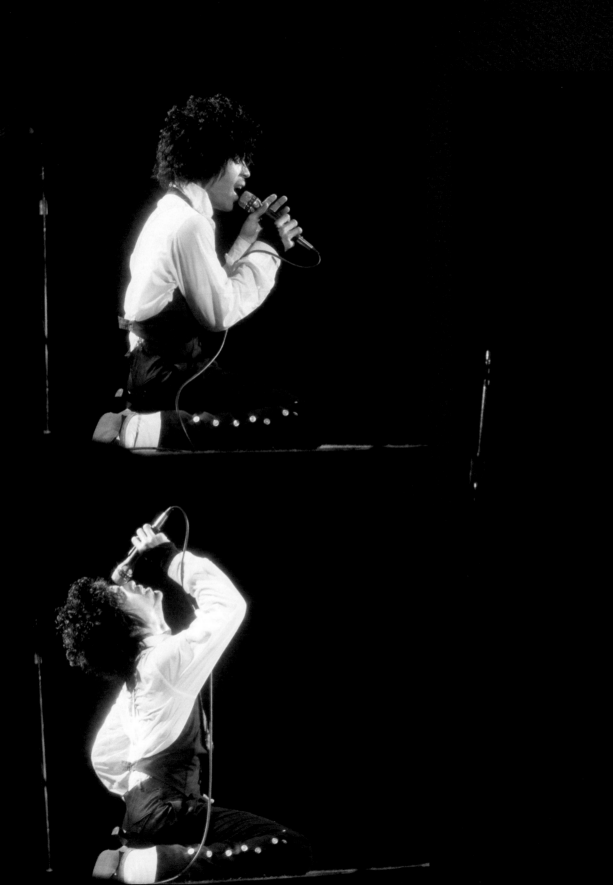

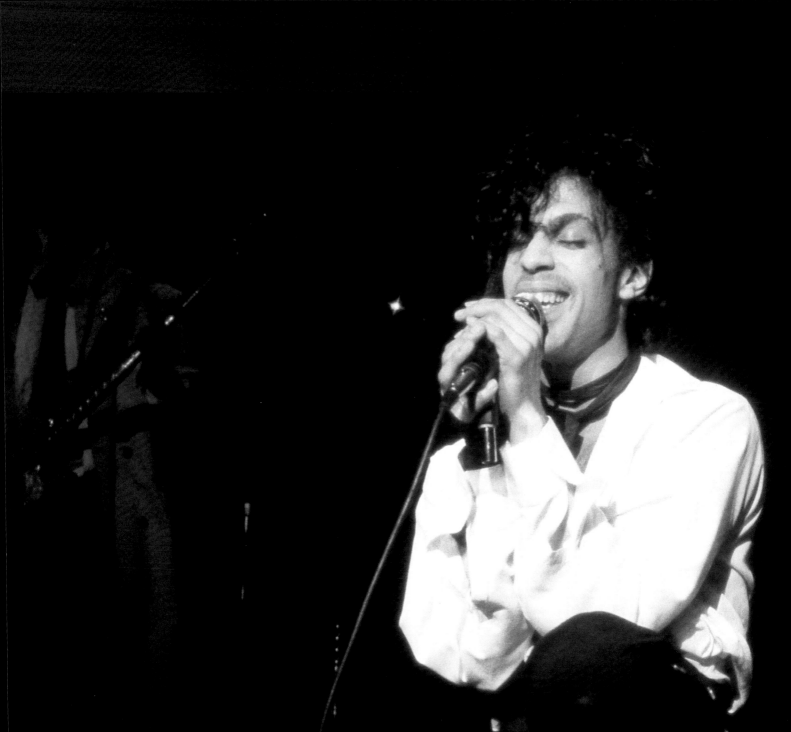

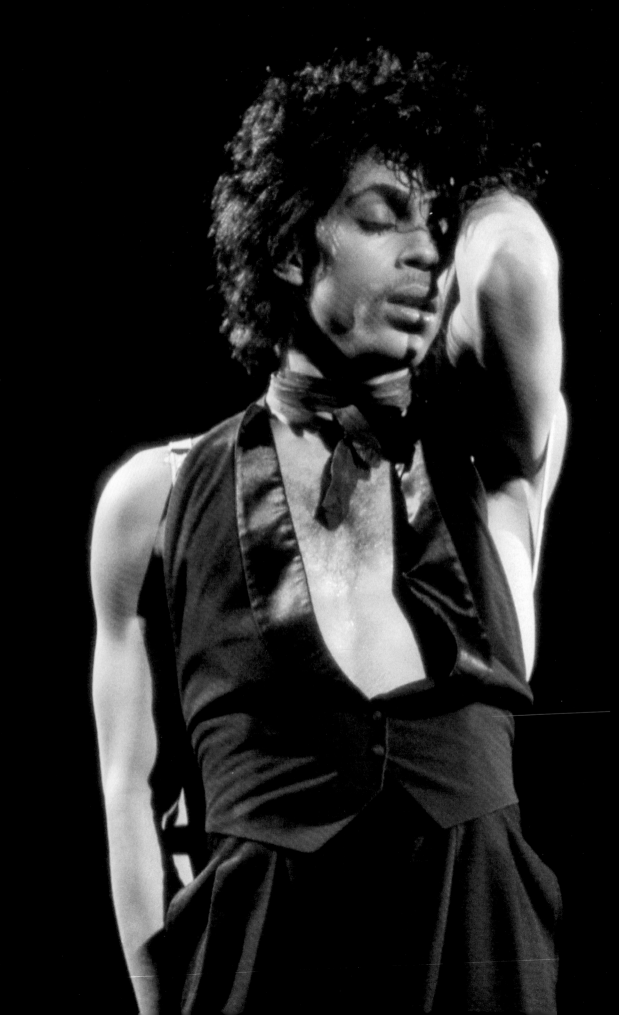

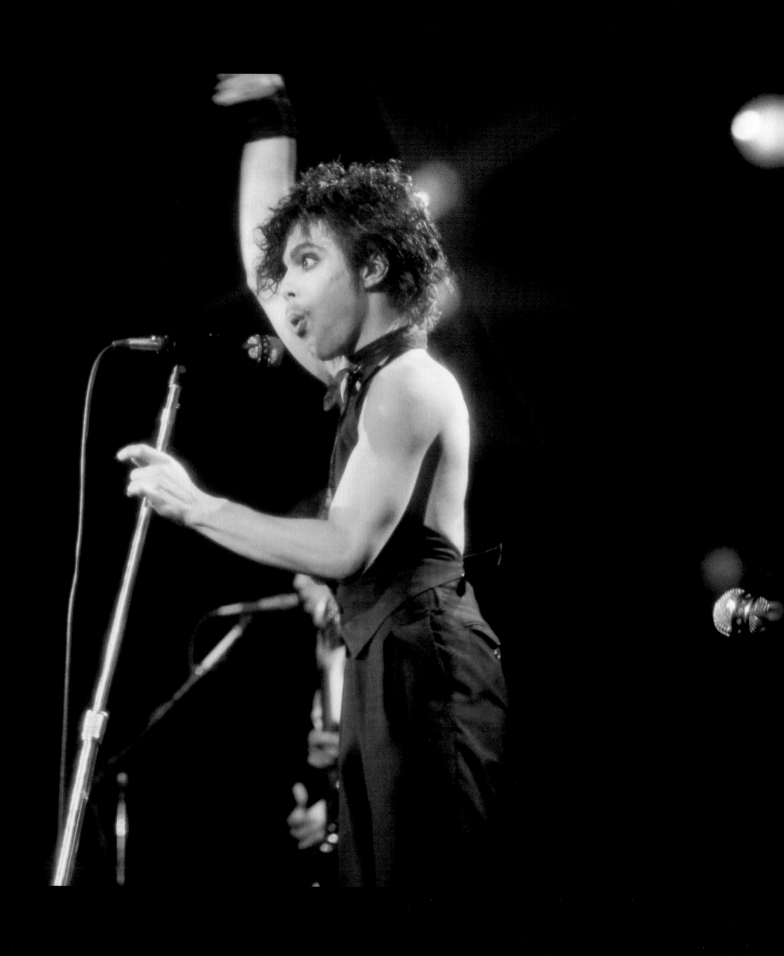

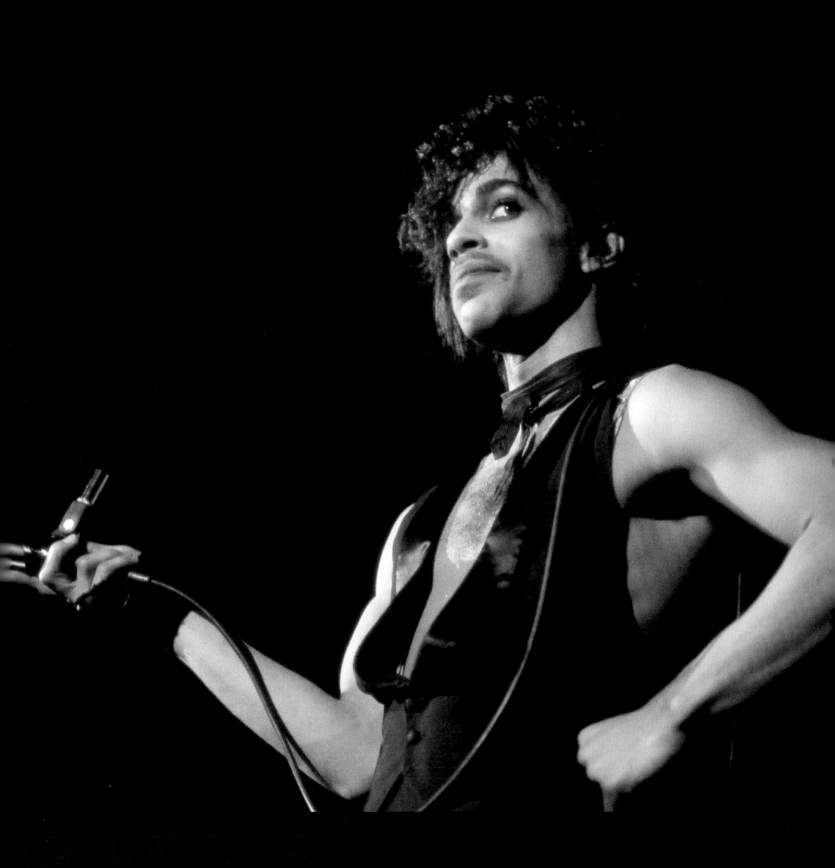

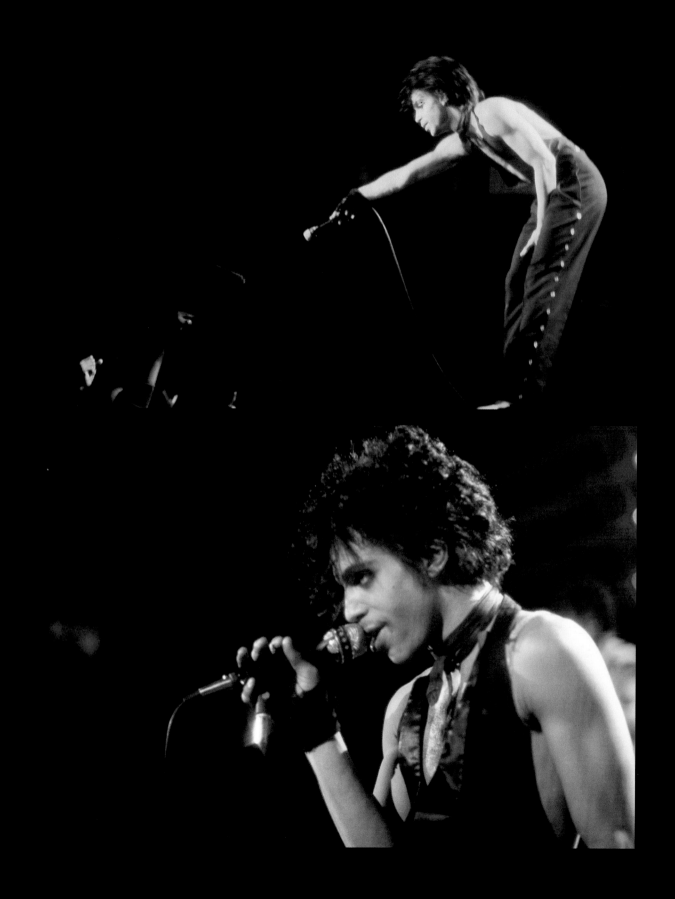

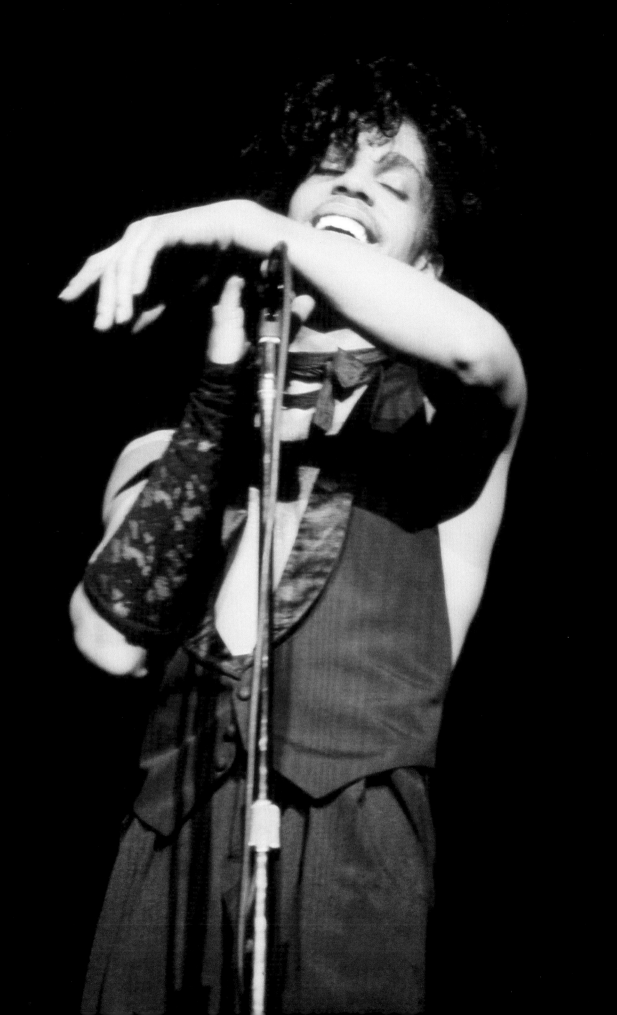

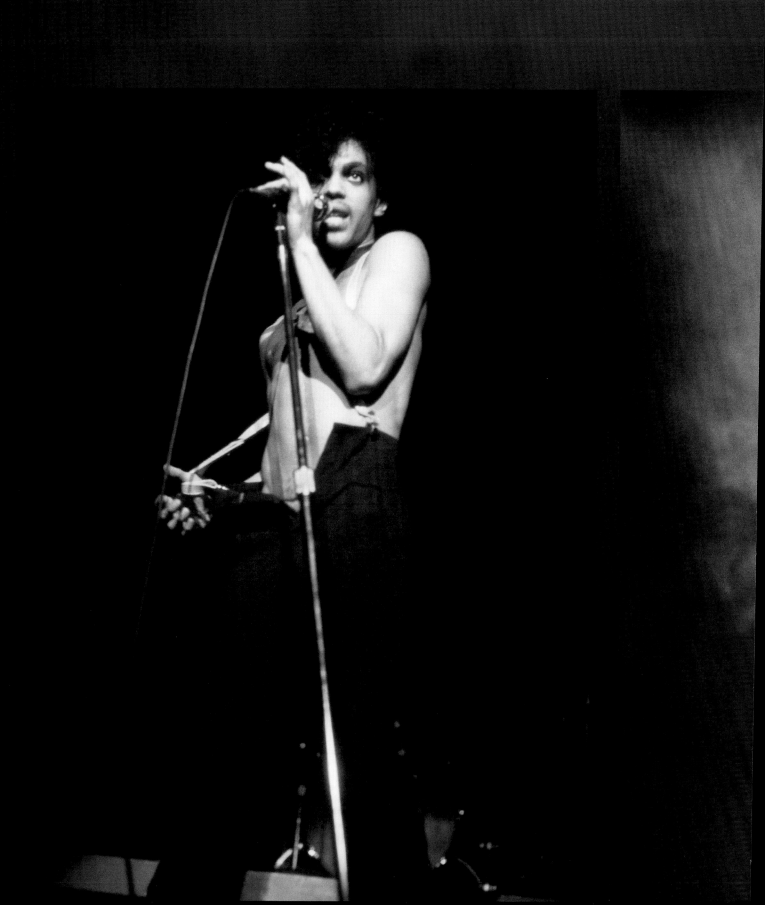

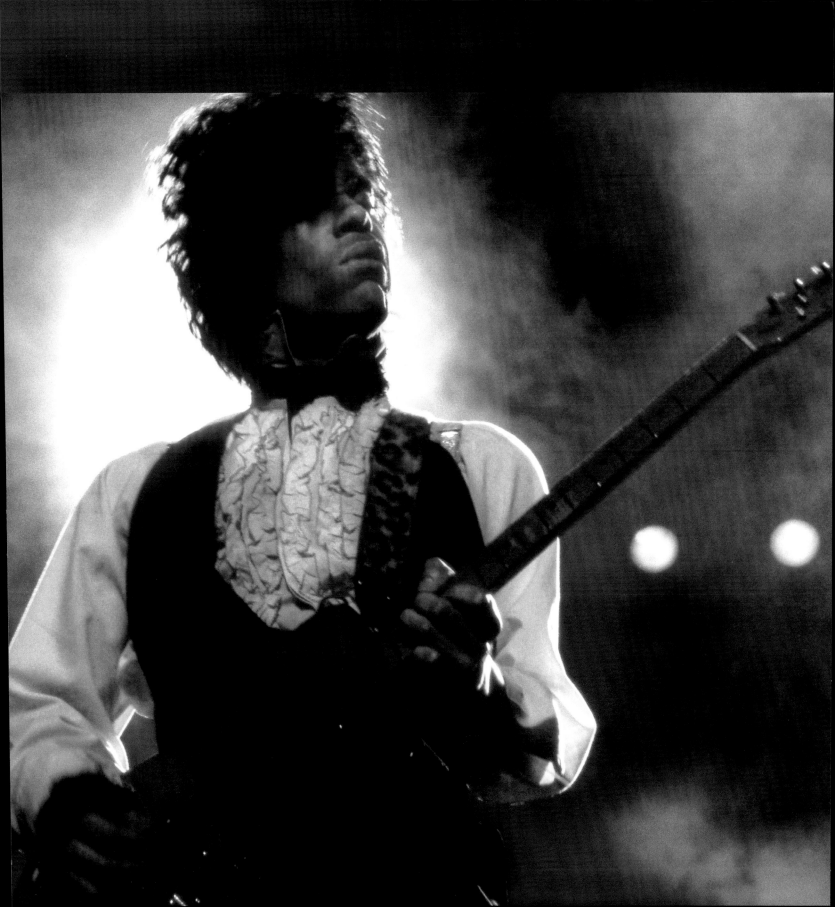

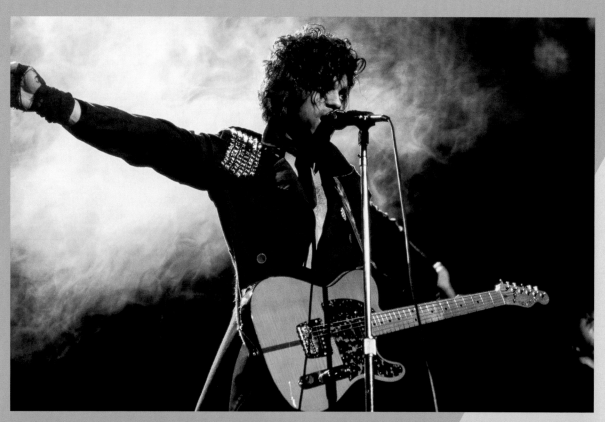

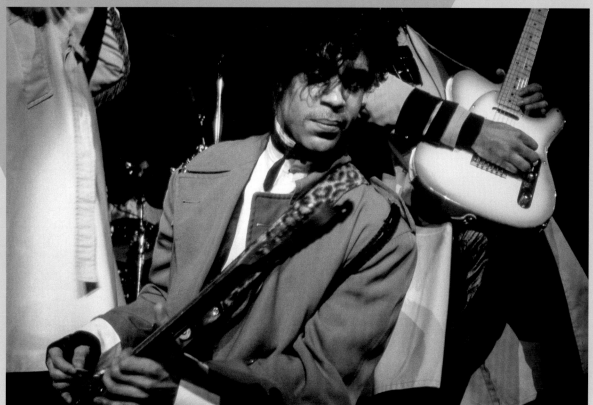

On the Road with Prince

While Prince's ever-developing musical ingenuity and creativity was evident in his album releases during this era, his energetic and magnetic live performances put him into a category all his own. "He was quite the showman," said his photographer, Al Beaulieu, who had the challenging task of capturing that explosive energy on film as Prince danced, shimmied, and gyrated across the stage. "I gotta say, for being what I knew as a shy guy at home, Prince was a very different character onstage. Even backstage, he would usually go into the 'Prince shell,' I'll call it. But when he was onstage, he was lightning in a bottle. He was so entertaining. Unbelievable."

Keyboardist Matt Fink, better known as Doctor Fink, compared the artist to another legendary performer, particularly in his role as lead conductor to the band. "He turned into James Brown in a sense, taking that lead," Fink said. "He started getting into cues and specific hand signals he could call on a whim. If you weren't watching properly, you could get caught naked and miss a cue or play late. Sometimes if you made a mistake he'd take over your instrument. People in the audience thought it was part of the show and didn't know it was really Prince messing with you."

By the *Controversy* tour, Prince and the Revolution were crisscrossing the country, playing a different city almost

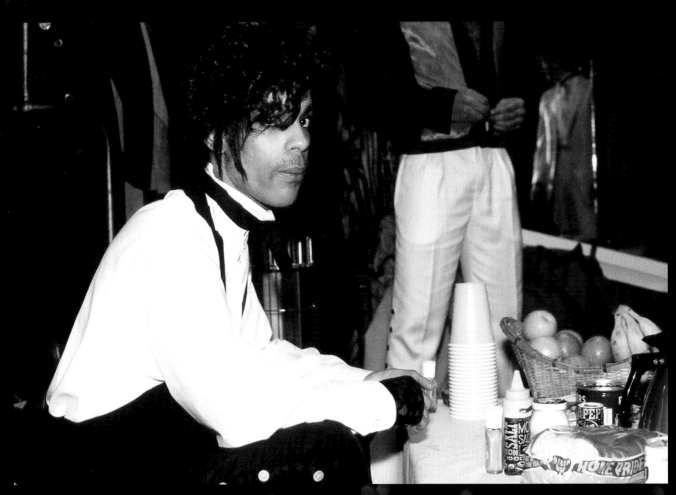

Enjoying the spread before a concert

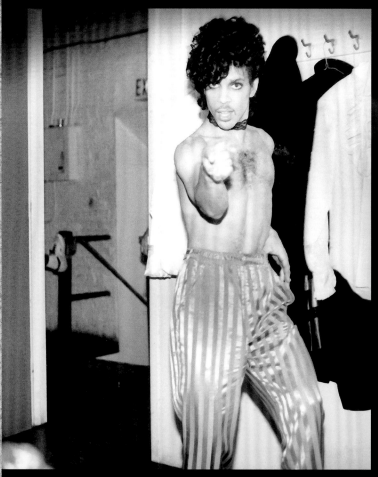

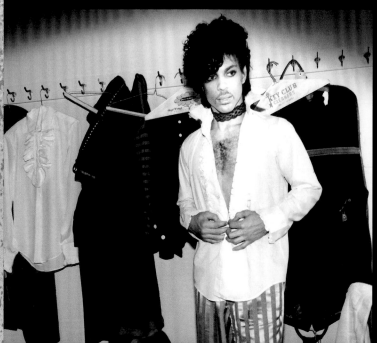

every night between November 1981 and March 1982 (save for a three-week hiatus in January, when Prince was in the studio recording songs for the next album, *1999*). Life on the road meant lots of time on buses and in hotels. It was grueling at times, but for Beaulieu, it was a chance to hang out with Prince and the rest of the band. "It was fun getting close to Lisa and Dez and Bobby and Fink," Beaulieu said. "You'd go to different hotel rooms and visit with everybody. You could knock on anybody's door. We had a lot of camaraderie. That was the golden part of being on the inner circle, and it was a great honor to be a part of that." Beaulieu also got some alone time with the Purple One himself.

"One night when we were in Cleveland during the *Controversy* tour, Prince suggested that we go play video games," Beaulieu recalled. "There was a huge arcade near the hotel, and Prince just put on a hoodie. Nobody recognized him in the whole place. It was one of those twenty-four-hour arcades, and we stayed there until about three in the morning. We were playing Centipede like crazy. He'd go and then I'd go and he'd go and I'd go. We never got bored. We were just talking and having fun and laughing. It was quite a time. I'll always remember it, because it was just me and him."

The bus was another place where Beaulieu got to hang with Prince, but it was off-limits for his camera. "The first thing Prince said to me when I joined them on tour was, 'Don't take any pictures while we're on the bus,'" Beaulieu explained. "I wish I could have, because some great stuff went on there. I had so much fun on those buses." It wasn't any of the clichéd rock 'n' roll excesses that Prince was worried about; it was simply a matter of making a safe space where everybody could just be themselves.

Beaulieu learned another valuable lesson early on: Never be the first one off the bus. "We'd get back to the hotel late after a gig, and there were always fans waiting there—I don't know how they knew where we were staying, but these people were like professionals. Fans would mob anybody as soon as they stepped off the bus, so I'd wait until Prince and the others had made it safely into the hotel, and then I'd quietly follow and go to my room."

Despite the late nights, Beaulieu's work would start up again early the next morning. "Every time we went to a new city, I had to figure out how to get the film processed from that night's show, because Prince always wanted to

see it right away. We'd get back to the hotel at two or three in the morning, I'd sleep for a few hours, and then I'd wake up and look through the phone book to find a photo place that opened early and could process film—this was before the internet, so the Yellow Pages were really handy! I'd take a cab and drop off the film, usually rolls and rolls of it, and tell them to call me at the hotel when it was done. I would meet with Prince around noon and show him what I got, and he'd tell me what he wanted, like some 8x10s of certain shots. Then I'd get the prints made. It was a time crunch to have everything done by three o'clock so that I could get to the venue for sound check and do it all over again. It was always the same job for me, and I would get everything done the same day. I think that's what Prince really liked about me: I was loyal and reliable. I think he liked that."

As the tours went on and Prince's success grew, the travel accommodations improved as well. For *Dirty Mind*, the band was all together on one bus. "Prince would stay in the back, and there was a nice bedroom and toilet and all that. The rest of the seating was like on any Greyhound bus. There were a couple bunks for anyone who wanted to sleep, but it certainly wasn't enough for everybody.

"The bus we had for the *1999* tour was so elegant. There were just three of us on our bus: Prince, [his longtime bodyguard] Big Chick, and me. The band had its own bus, and the Time had theirs, and Vanity 6 had theirs. I loved that bus so much I just wanted to hug it. It was like a companion that you could always count on."

The bus was also a place where Prince's creative juices flowed. "Prince would be sitting in the back of the bus writing songs for *Purple Rain* and trying them out on a little guitar and a Casio keyboard. I heard a version of 'I Would Die 4 U' on one bus ride. The song was really slow, so when I heard it on the album, I was surprised because he sped it up a lot. But when I first heard it, it was really slow, way different. So, Prince would share songs like that on the bus. He'd play all this beautiful stuff, and I got to see it in person. Only on the bus could you see that and hear it and be part of it.

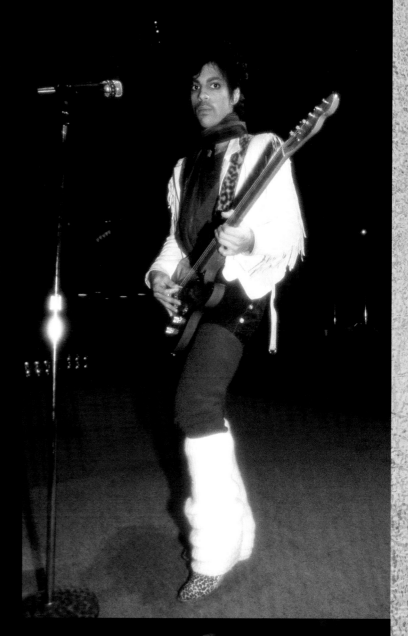

"The bus was a fun and creative place for Prince and for me. I wish I could have taken pictures of that. I have pictures in my mind, mental pictures of each bus, because I just loved them so much." •

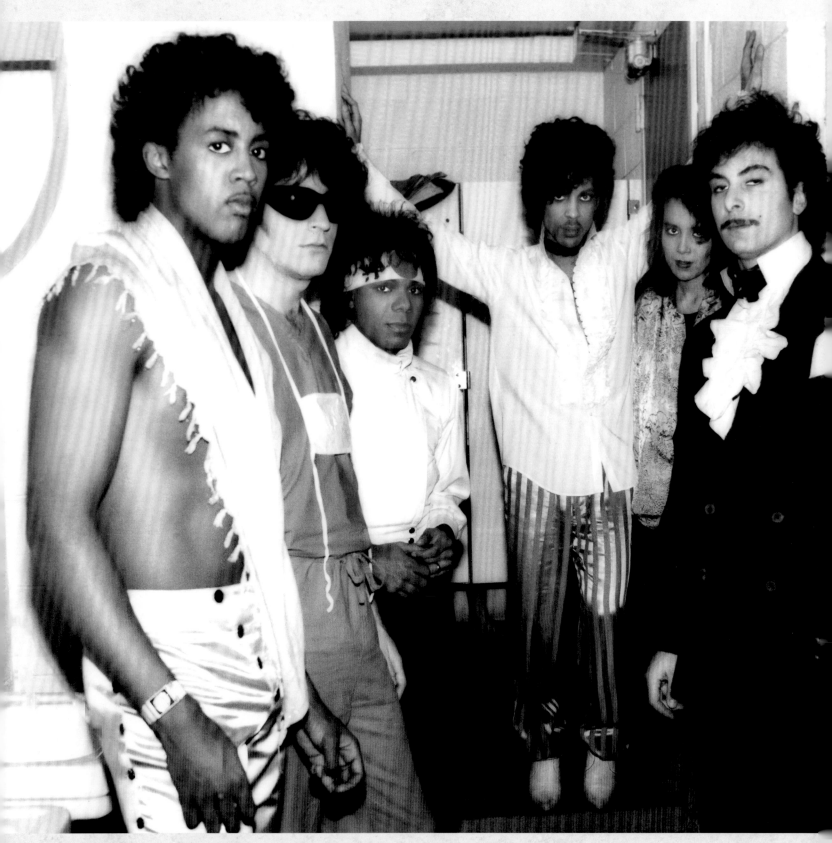

Prince and the Revolution, backstage during the *Controversy* tour, late 1981 or early 1982

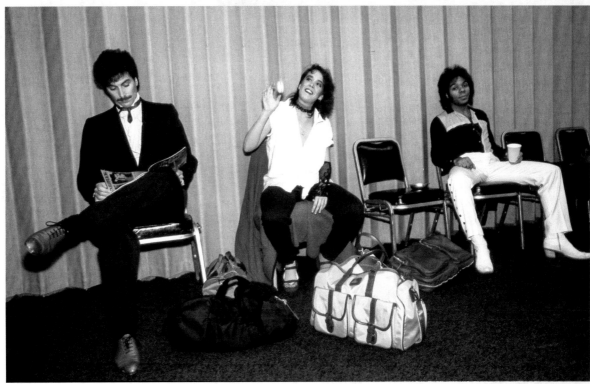

Bobby Z, Lisa Coleman, and Dez Dickerson relaxing on the road

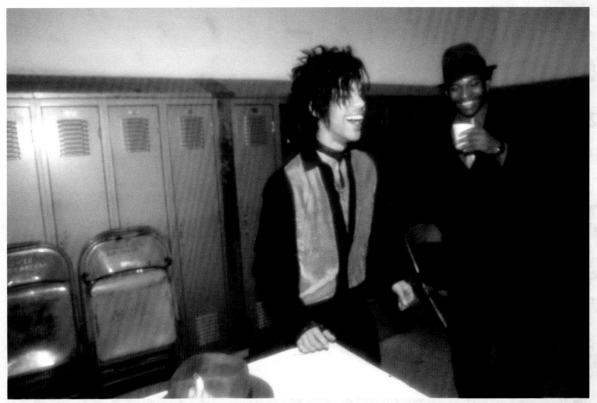

Prince and Jellybean Johnson of the Time, having a laugh backstage

Prince and Morris
Day backstage,
Controversy tour

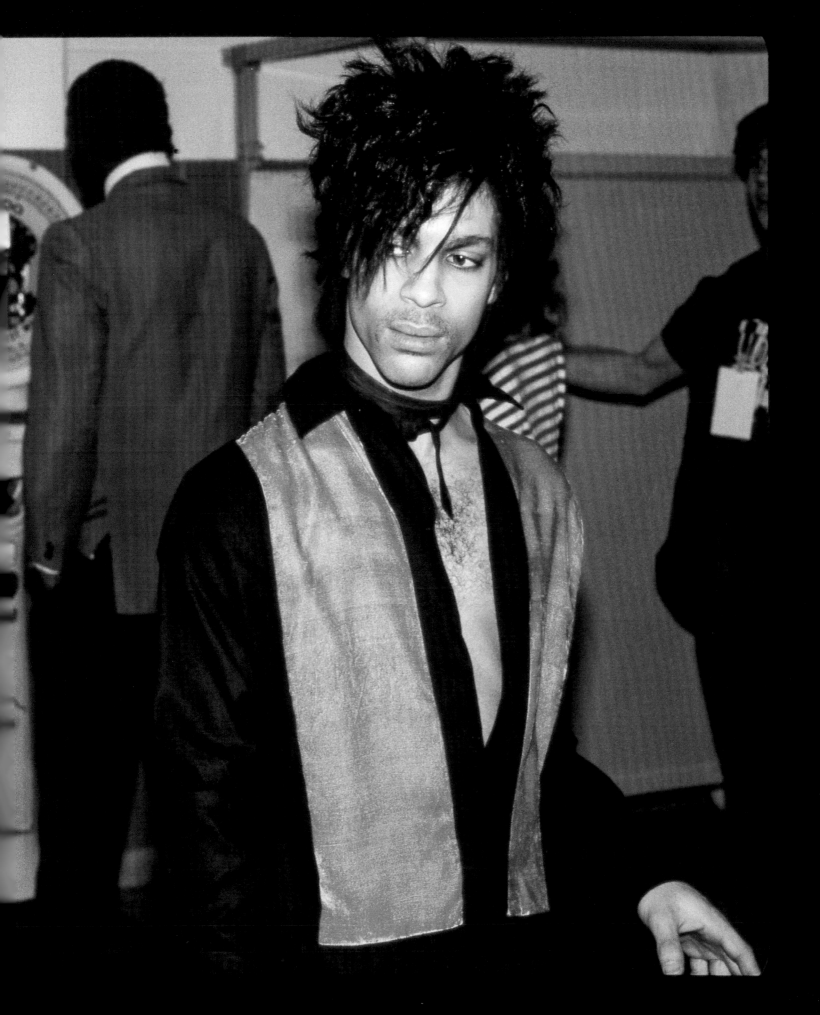

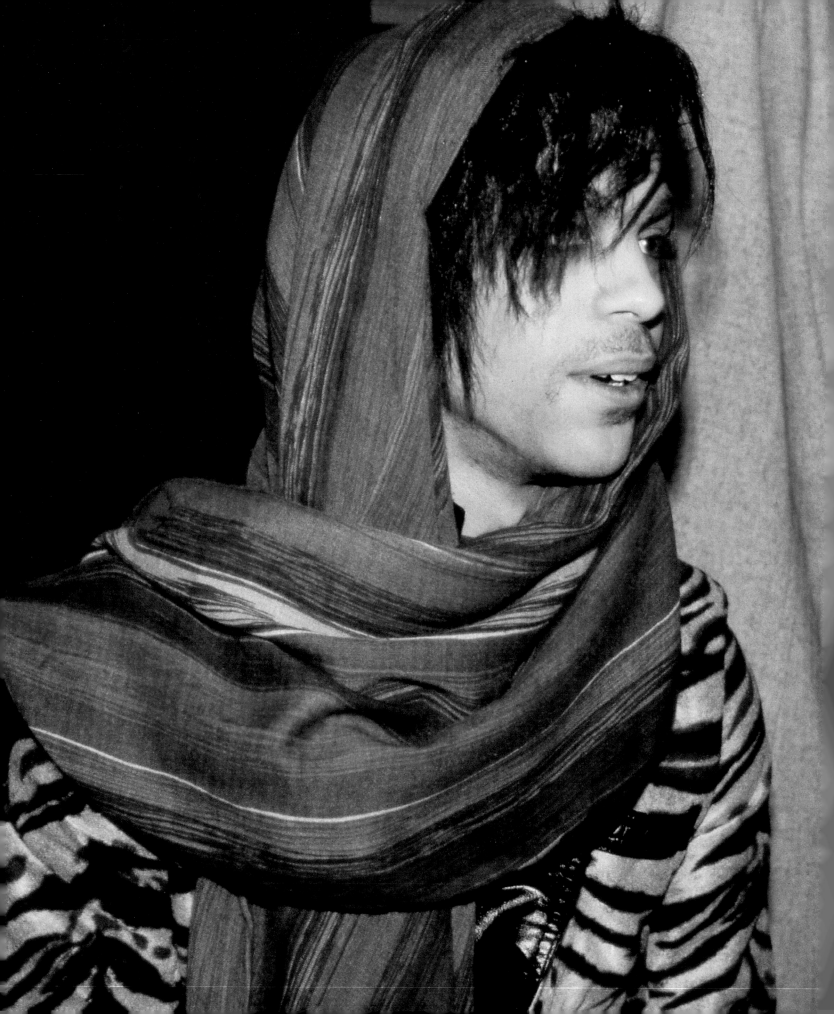

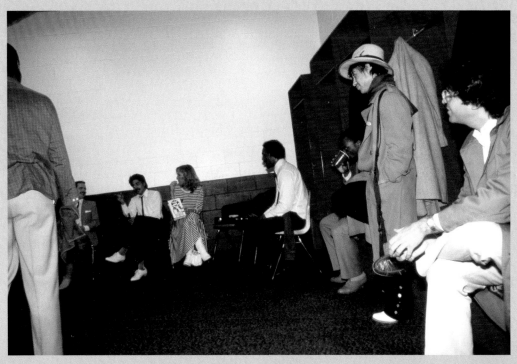

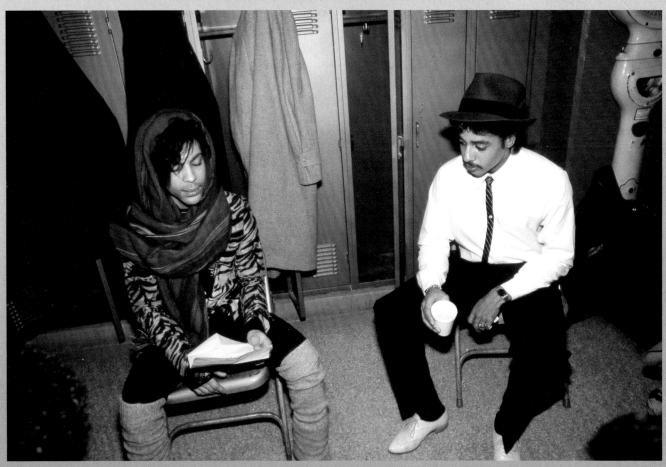

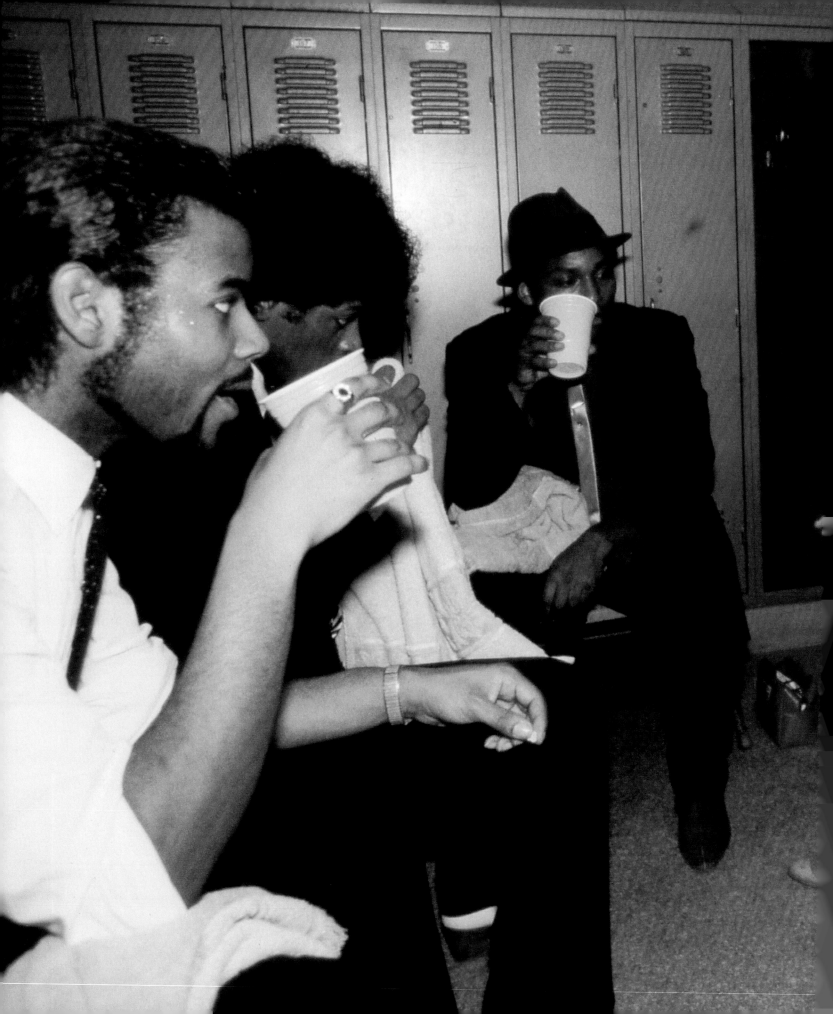

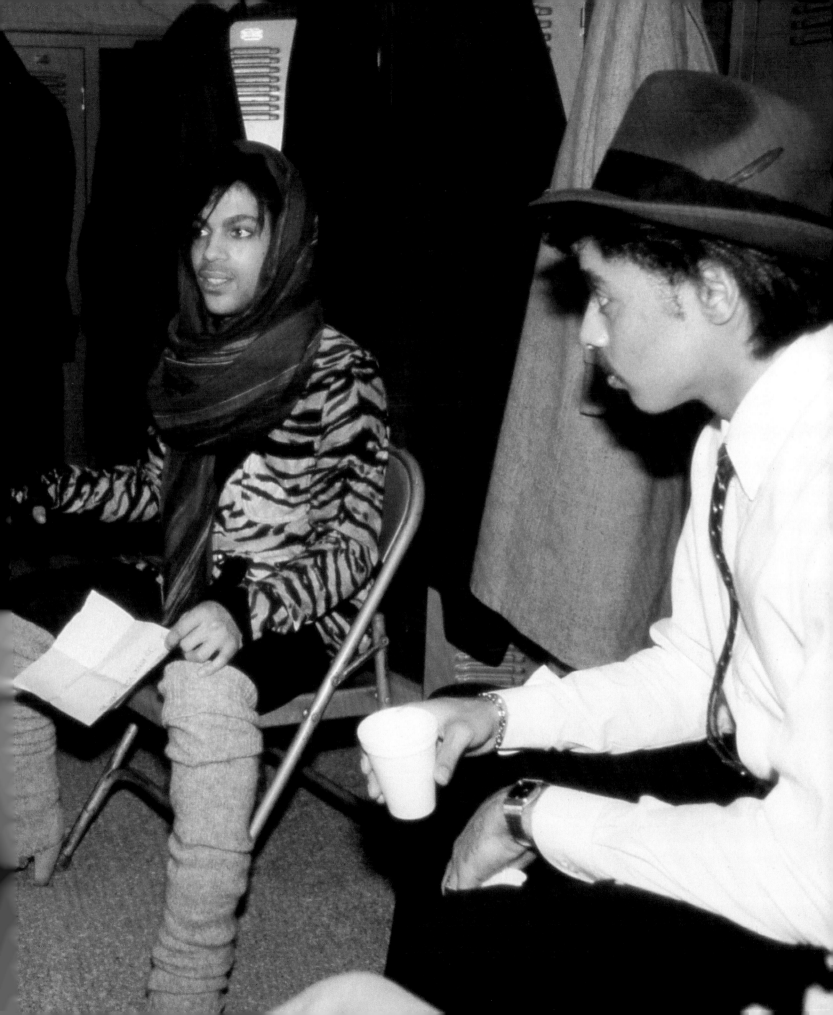

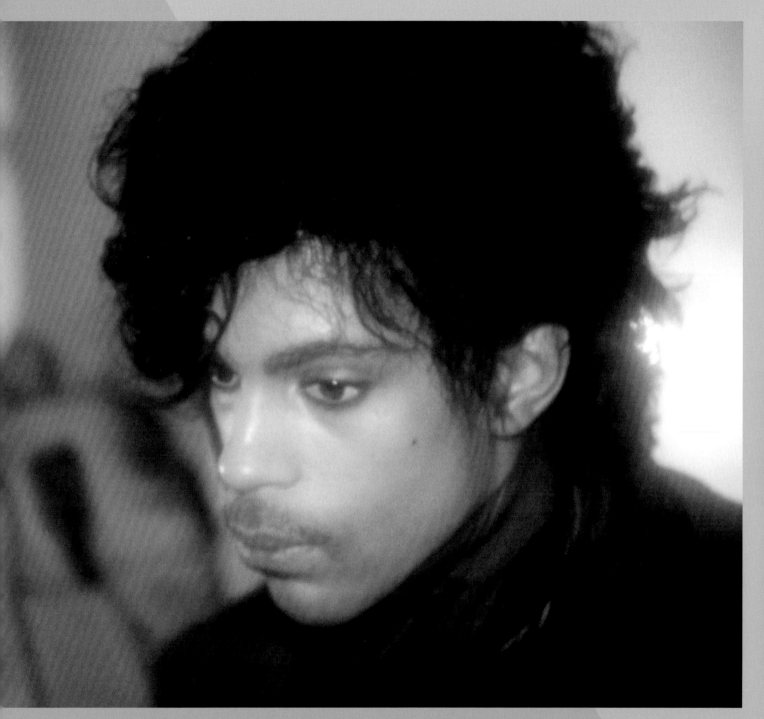

Backstage after a concert

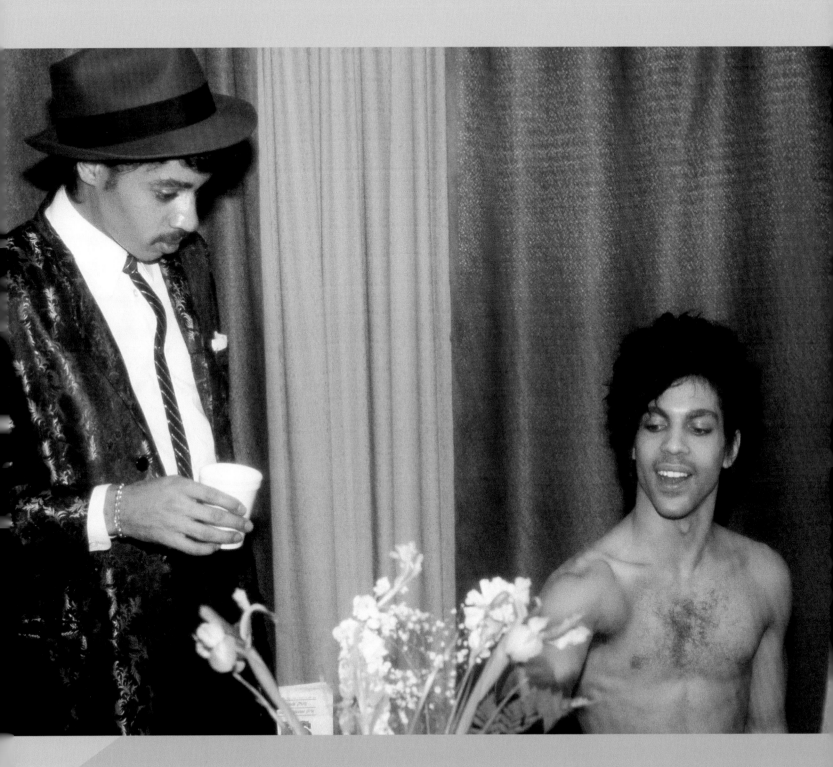

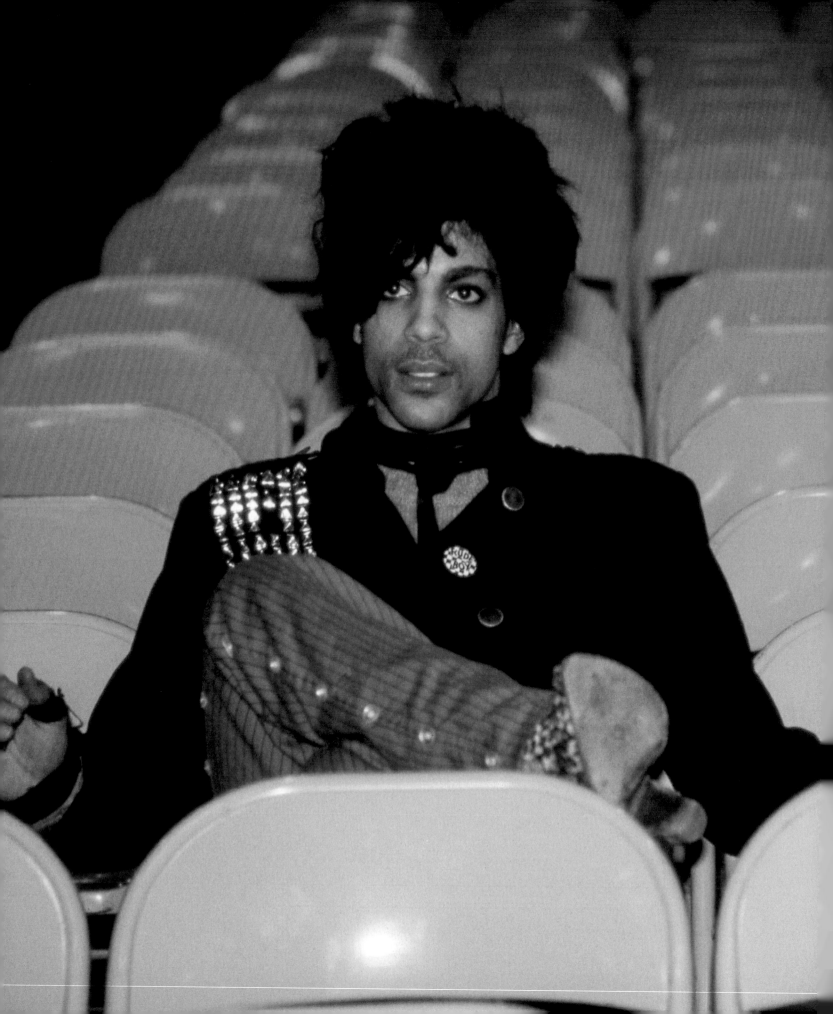

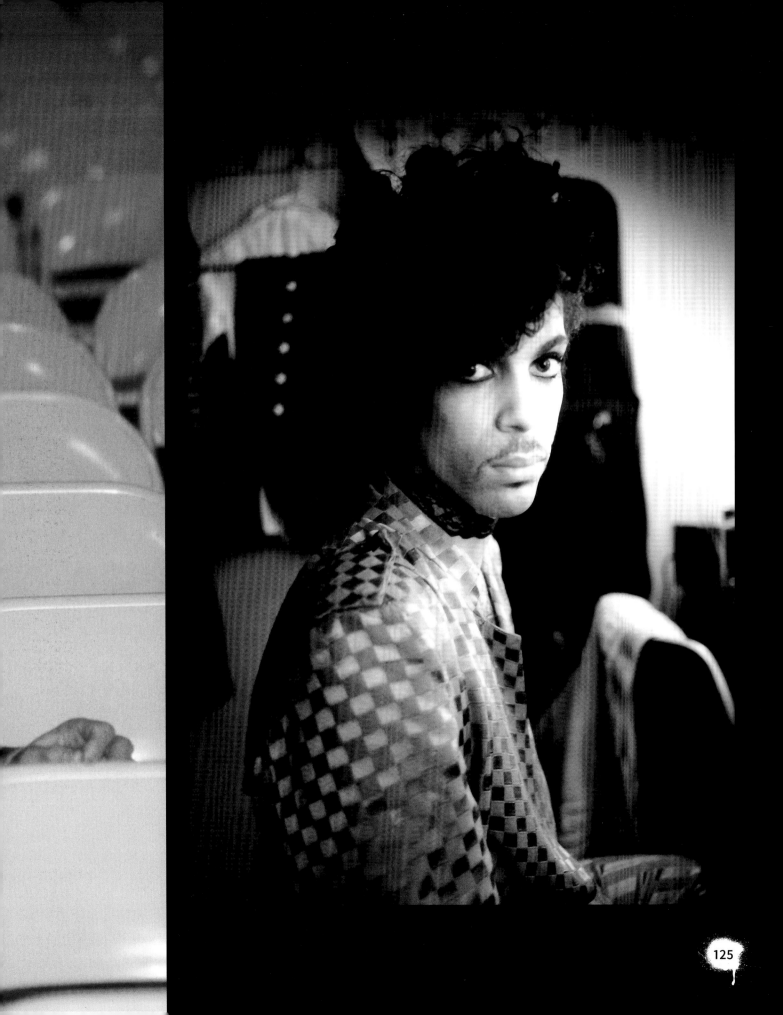

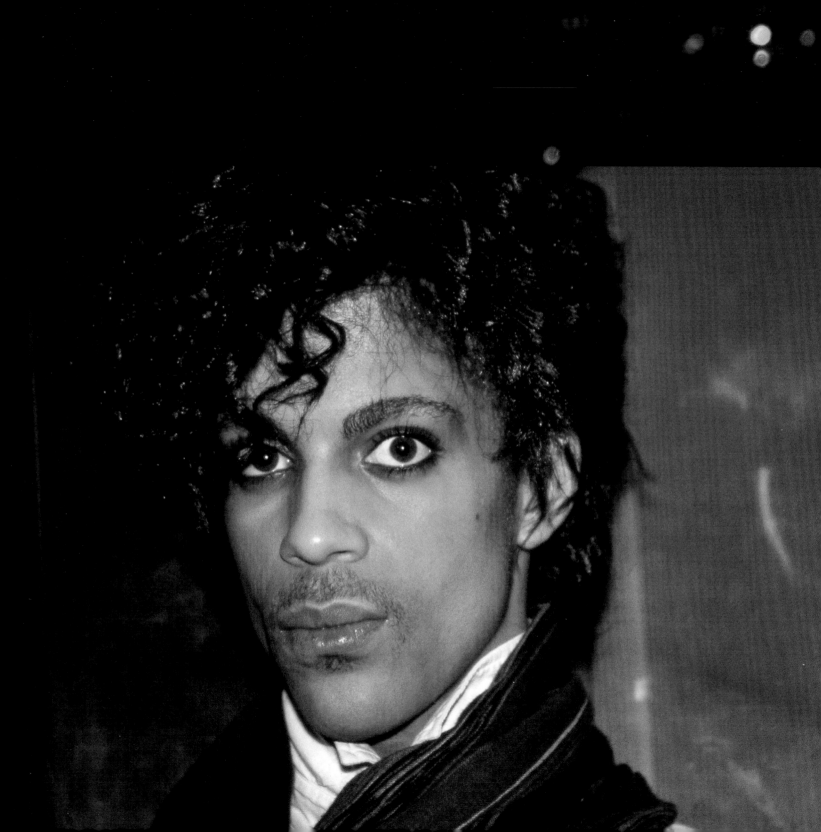

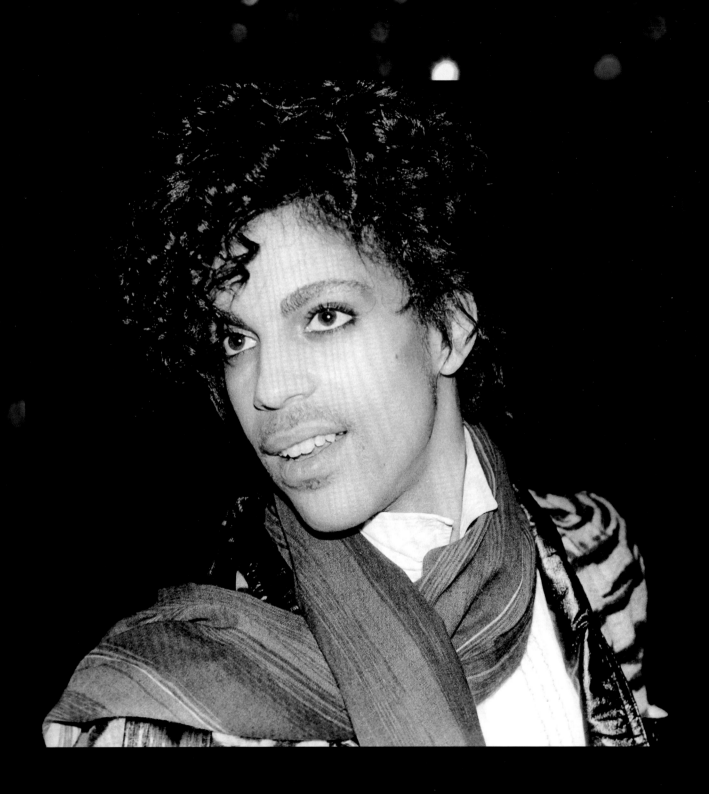

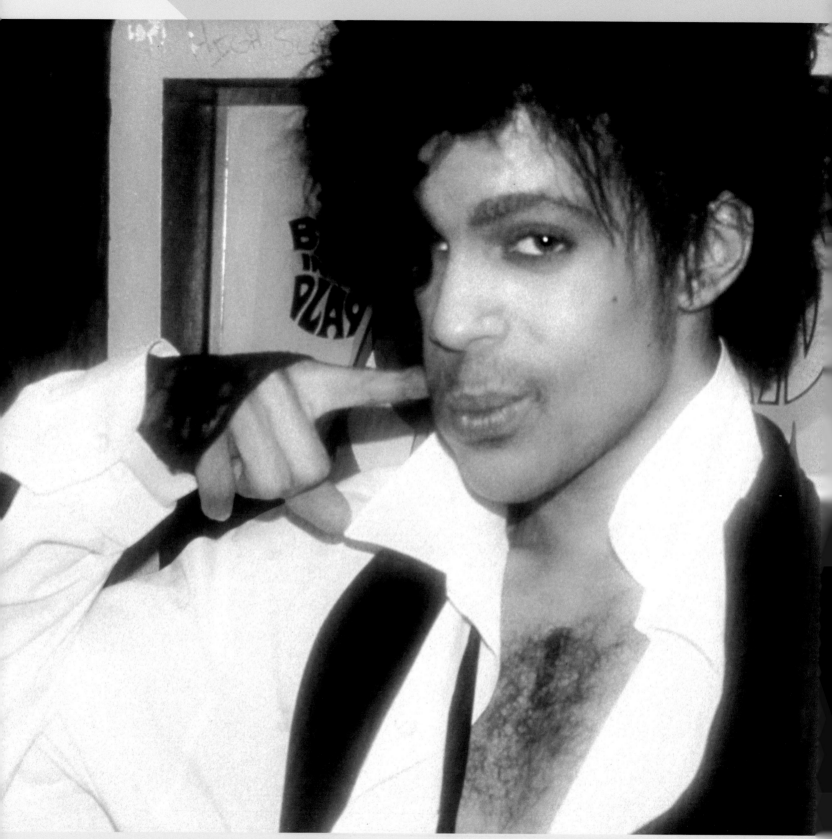

Prince, hamming it up in front of a pinball machine backstage on tour

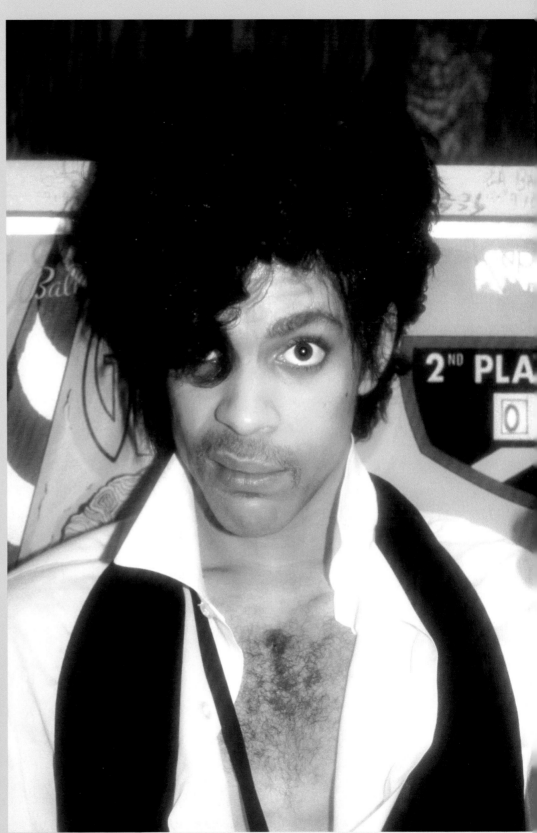

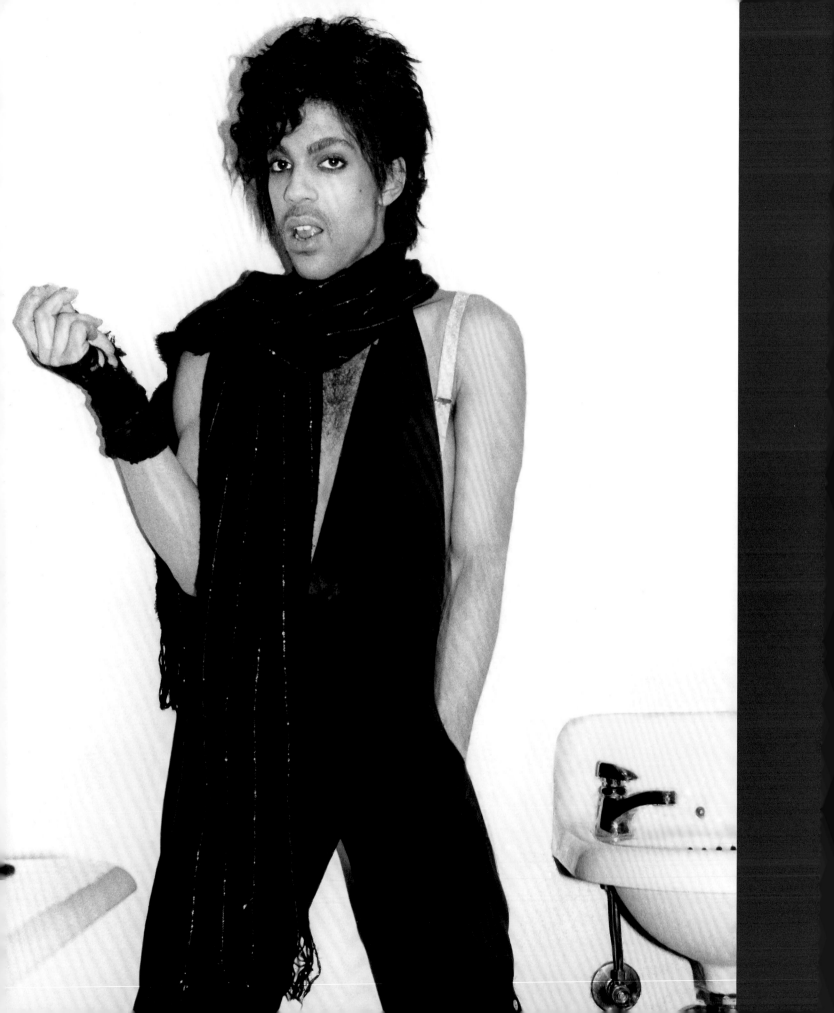

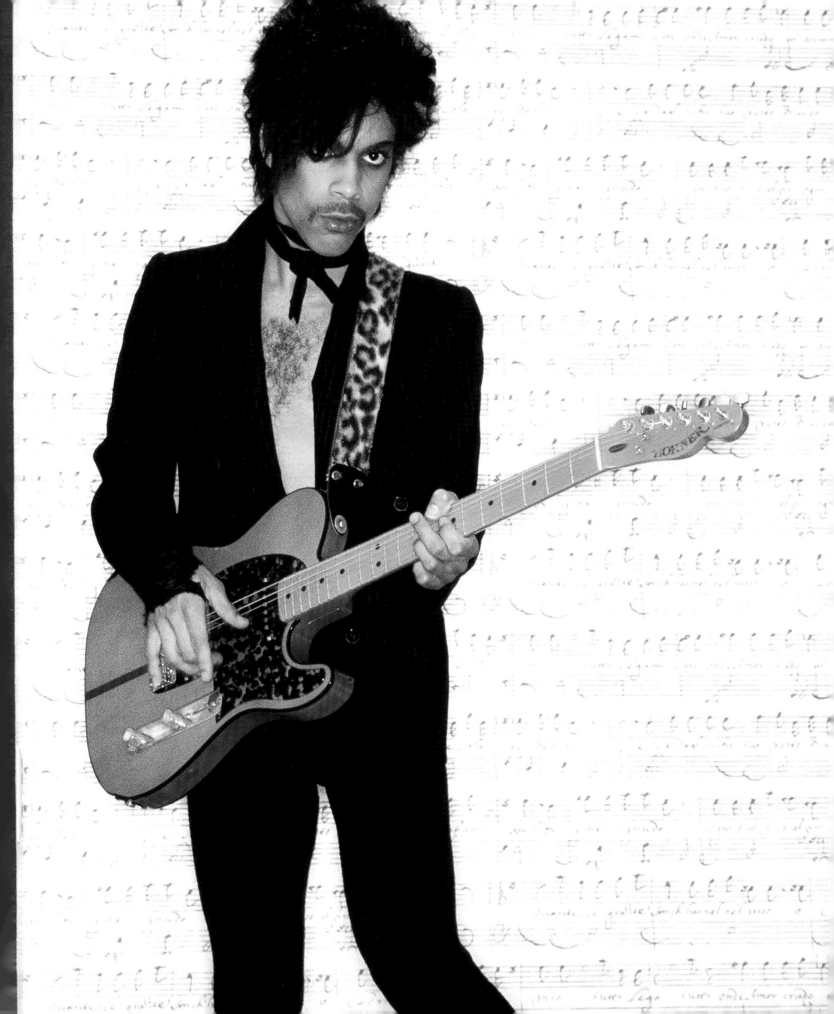

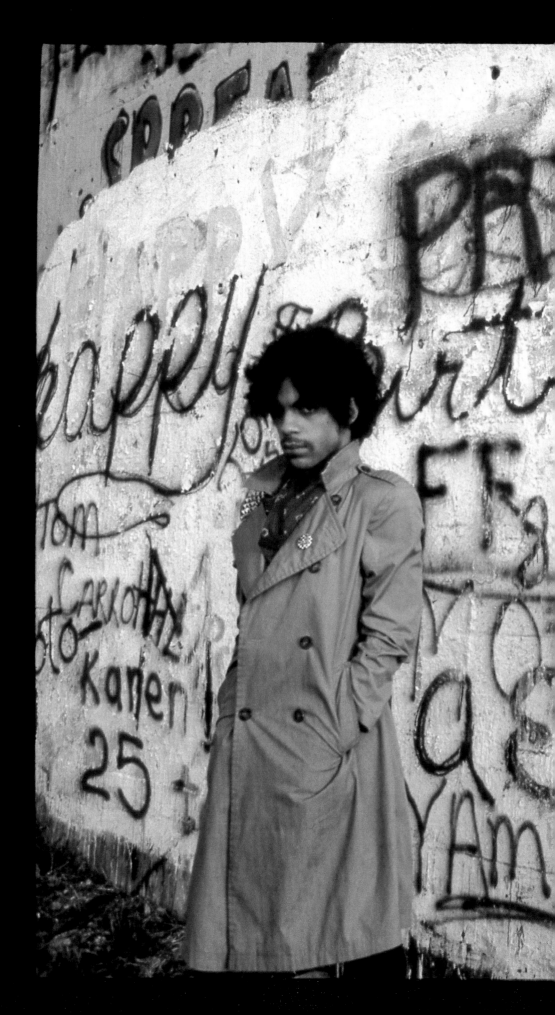

Beaulieu brought Prince to Graffiti Bridge in suburban Eden Prairie to shoot photos in front of the popular local landmark. Prince graffitied his own name on the wall, but they had to leave after shooting just one roll of film, as a crowd gathered to catch a glimpse of the rising superstar.

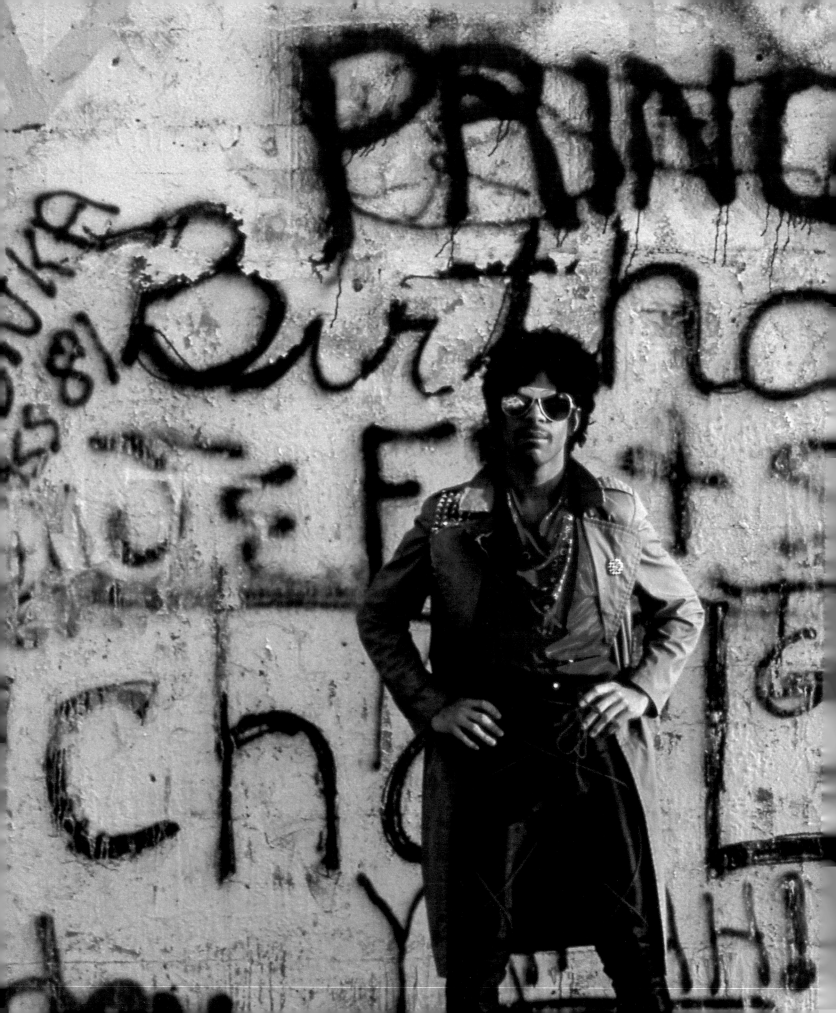

CHARGERS

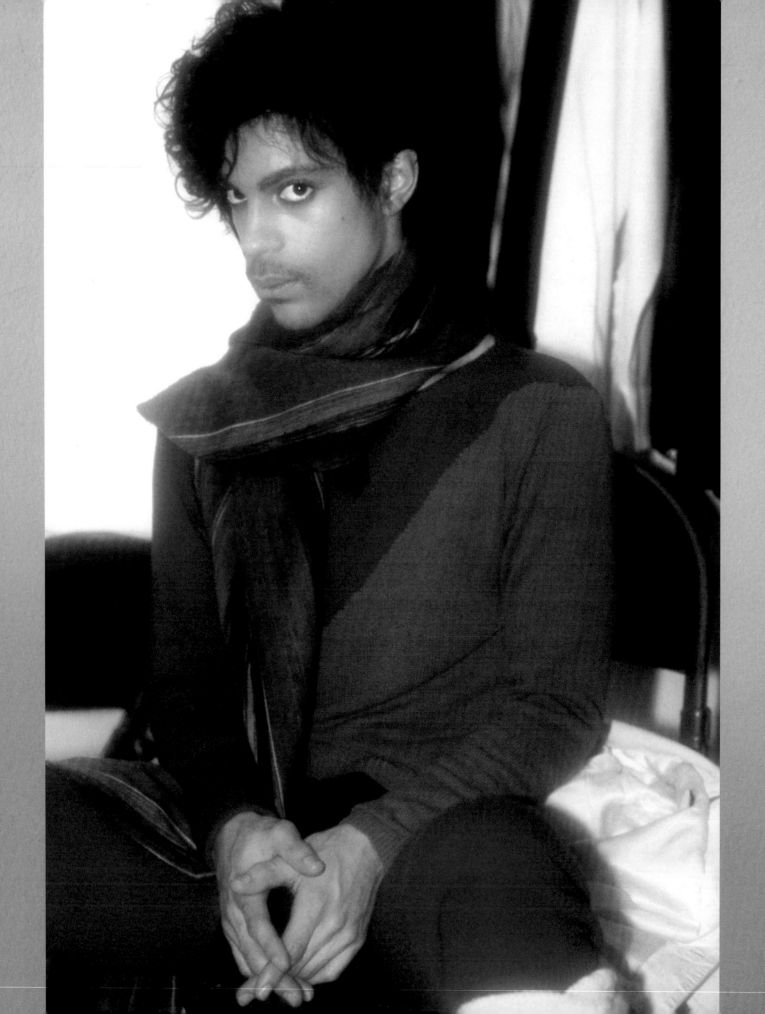

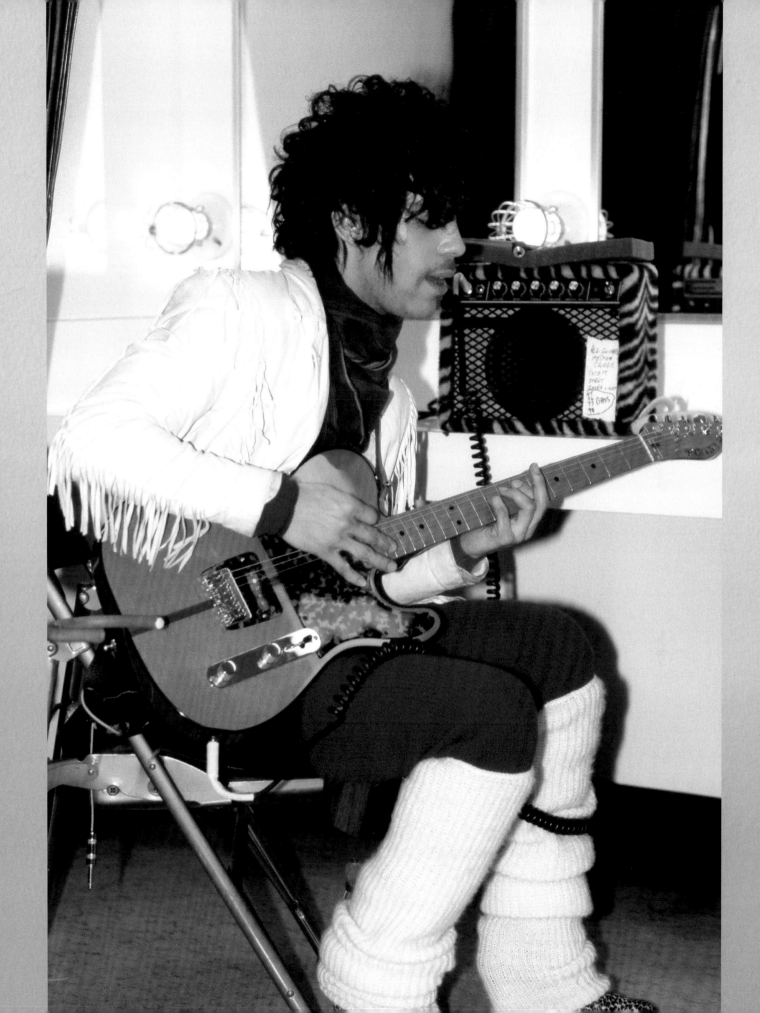

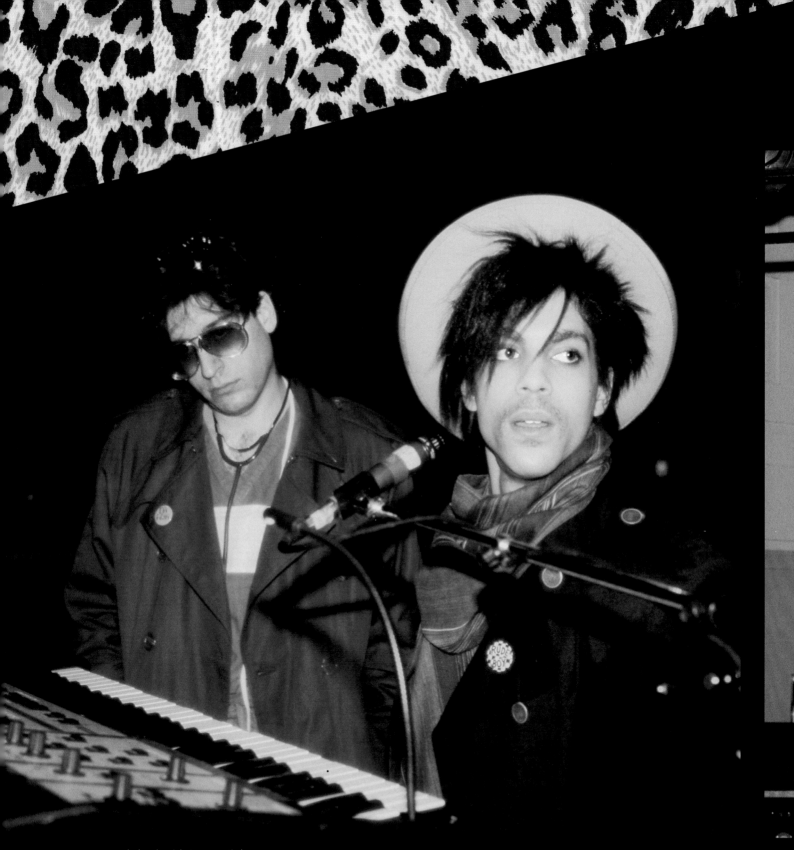

At sound check with Doctor Fink

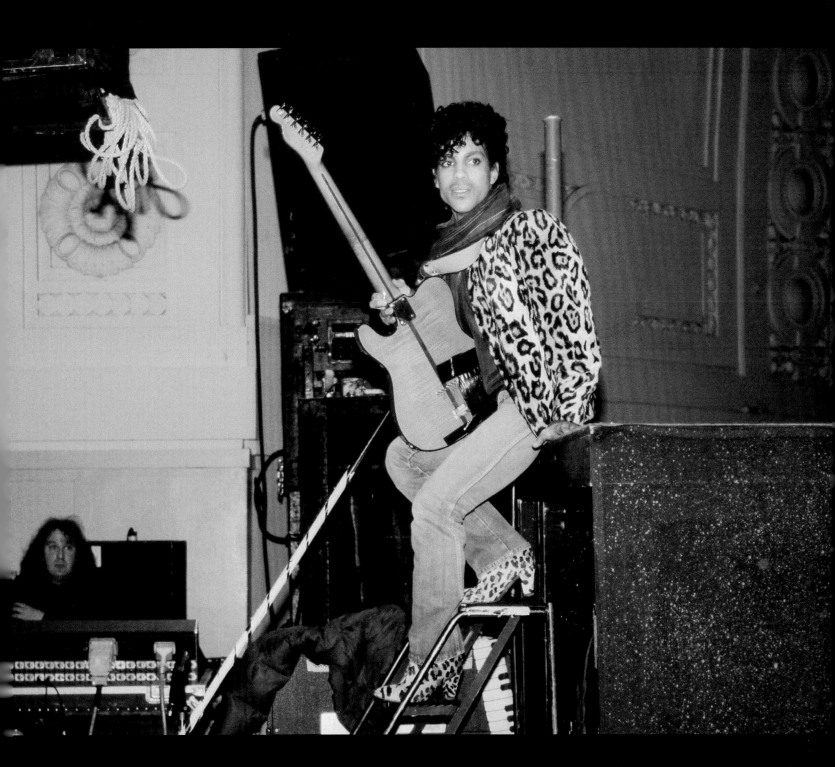

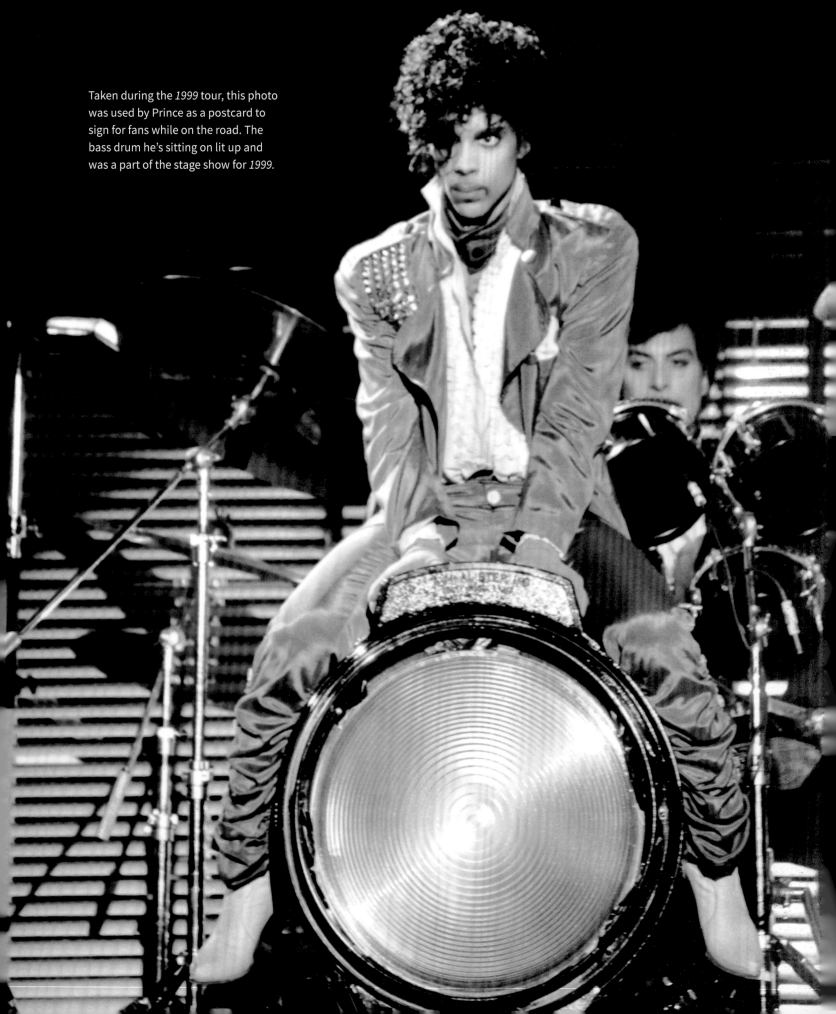

Taken during the *1999* tour, this photo was used by Prince as a postcard to sign for fans while on the road. The bass drum he's sitting on lit up and was a part of the stage show for *1999*.

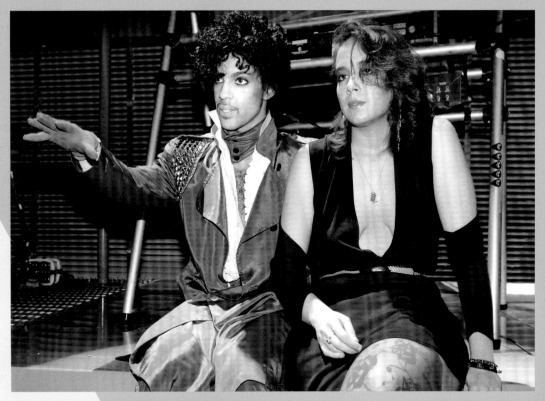

Prince with Lisa Coleman during sound check, *1999* tour. While this photo appears to be spontaneous, it was staged by Prince, as he did for many seemingly casual or candid images taken of him behind the scenes.

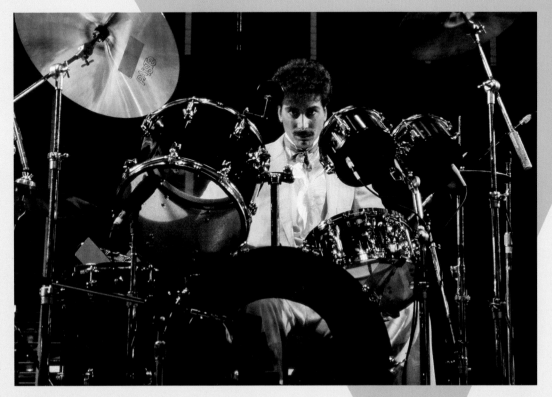

Drummer Robert B. Rivkin, better known as Bobby Z, was Prince's drummer from the very first concerts in 1979 until the Revolution disbanded in 1986, after the *Parade* tour.

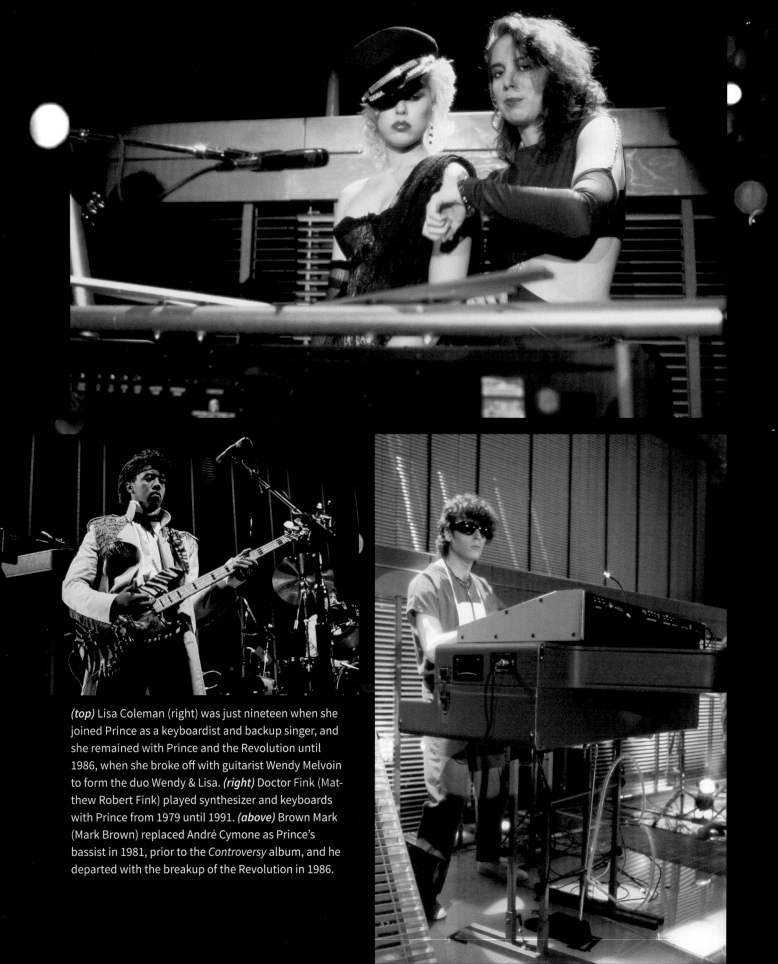

(top) Lisa Coleman (right) was just nineteen when she joined Prince as a keyboardist and backup singer, and she remained with Prince and the Revolution until 1986, when she broke off with guitarist Wendy Melvoin to form the duo Wendy & Lisa. *(right)* Doctor Fink (Matthew Robert Fink) played synthesizer and keyboards with Prince from 1979 until 1991. *(above)* Brown Mark (Mark Brown) replaced André Cymone as Prince's bassist in 1981, prior to the *Controversy* album, and he departed with the breakup of the Revolution in 1986.

"We did get really close. We discovered each other in layers. When we started getting deeper and deeper, we really connected. He said to me one time, 'I think we were brother and sister in a past life.' We had the ability to fight and bicker like brother and sister but always be totally in love. On the road I would help him do his makeup and he would help me do mine, either in one of our hotel rooms or just backstage in the club in some weird bathroom. I remember those being some very close and personal times. I don't talk about that much since I don't know if Prince would appreciate me telling everybody that I put base makeup on him."

—Lisa Coleman

Guitarist Dez Dickerson played alongside Prince from 1979 until 1983, when he left the band to pursue a solo career just after the *1999* tour.

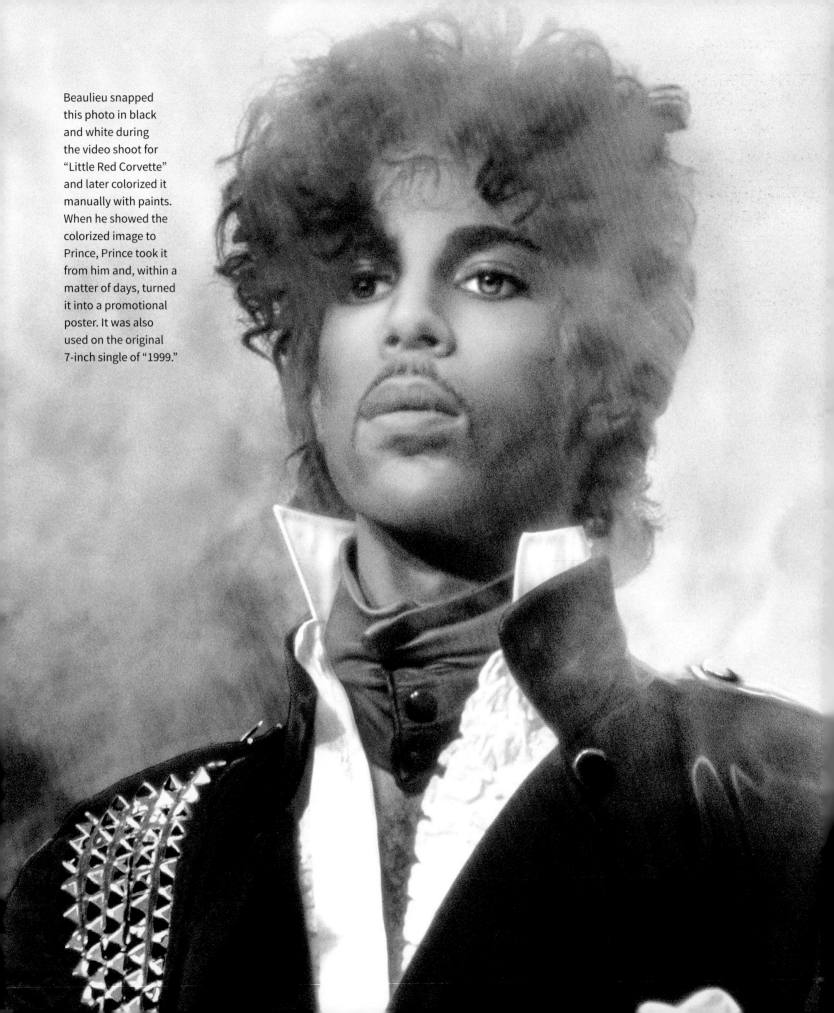

Beaulieu snapped this photo in black and white during the video shoot for "Little Red Corvette" and later colorized it manually with paints. When he showed the colorized image to Prince, Prince took it from him and, within a matter of days, turned it into a promotional poster. It was also used on the original 7-inch single of "1999."

rince's fifth album was his first that did not include an image of the artist on the cover. Instead, Prince opted for a graphics-only approach for the front and back artwork of *1999*. Inside, however, were two photos that would become iconic images of this period: one of a nude Prince snaking on a silk-sheeted bed and another of him in a shiny purple trench coat in front of a fog-drenched Revolution. Both photos were by Allen Beaulieu.

For the bed scene, Beaulieu created a futuristic, neon-saturated environment in his studio. "Prince told me to go see the movie *Blade Runner*," the photographer explained. "He said it was a lot of neon and a lot of smoke, so that's what I did. And he was running around naked in my little studio, so that was a first."

As was typical, the photo shoot took place late at night. "We started about ten-thirty at night and I was back in my bed at noon the next day."

The initial setup was a lot of work for the photographer. Beaulieu got a neon fabricator to create the designs for the lights. He requested a heart shape (Prince would later take

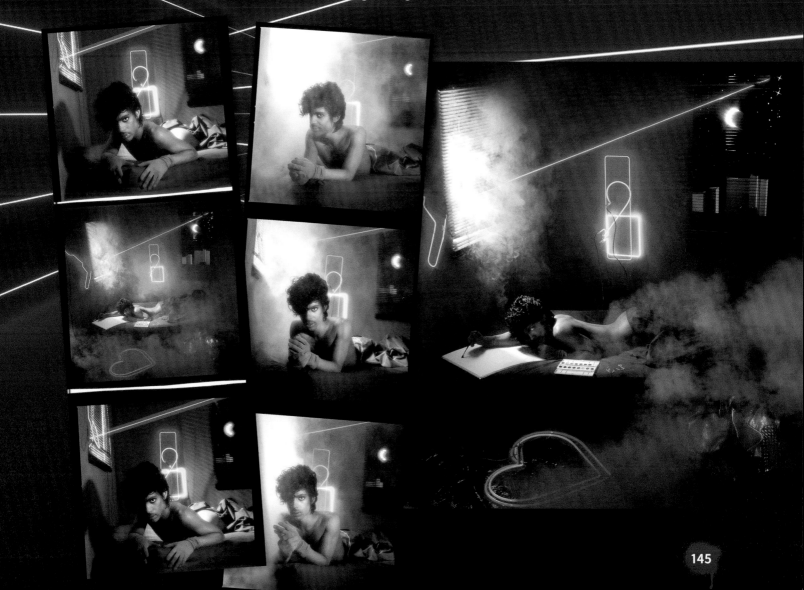

the neon heart on the *1999* tour) and some abstract designs. Each neon piece required its own transformer, and Beaulieu wasn't sure if his studio's electrical system could handle it. It did, and the result was a classic.

The band photo on the inside of the double album was shot at a rehearsal space where Prince had a full stage set up in preparation for the tour. "The music was done," said Beaulieu. "By the time he got to me, I was the last thing, and they needed it quickly."

Beaulieu used similar neon and fog effects as in the bedroom shoot. He was initially concerned that the band members, especially Lisa Coleman and Bobby Z, were too obscured by the fog, but Prince liked it. "It's perfect as is," he said. ◑

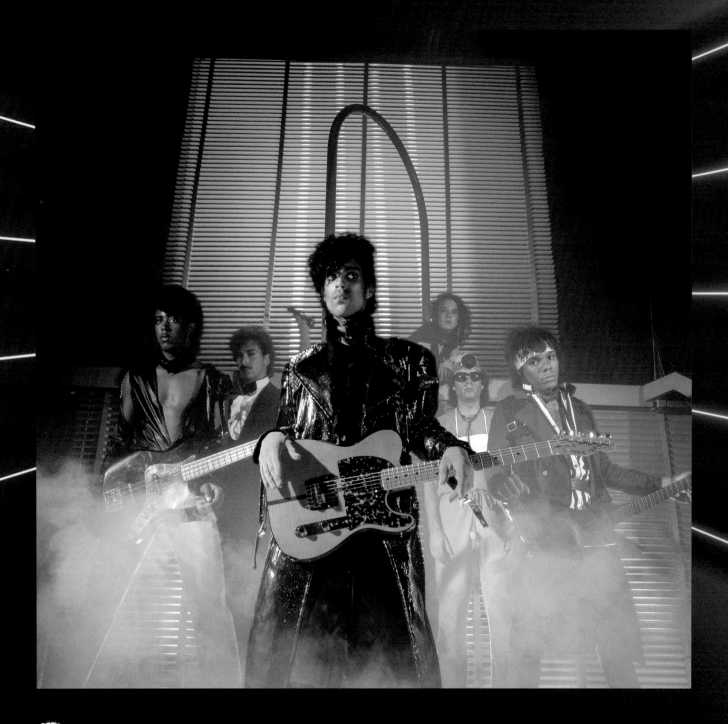

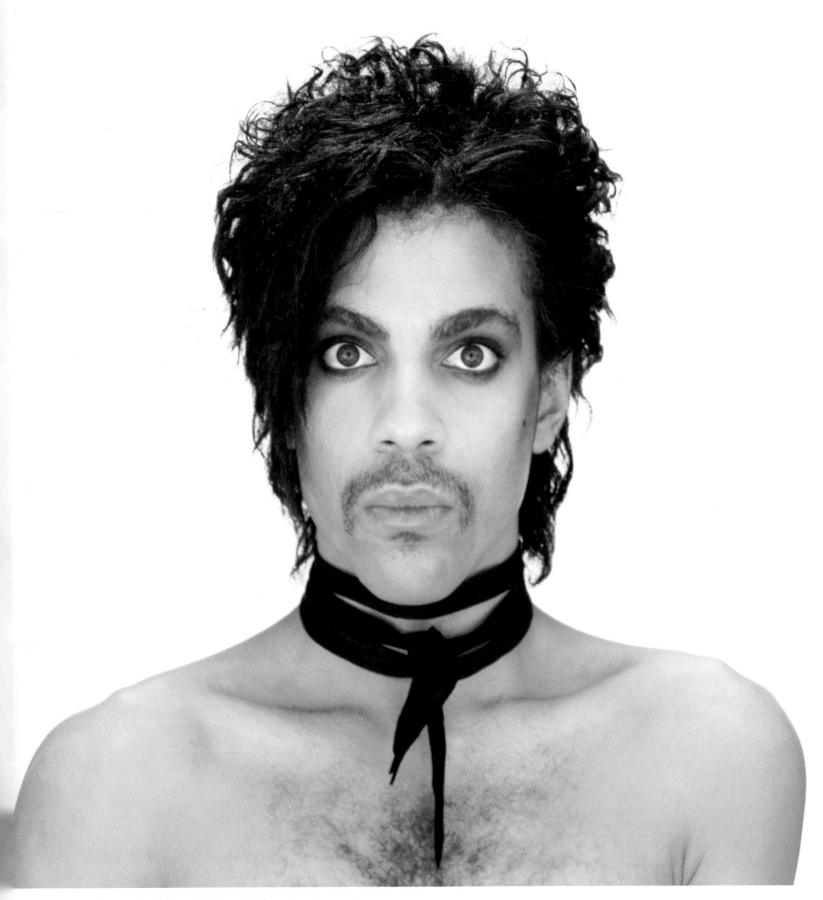

Photo, taken in Beaulieu's studio, for a *1999* tour poster

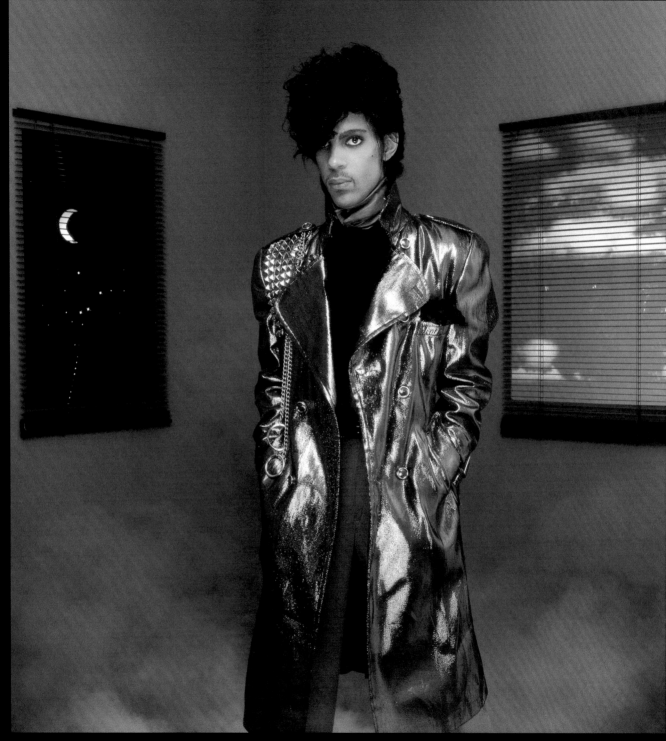

Beaulieu created this night-and-day set because he thought it reflected Prince's split, night-and-day personality. When Prince first saw it, he stormed out, but he returned long enough for the photographer to snap one roll of film. The image would be used on several imports and other record releases.

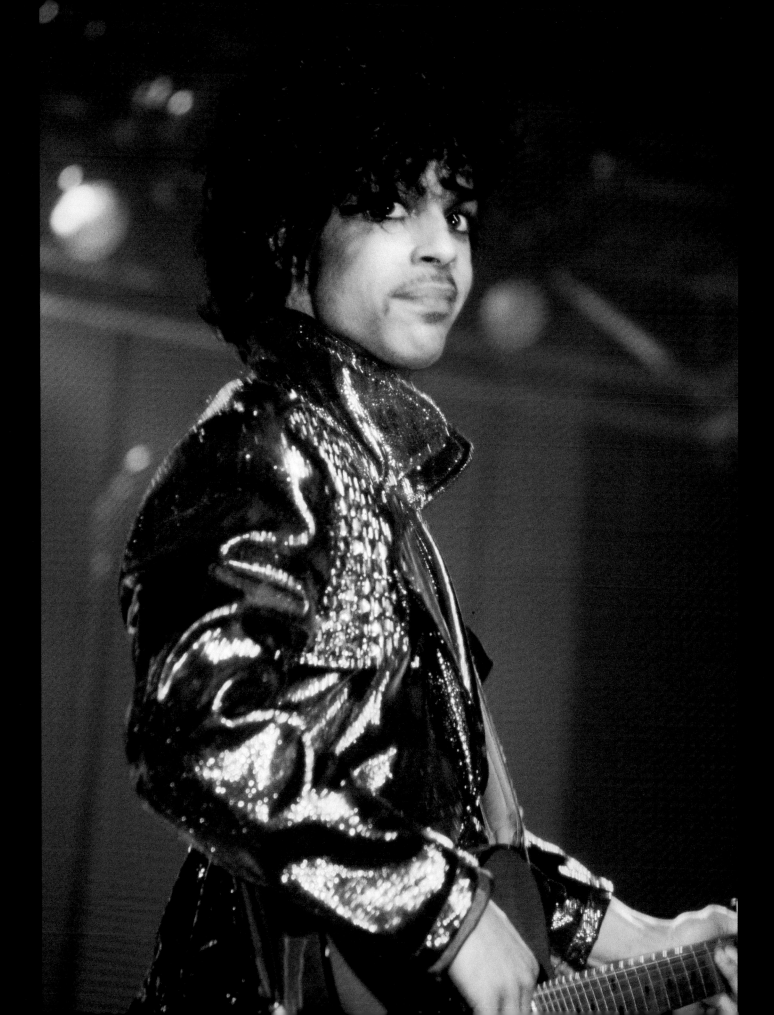

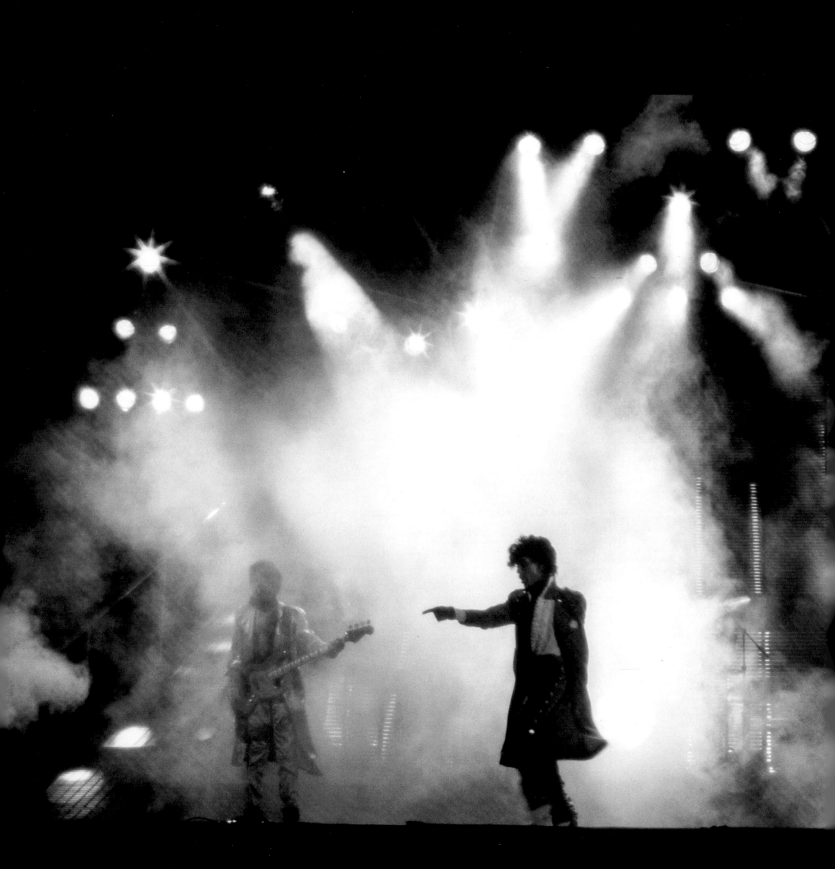

1999 tour

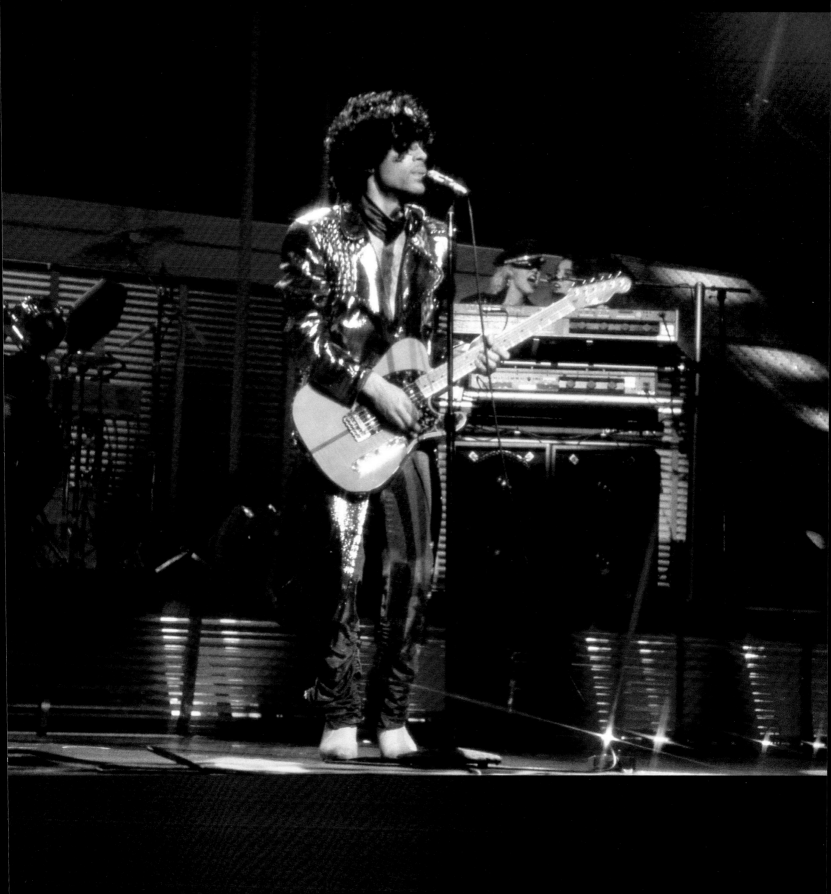

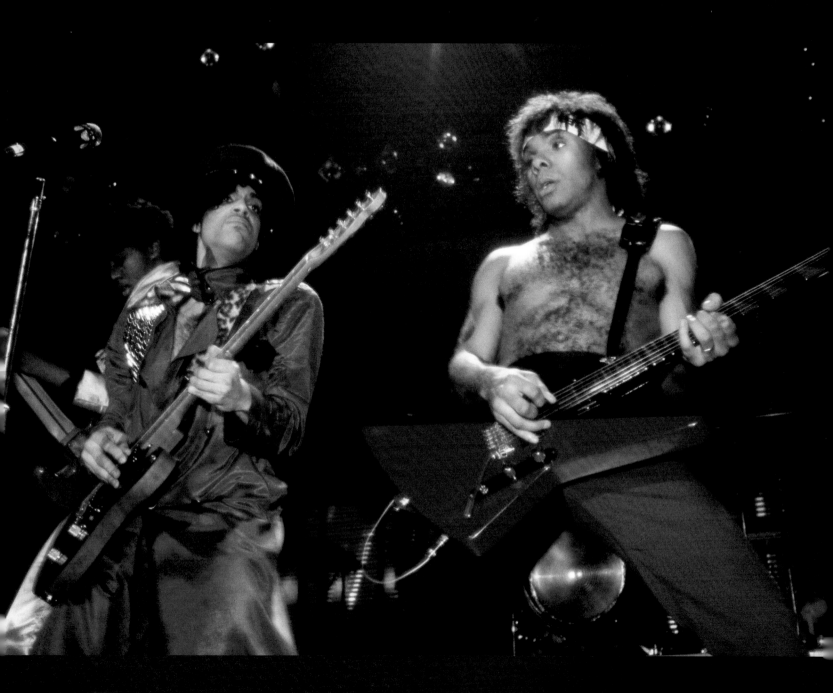

"Prince was very deferential [about my guitar playing]. I remember he came into the dressing room before a show and said, 'I'm gonna start letting you do most of the soloing live. I want to focus more on the performing, and there's no sense for us to be dueling guitars up there.' He was comfortable enough to do that. He had his spots, because he always orchestrated the shows in such a way to make sure he highlighted things that had been tested and tried and true onstage, and it worked. So, he made sure he had his moments, but he was more than happy, for the most part, to just let me be the guitar hero up there."

—Dez Dickerson

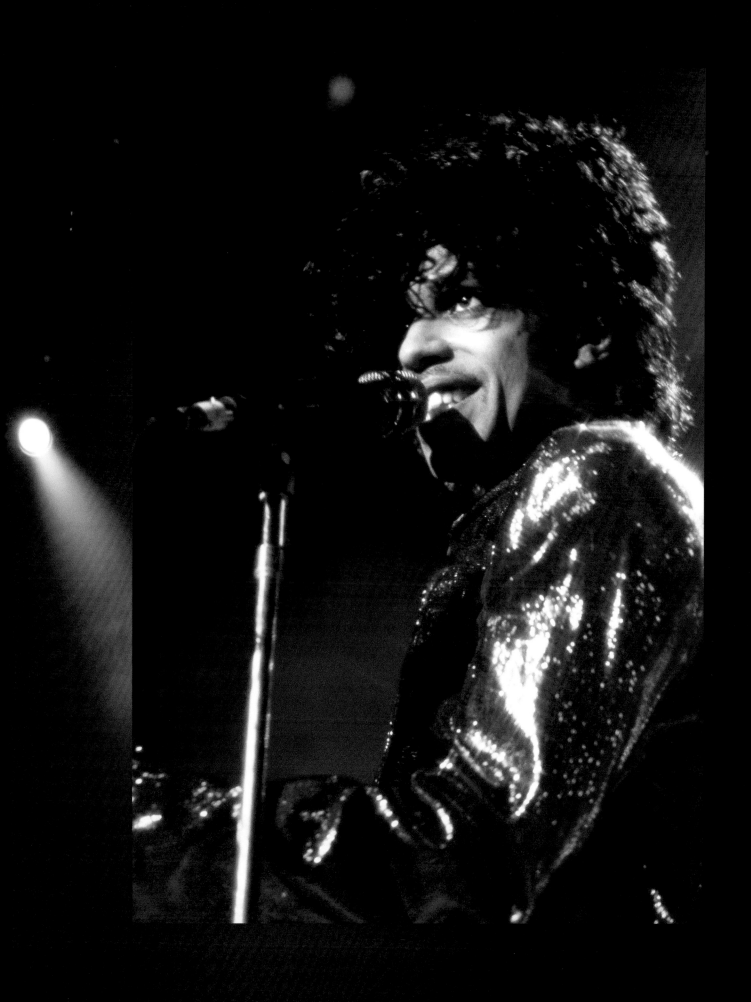

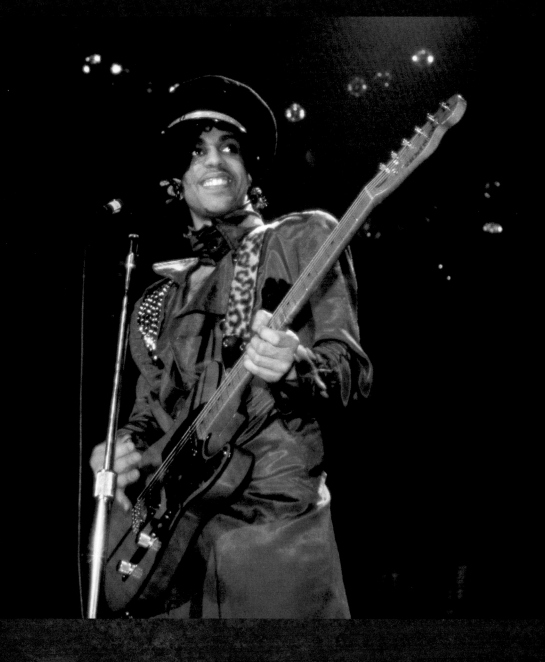

rom the time I knew him, Prince's fashion sense was always changing, in different ways. With *Dirty Mind*, it was the trench coat and bikini briefs. With *Controversy*, it was similar—trench coat, a little better made, a little less raggedy—but he started wearing pants, got a little dressier onstage. He'd wear that white shirt with the tie and really nice pants and boots. By the time we got to *1999*, it was even more dressy, more . . . Prince, I guess. Of course, with *1999*, that's when he got into the purple."

—Allen Beaulieu

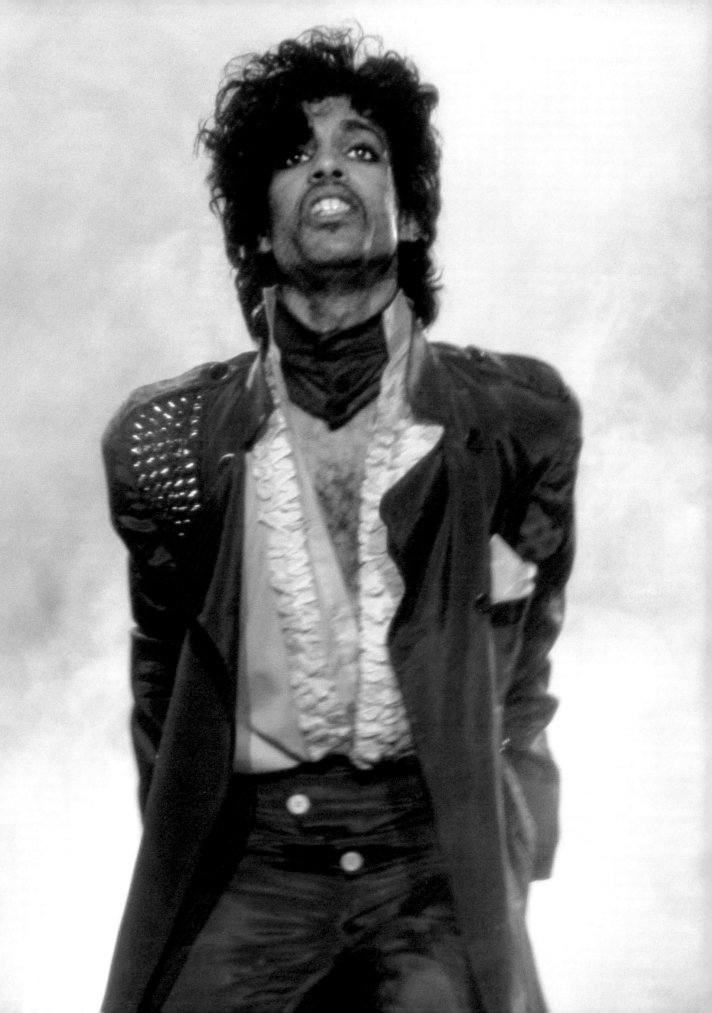

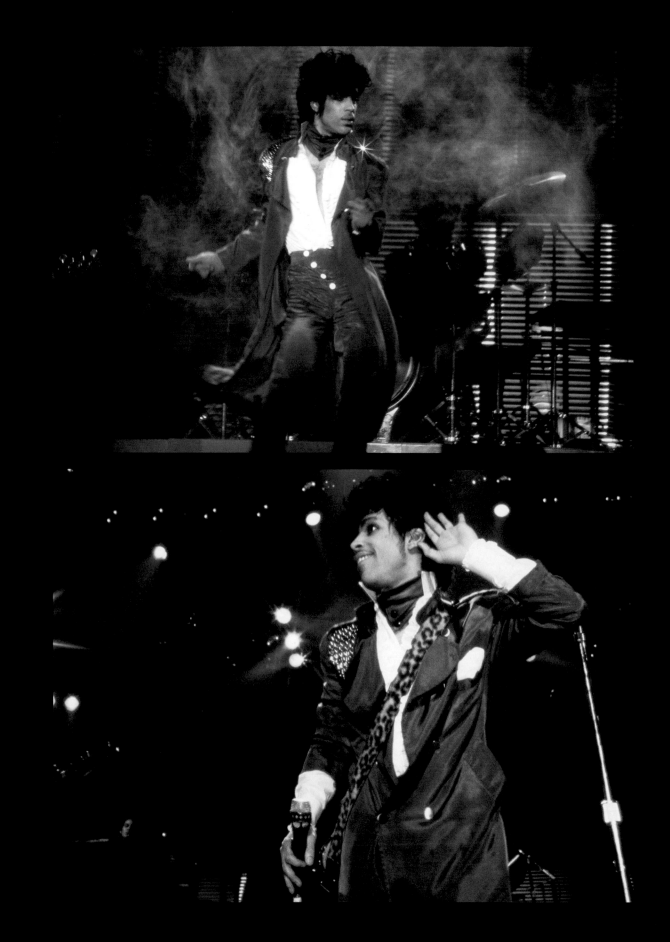

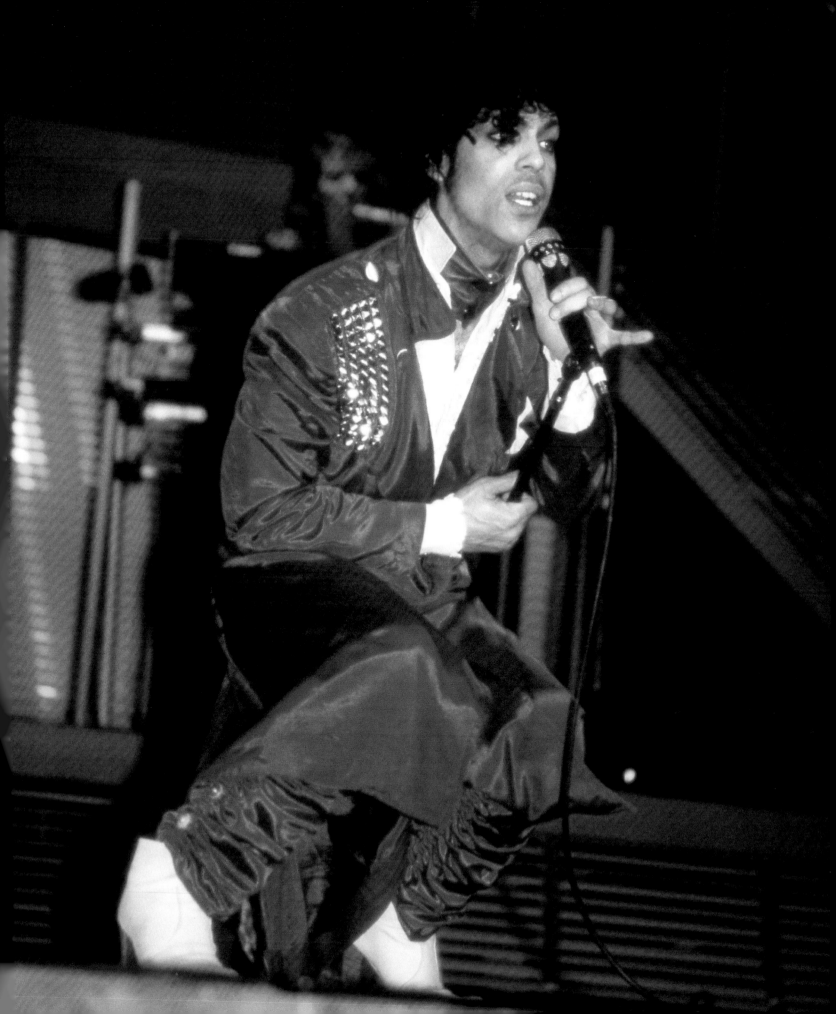

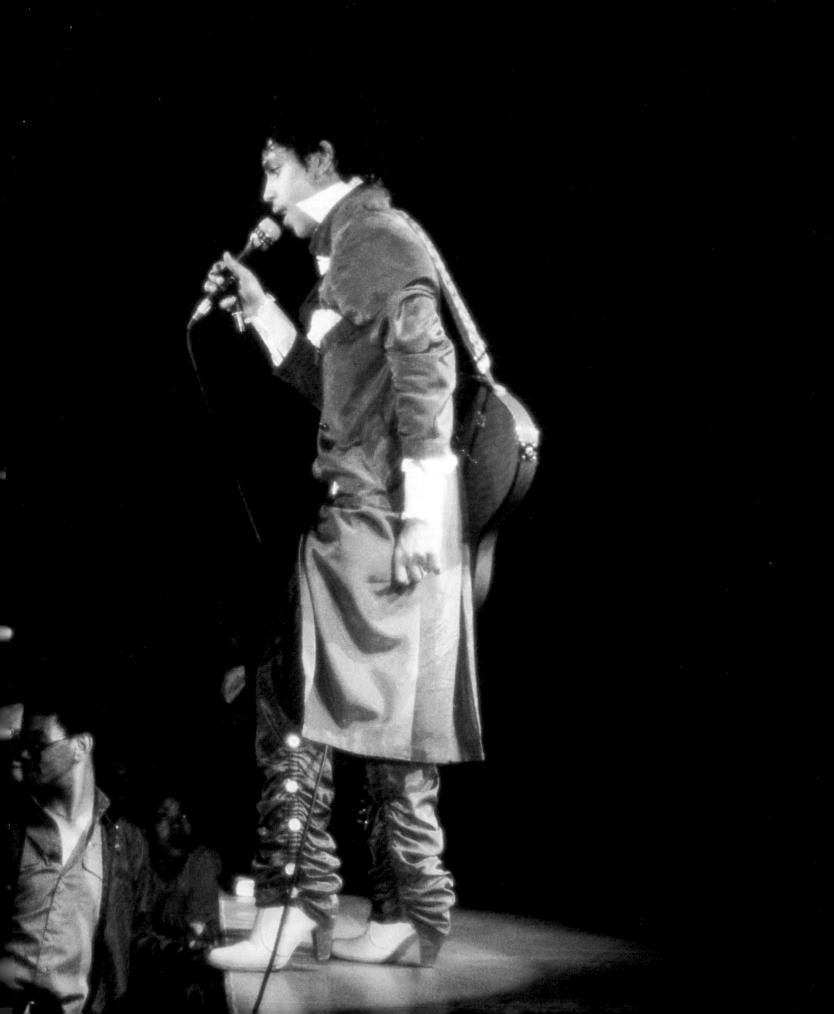

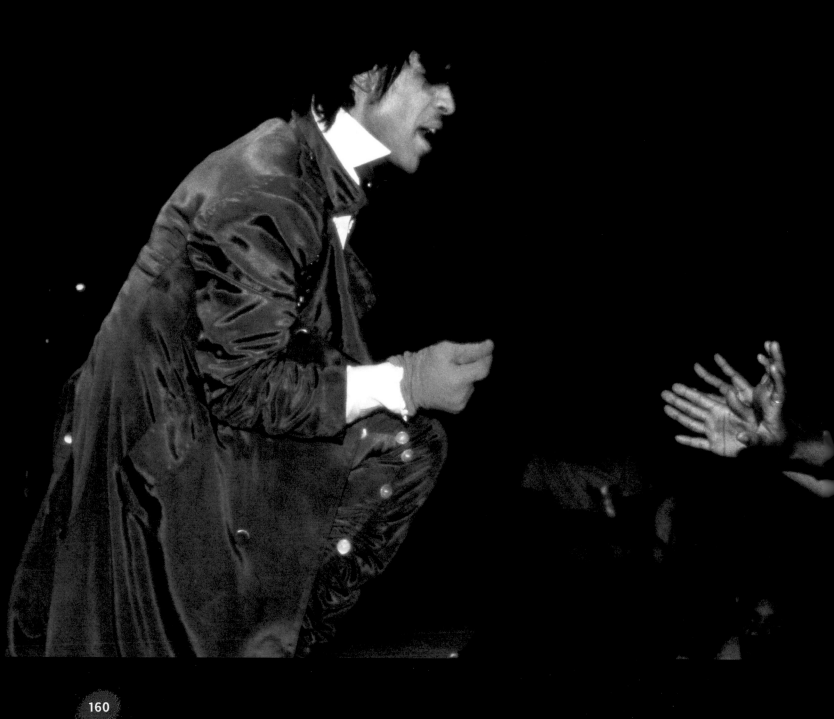

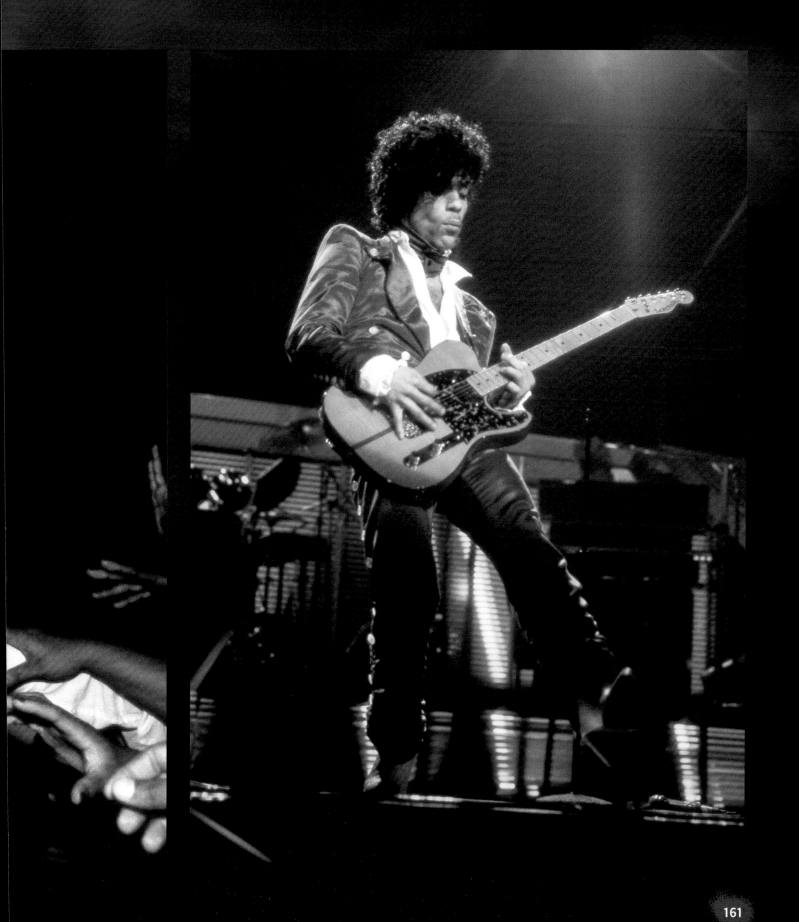

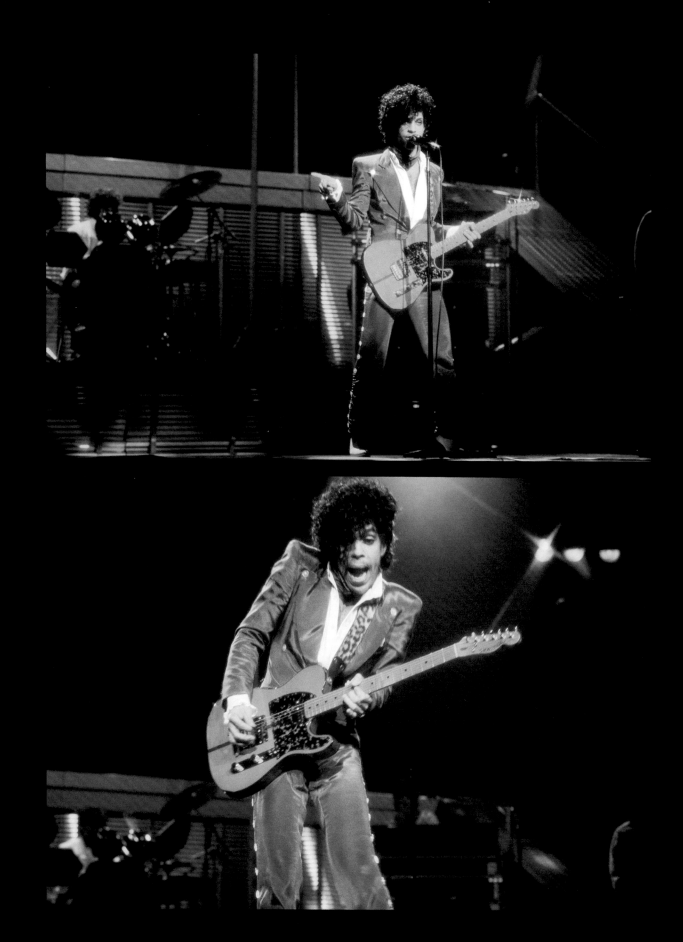

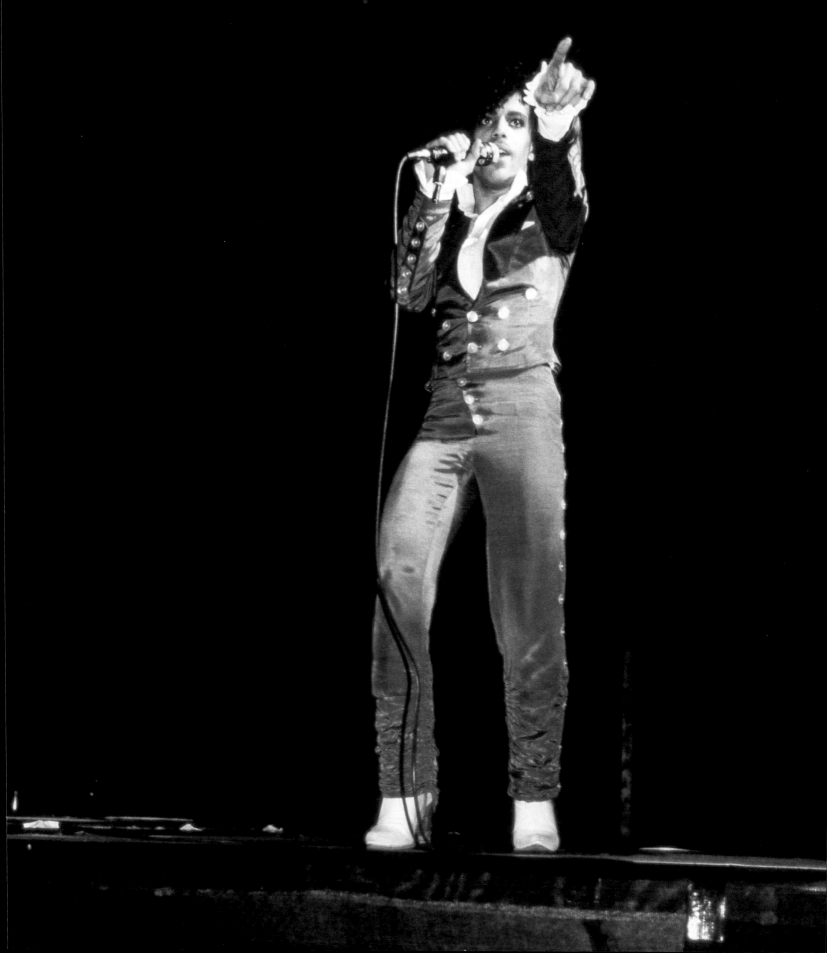

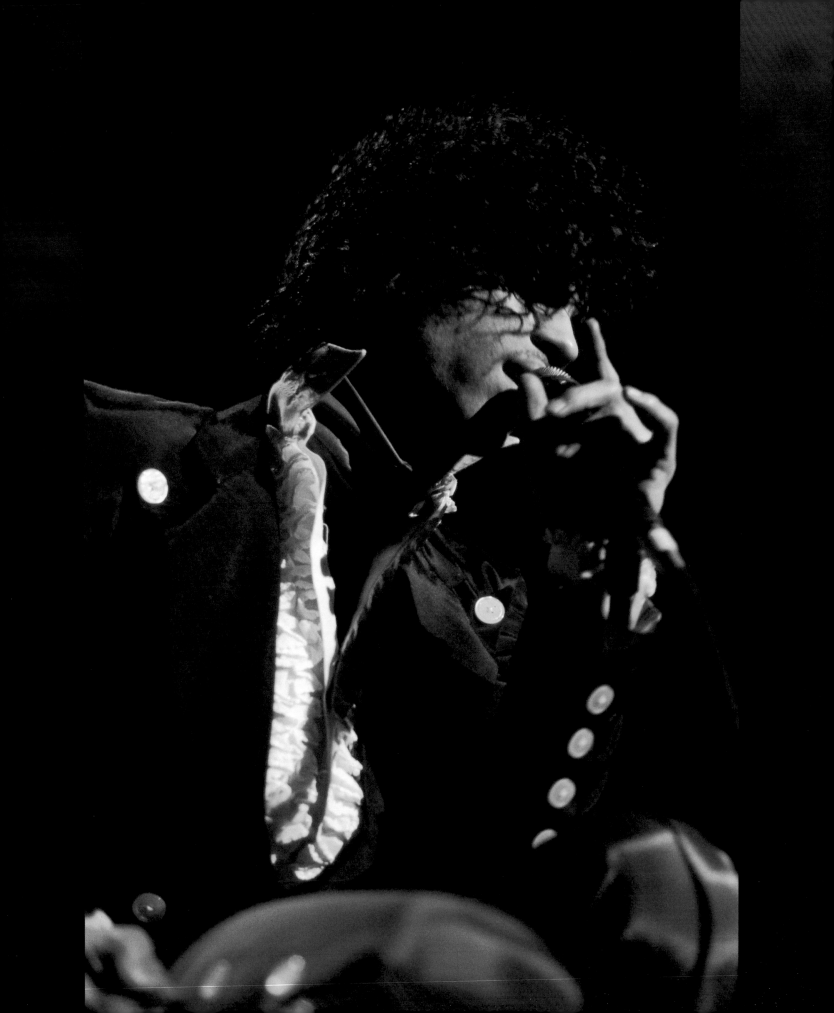

1999

By Eloy Lasanta

Prince's fifth album, *1999*, is widely considered his breakthrough into the mainstream, and it would prove to be the second-best-selling album of his career (after *Purple Rain*). Prince was named Rock Artist of the Year in *Rolling Stone* after its release, and the album sold more than one million copies by the end of 1983.

Recorded over a nearly eight-month period, from January to August 1982, *1999* was Prince's first double album. In an interview with the *Los Angeles Times* a month after the album's release, the increasingly prolific musician and songwriter explained, "I didn't want to do a double album, but I just kept writing and I'm not one for editing." He bumped up the number of tracks to eleven (compared to eight on the previous two albums) and gave lots of room for guitar and keyboard solos—with plenty of funk along the way. And Warner Bros. couldn't say no. It was obvious that Prince was calling the shots.

Some fans and critics might contend that *1999* was a "safer" album after *Dirty Mind* or *Controversy*, but its mix of pop, funk, rock, and dance allowed Prince's music to connect with a wider—and whiter—audience. Prince's listener base shifted from what had been predominantly an African American audience to one that was closer to an even fifty-fifty split of black and white.

Prince also asked for more involvement from his band, the Revolution, on the albums. While they touched only a few tracks on *Dirty Mind*, and a few more on *Controversy*, the team effort showed through more on *1999*. An even bigger factor, however, was the increasing influence of a new media phenomenon: MTV. With the advent of MTV, Prince was played to a mainstream, nationwide audience alongside the likes of Michael Jackson and Madonna. Songs like "Little Red Corvette" and "1999" flourished as a part of American pop culture. For many, seeing and hearing those songs on MTV was their first exposure to Prince, which is why the album remains a favorite for so many fans.

"Little Red Corvette" was the second single released, coming more than three months after the album's release, one month after *1999* hit gold, and amidst epic tour ticket sales—making it the most successful single from the album, hitting No. 6 on the pop charts. *1999* contained many other hits as well, like "Delirious," "Automatic," "Something in the Water," and "D.M.S.R.," making it a standout album for Prince. ◗

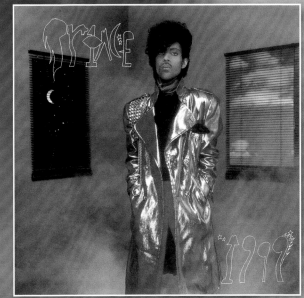

Singles, EPs, and other releases from *1999*, featuring photos by Allen Beaulieu

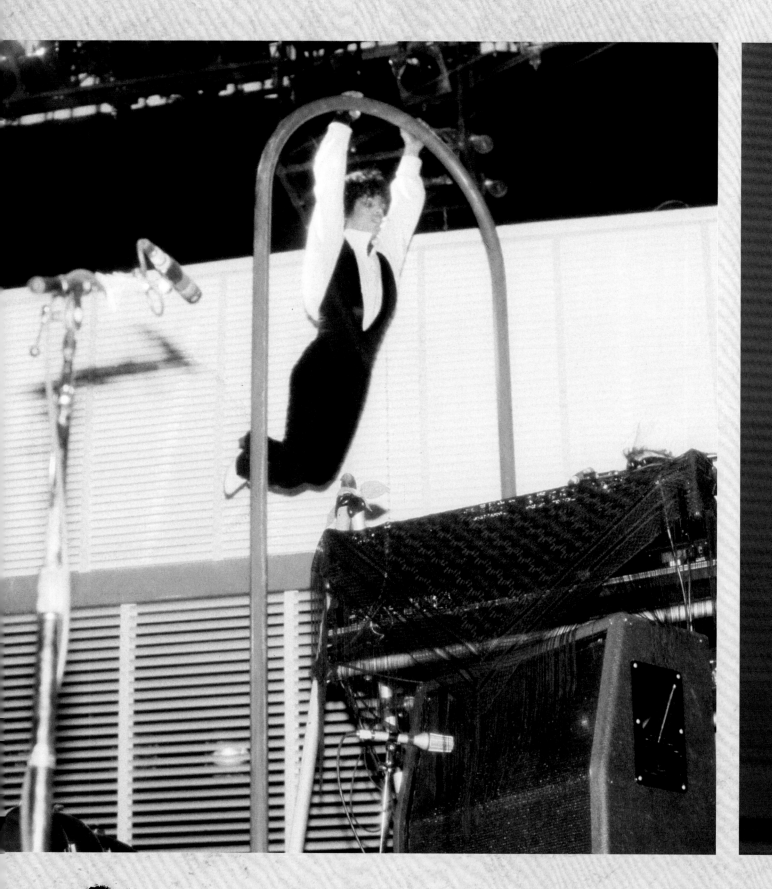

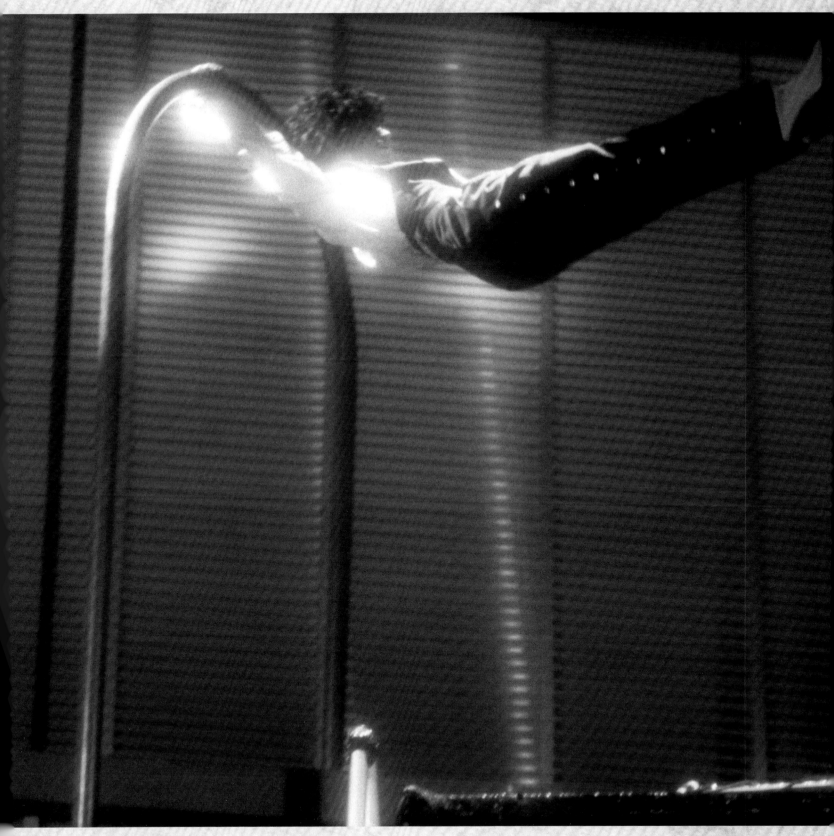

Prince swinging from the bar on the *1999* tour set

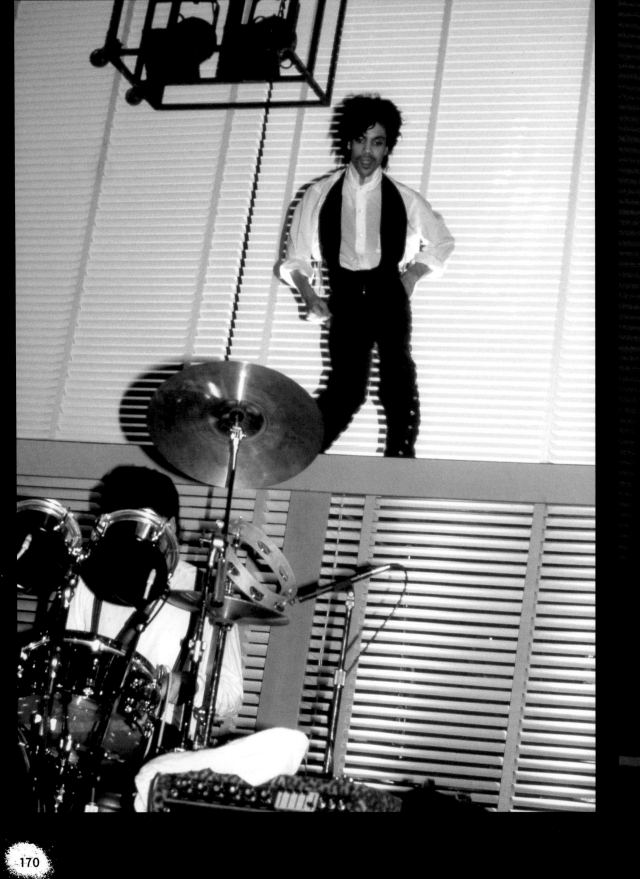

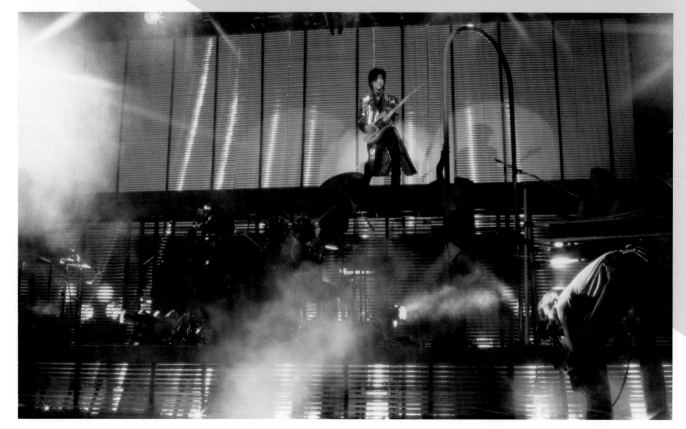

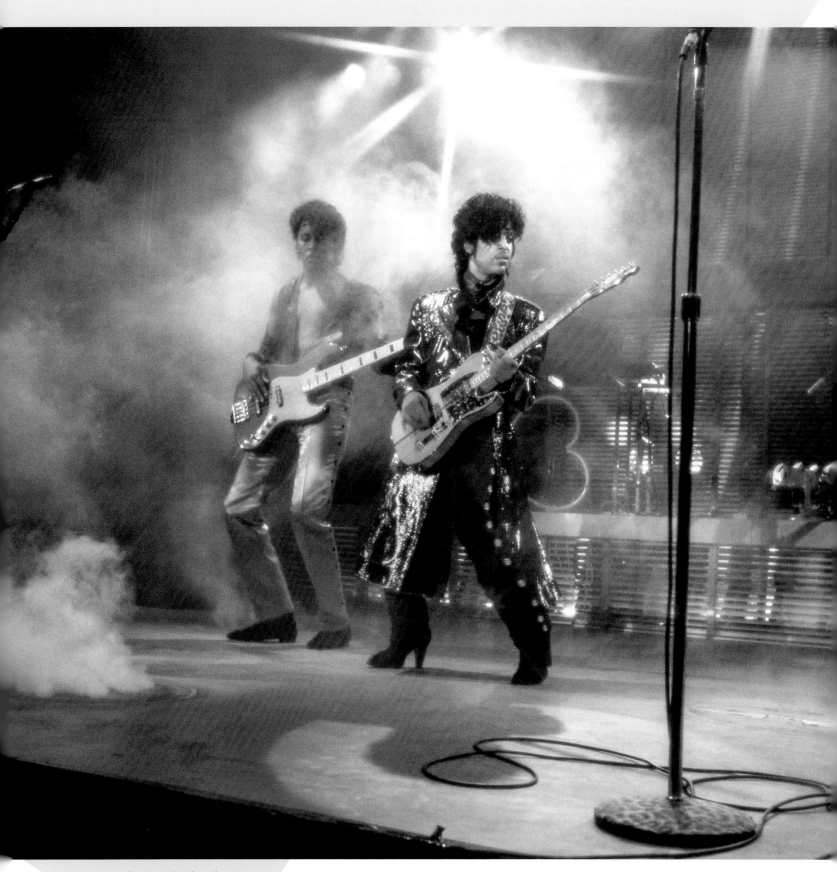

From the "1999" video shoot

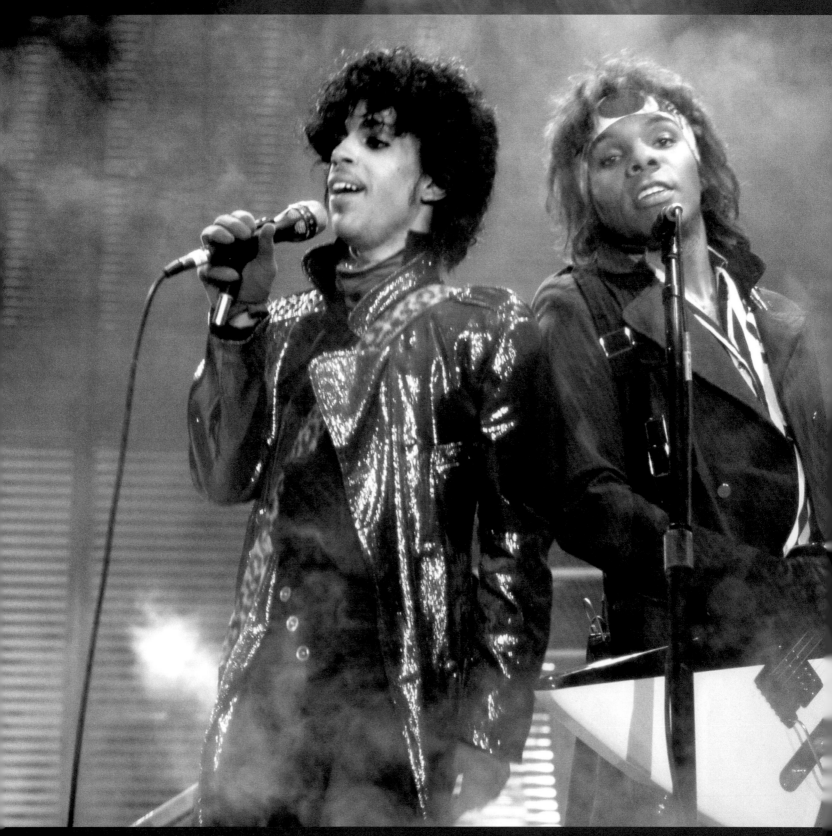

From the "1999" video shoot

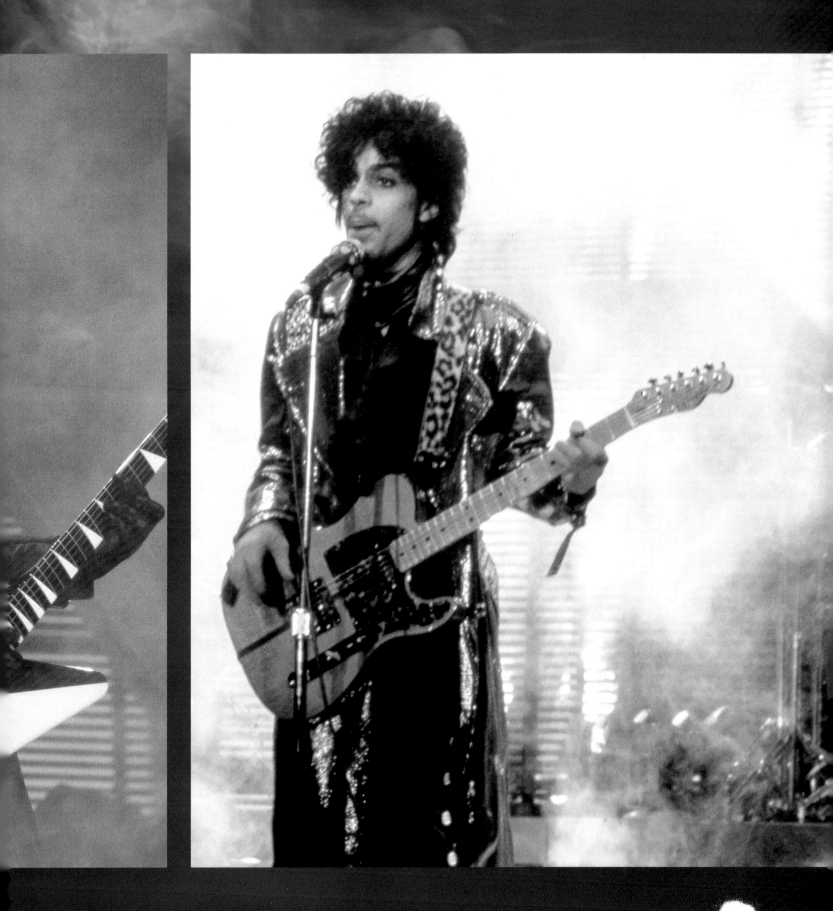

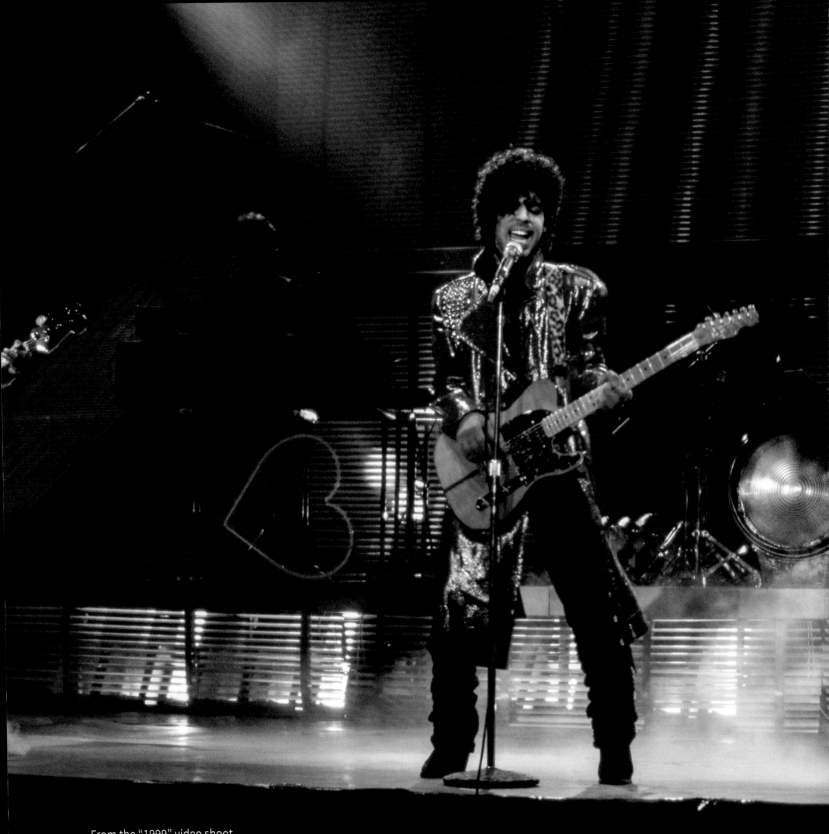

From the "1999" video shoot

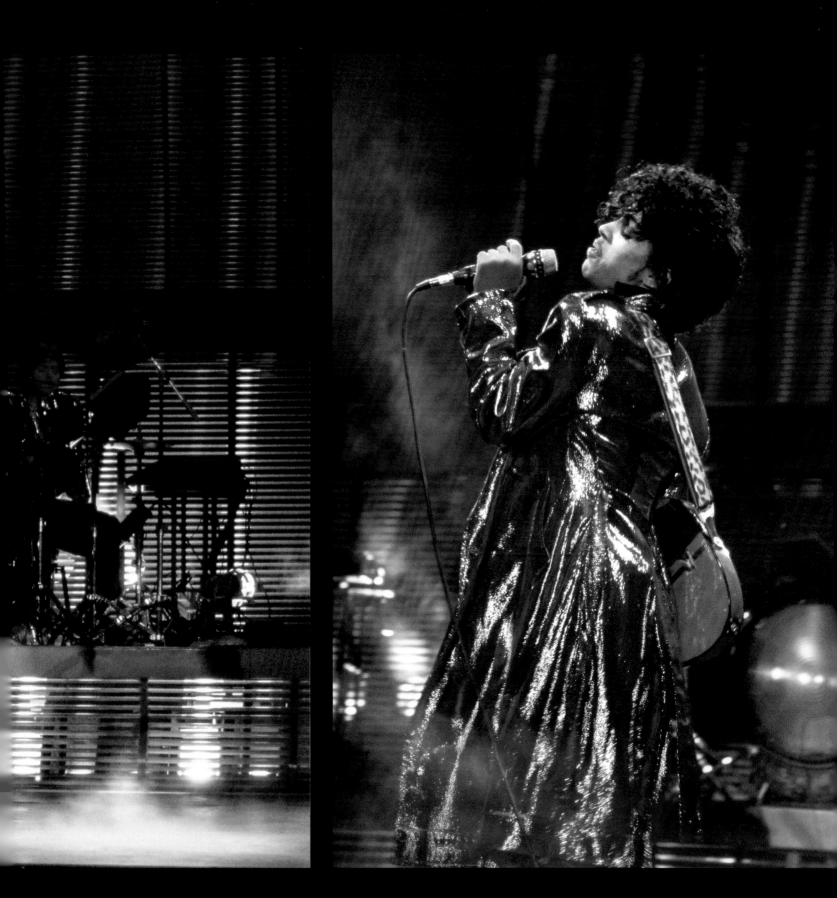

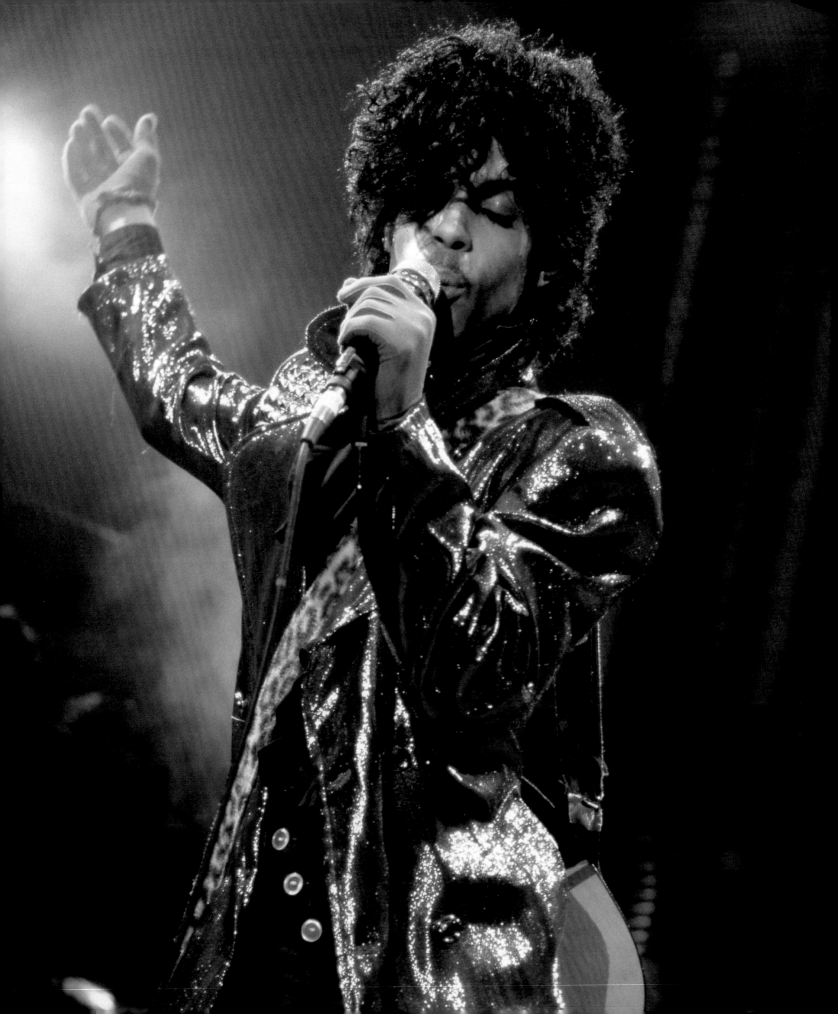

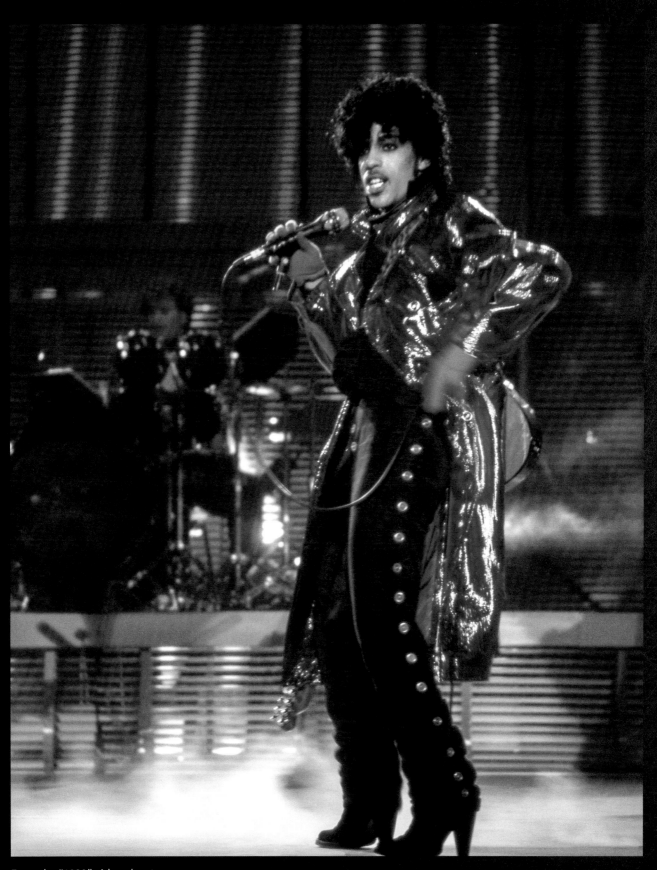

From the "1999" video shoot

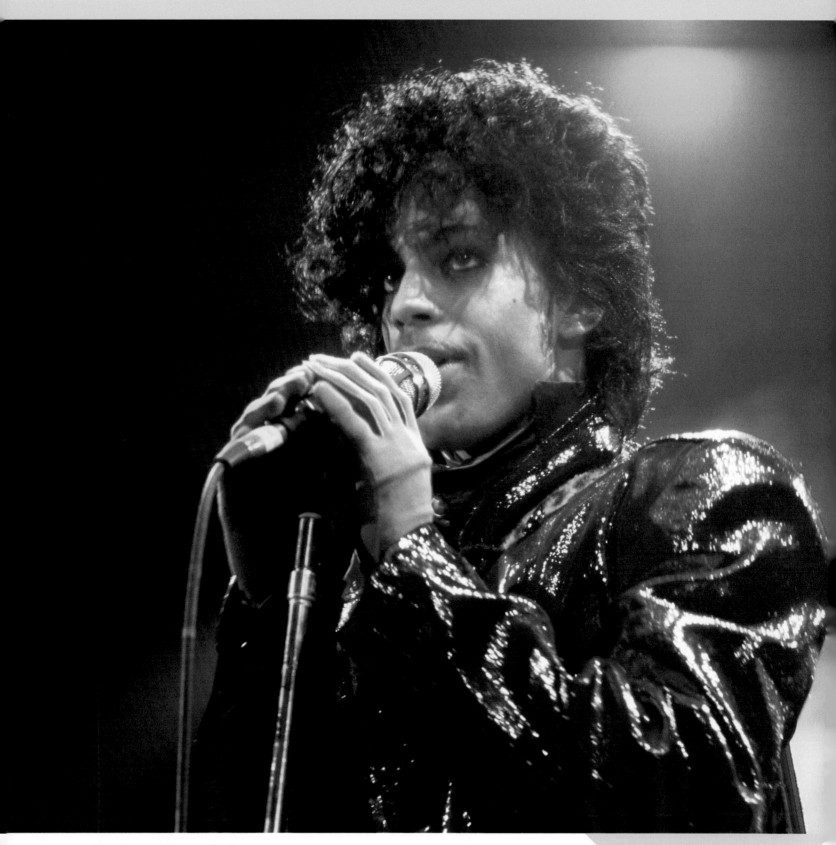

From the "1999" video shoot

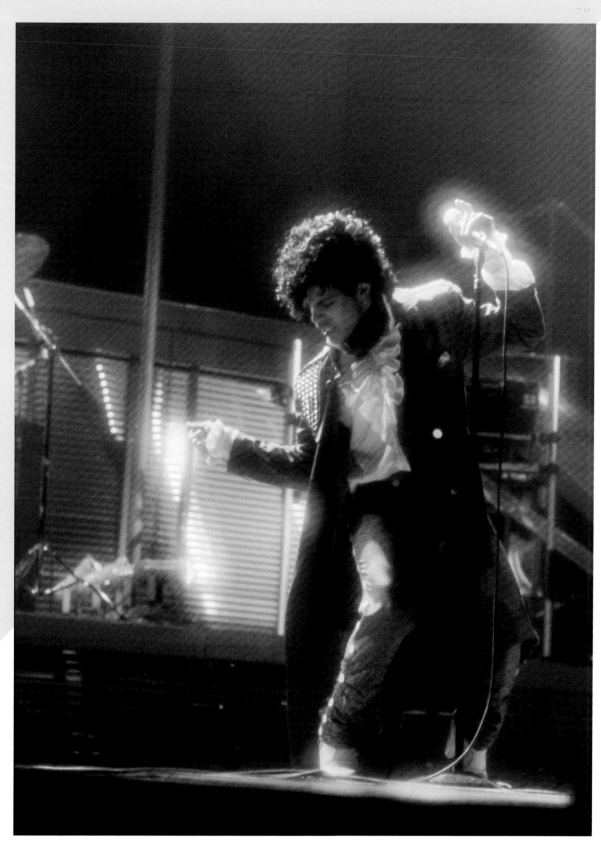

From the "Little Red Corvette" video shoot

Purple Coats and Bondage Fantasy

With the *1999* album and the videos that followed, Prince was even more focused on creating a strategy to propel him as an icon and prepare the band for what was to come with *Purple Rain*. This was evident in both the music and the visuals, according to drummer Bobby Z, who had been with Prince since the beginning. "For me, the signal was the purple trench coat," he said. "We were coming from shopping at used clothing stores and digging through barrels, and then the symbolism of the purple trench coat was, 'this is serious business.' I knew he was going to go for it then. He was going to be flashier. Still rude and crude, but now a slicker guy, a ladies' man. Before that, he wasn't playing a ladies' man; it was all shock value. Then he turned it into a Casanova."

Prince and the Revolution shot three videos for singles from *1999* over a few days while rehearsing at the Minneapolis Armory in early November 1982. The videos for "1999" and "Little Red Corvette" were fairly standard simulated live performances, using the same stage set that the band took on tour—with Prince wearing his shiny purple trench coat and everyone heavily made-up.

For "Automatic," a deep cut from the album, the video transitions from band performance to bondage-inspired sexual fantasy, as backup singers and keyboardists Lisa Coleman and Jill Jones strip Prince down and tie him to a bed, before Coleman whips him with her belt. The video put on blatant display Prince's perpetual exploration of sexuality and power.

Coleman sees the video as an example of Prince's willingness to play with norms. "A lot of people aren't willing to be the victims in their songs," she said. "They blame everybody else, like, 'You broke my heart and you did this to me and that to me. Oh, I'm just so hurt!' Prince did it from the other side: 'Look at my vulnerability; look how I open myself up to you. Look at me laying on this bed, being willing and taking everything.' He put a twist on it. It was really intriguing. And it was a lot of fun, especially at that age, when you're so highly sexual and trying to figure that stuff out and having fun with it and challenging people."

Coleman also saw the video as a kind of foreshadowing: "Look out: this is who you're going to be dealing with over the next couple years, and we are going to be amazing!" ◗

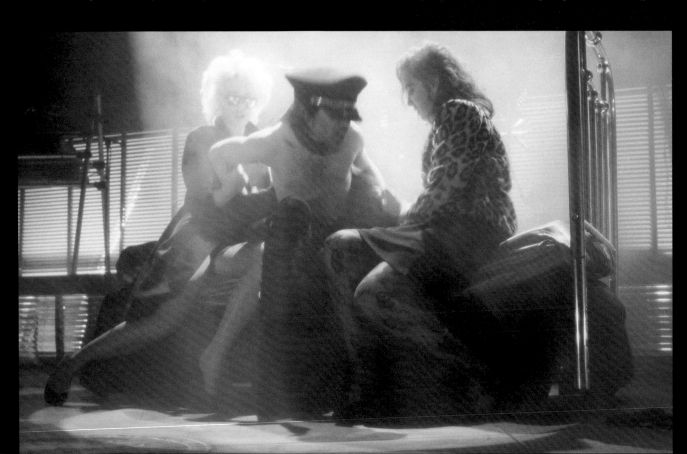

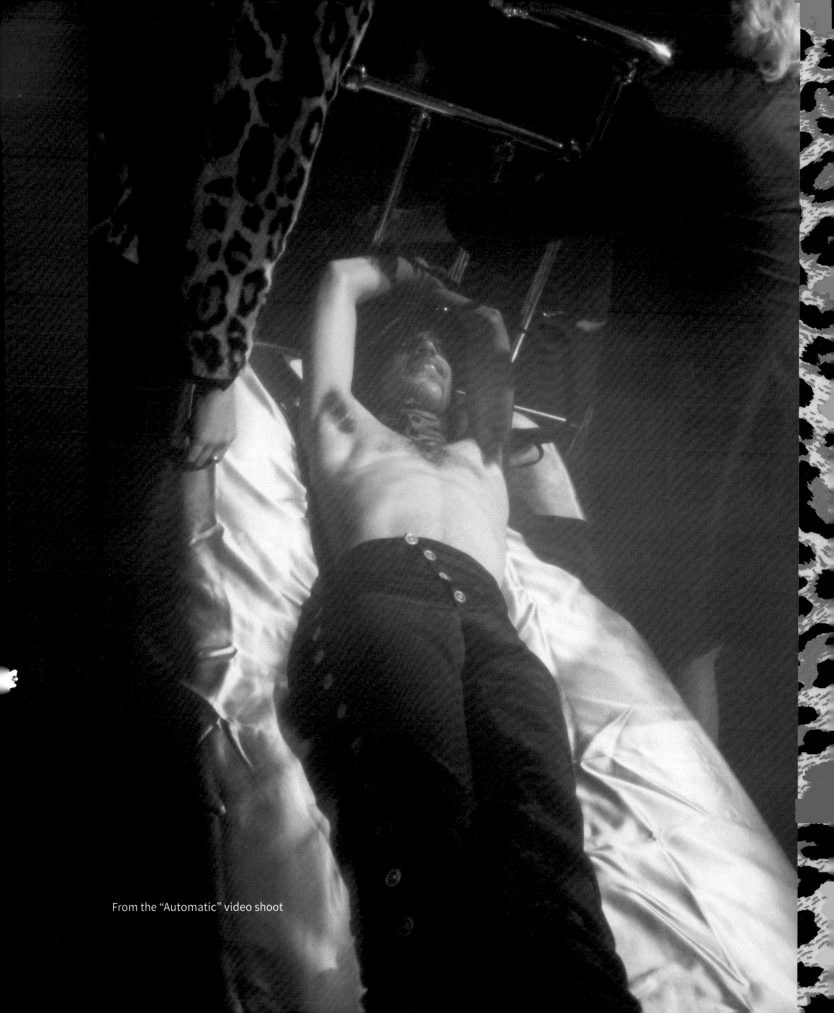

From the "Automatic" video shoot

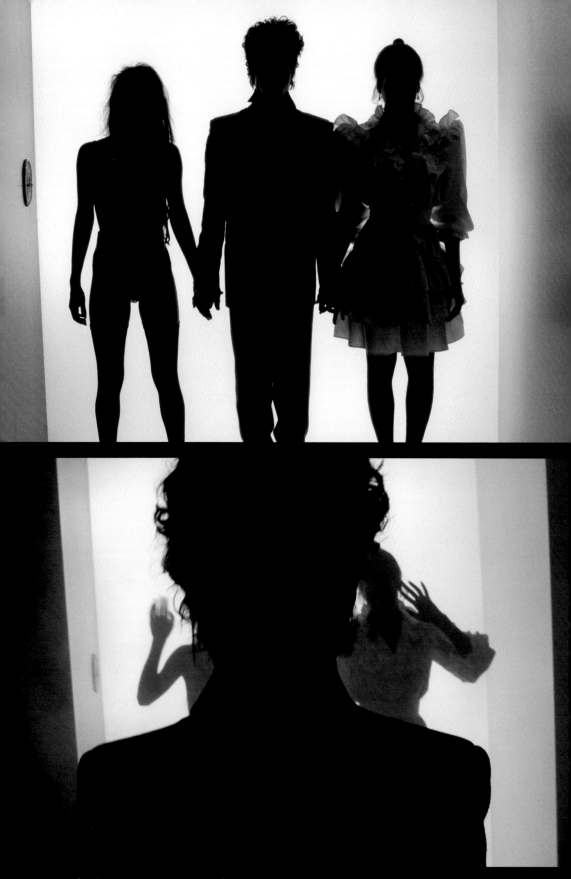

n preparation for the as-yet-unwritten *Purple Rain* movie, Prince hired esteemed Minneapolis video producer
Chuck Statler to shoot some test footage. Beaulieu snapped these photos during that session.

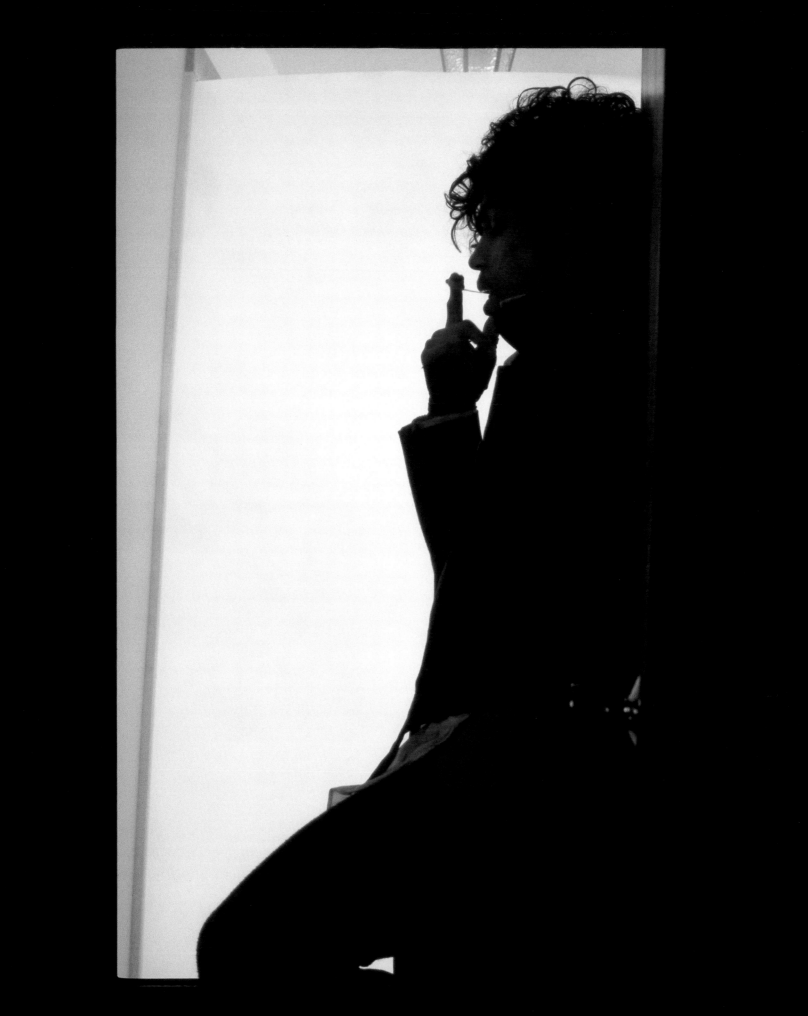

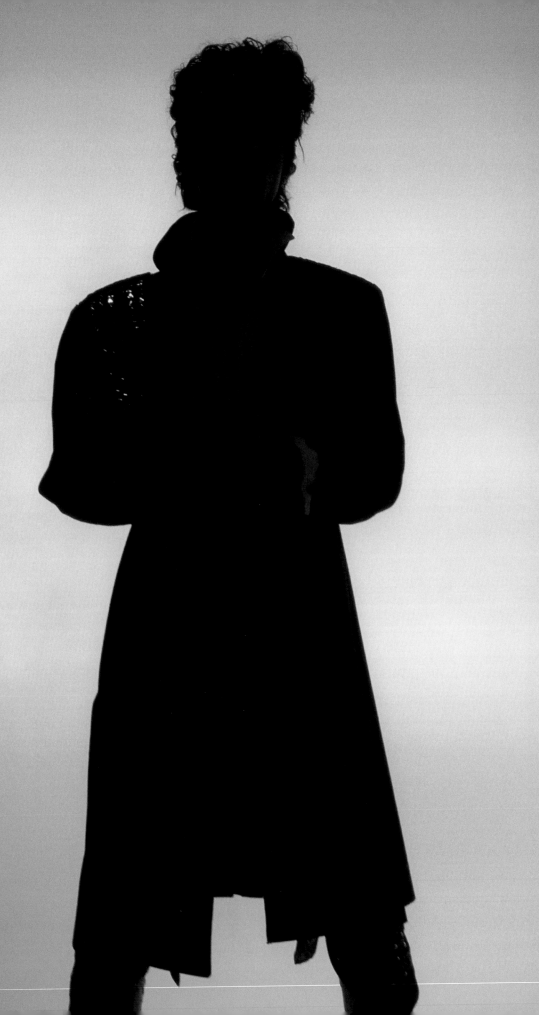

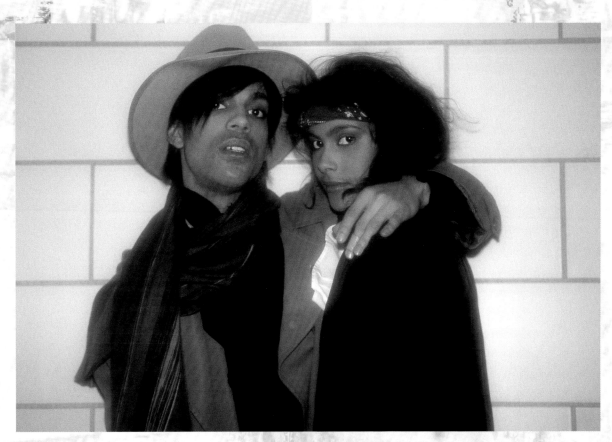

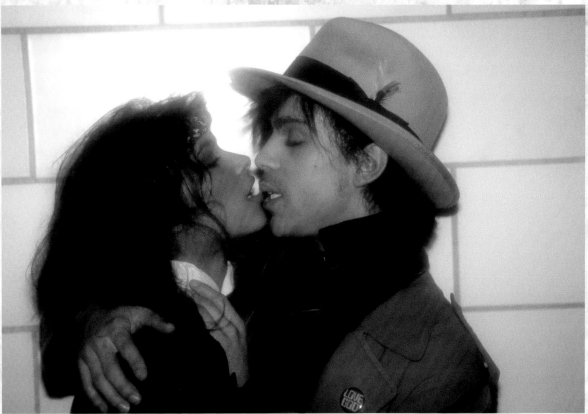

Prince goofing backstage with Vanity (Denise Matthews)

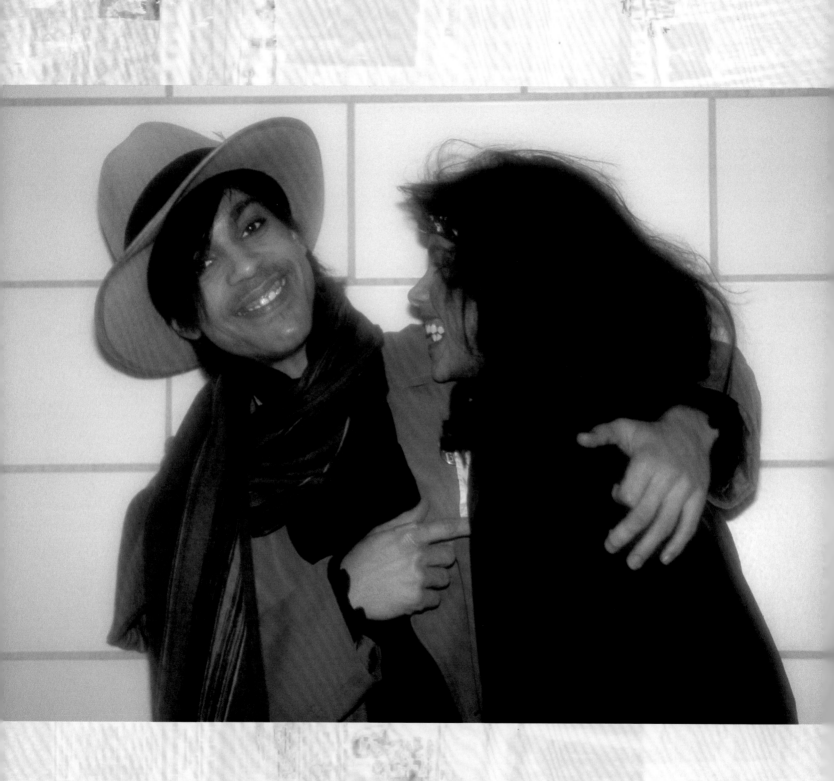

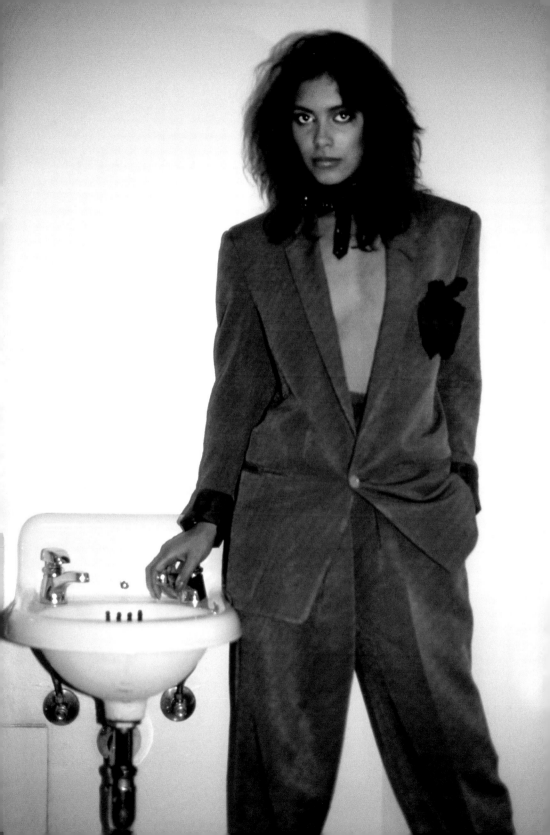

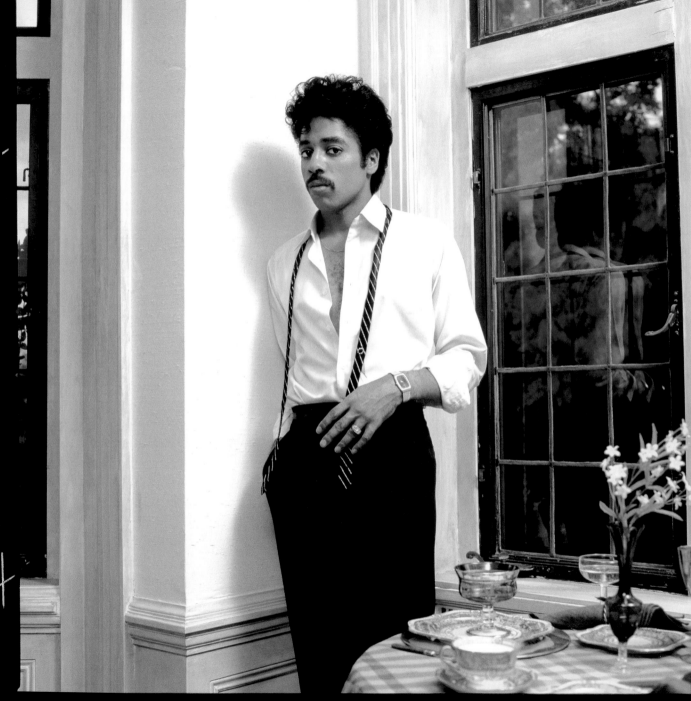

Morris Day

SHOOTING THE TIME AND VANITY 6

As his own musical career was reaching new levels of success and innovation in the early 1980s, Prince was exploring various side projects as an outlet for his ever-flourishing creativity. Formed in 1981 from the ashes of the Minneapolis Sound cornerstone group Flyte Tyme—including Jimmy Jam, Terry Lewis, Jellybean Johnson, and Monte Moir—the Time was fronted by Prince's longtime friend and onetime bandmate from Grand Central, Morris Day. Guitarist Jesse Johnson and "hype man" Jerome Benton rounded out the Time's original lineup.

The band's mix of funk, pop, and R&B was clearly derivative of Prince's own sound—not surprising, since Prince wrote the songs, with Day, and performed all the instruments on the band's self-titled debut album, which was released on July 29, 1981, just two and a half months before *Controversy*. Prince was also the producer and engineer on *The Time*, under the pseudonym Jamie Starr.

And Prince turned to his go-to photographer to shoot the album cover.

"I didn't know who the Time was," recalled Beaulieu. "I only found out later that Prince wrote all the music and played all the instruments. The only thing he didn't do was sing; that was Morris."

Beaulieu took his Polaroid around Minneapolis's West Bank neighborhood to scout possible locations. Prince chose the location from the Polaroids, and Beaulieu posed the band members on the front steps under a "Please No Loitering" sign.

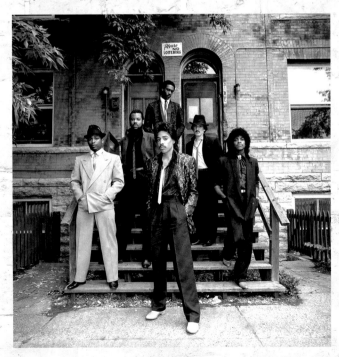
From *The Time* album cover shoot in Minneapolis's West Bank neighborhood

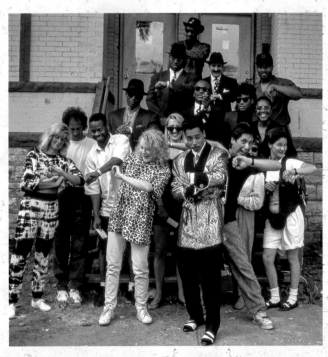
The crew got into the act for this outtake photo with the Time. Allen Beaulieu is seen standing just behind Morris Day.

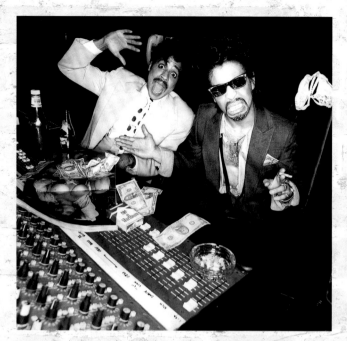

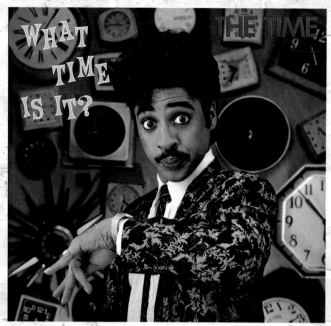

Prince adopted the pseudonym—and in this photograph, the persona—of Jamie Starr to produce the Time's albums.

"By the time I got to the Time, they knew who I was," Beaulieu said, "because I had shot a couple Prince albums, so they treated me pretty good."

Prince also told Beaulieu he needed a photo of the producer of *The Time*. "See, Warner Bros. was paying Jamie Starr to produce these records, and they wanted a shot of Jamie Starr. Prince decided he wanted me to be Jamie Starr [in a photograph]. So, he dresses me up like a pimp. I'm an American Indian—I don't look like a pimp; there's no way you're going to be able to make me look like a pimp. Actually, Prince burned me. He was trying to curl my hair for the photo, and he burned me. He didn't mean to. It was pretty comical."

For the Time's second album, *What Time Is It?*, Beaulieu spent a month collecting different clocks for the set. "It's not so easy to find wall clocks that look different or interesting," he noted. He shot five variations for the cover, and Prince went with an image of Morris only. "The other members of the band weren't very happy about that," Beaulieu recalled, "but it wasn't my decision."

Tension had also emerged between Prince and the Time during the *Controversy* tour in late 1981 and early '82. The Time's band members resented being shut out of the recording and creative process, and they felt they were

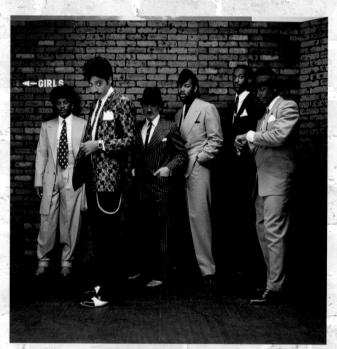

Left off the front cover, the full band is included in this photo, which was used on the back cover of *What Time Is It?*

being underpaid. A rivalry developed during the tour, as each act tried to outdo the other from the stage, culminating in Prince and others from the Revolution throwing eggs during the Time's set on the final night of the tour.

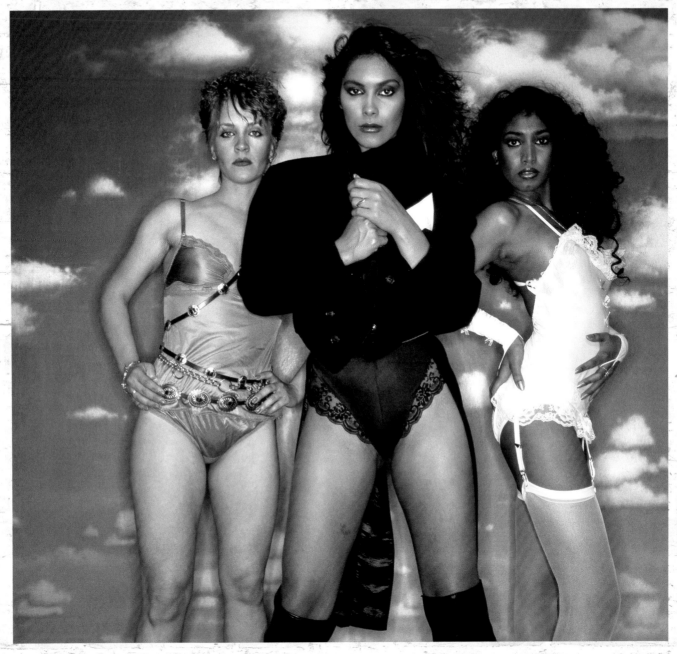

Brenda Bennett, Vanity, and Susan Moonsie of Vanity 6

Although Prince (and Jamie Starr) again wrote, performed, and produced all the songs on 1982's *What Time Is It?*, the Time couldn't pass up the chance to tour with Prince for *1999*, beginning in November 1982. This time there was a third act on the bill, another of Prince's side projects: Vanity 6.

Prince put together the all-girl trio, originally known as the Hookers, in 1981. He brought in Denise Matthews to front the group and rechristened her Vanity, and the band was renamed Vanity 6. While Prince and Vanity developed a romantic relationship, musically it was a challenge.

"Vanity was hard because she couldn't sing," recalled Beaulieu. "I remember being there for a couple of her recording sessions, and Prince would get so mad at her: 'I gotta do one line at a time with her. It's push in, push out every song.'

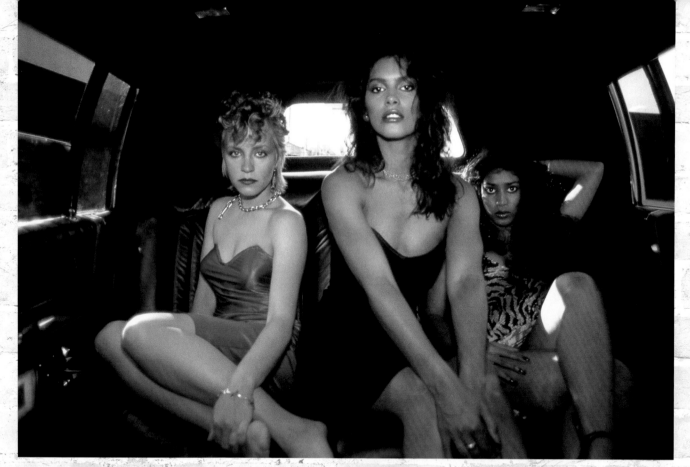

(above) Vanity 6. (right) Vanity 6, shot in a downtown Minneapolis alley.

That's what I most remember about working with Vanity 6: Prince being mad at her because she couldn't sing."

Beaulieu also worked with Vanity 6 for the cover of their first and only album, the three female singers clad in their trademark lingerie. Aside from Vanity's limited vocal abilities, Beaulieu was struck by her "magnetism." He remembers "walking down the street with her in downtown Minneapolis after the photo shoot. I'd walked around with models all the time from my other shoots, and nothing would happen. But when I walked down the street with Vanity, it was whistles, catcalls, everything."

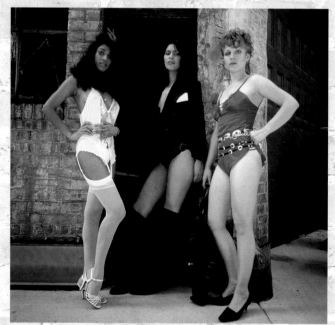

On the 1999 tour, Vanity 6 was the opening act, followed by the Time, and then Prince. The Time also served as Vanity 6's backing band, performing out of sight off-stage or behind a curtain. The band was okay with that, but they were not okay with the treatment they got when the tour came to Minnesota, on March 15, 1983, for a concert at the Met Center in suburban Bloomington. "I don't know if Prince was mad at the Time or Vanity or what was going on," Beaulieu said, "but he only advertised himself. Even though the Time and Vanity opened, they weren't mentioned in promotions for the Met Center show. I remember they were very upset: 'We're in our own hometown, and we don't even get a mention.' But that's the kind of guy Prince was. With one hand he'd give, and with the other he'd take away." ●

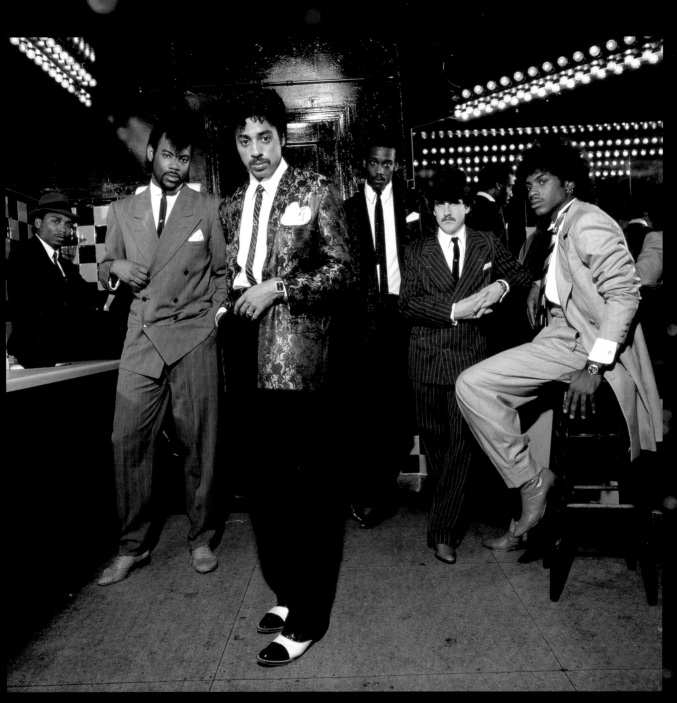

The Time, posing in the women's restroom at First Avenue. The photo was used for the single of "The Walk," from *What Time Is It?*

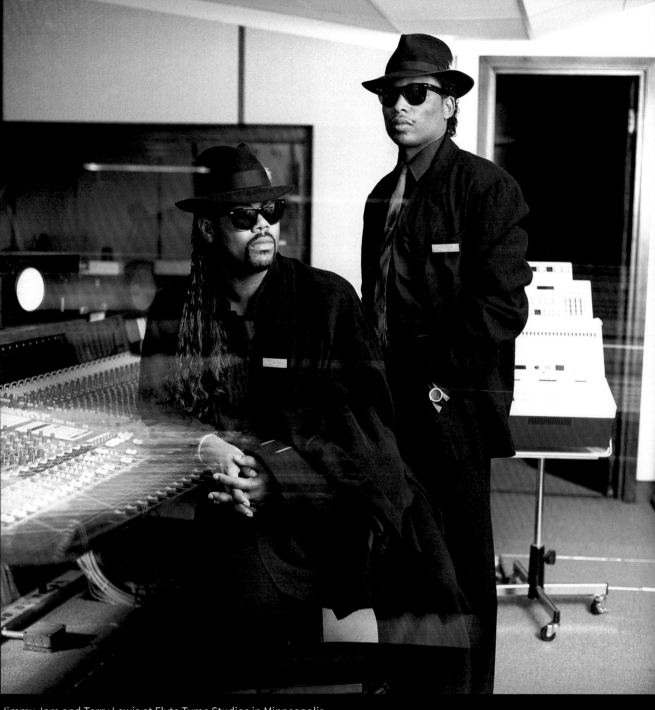

Jimmy Jam and Terry Lewis at Flyte Tyme Studios in Minneapolis

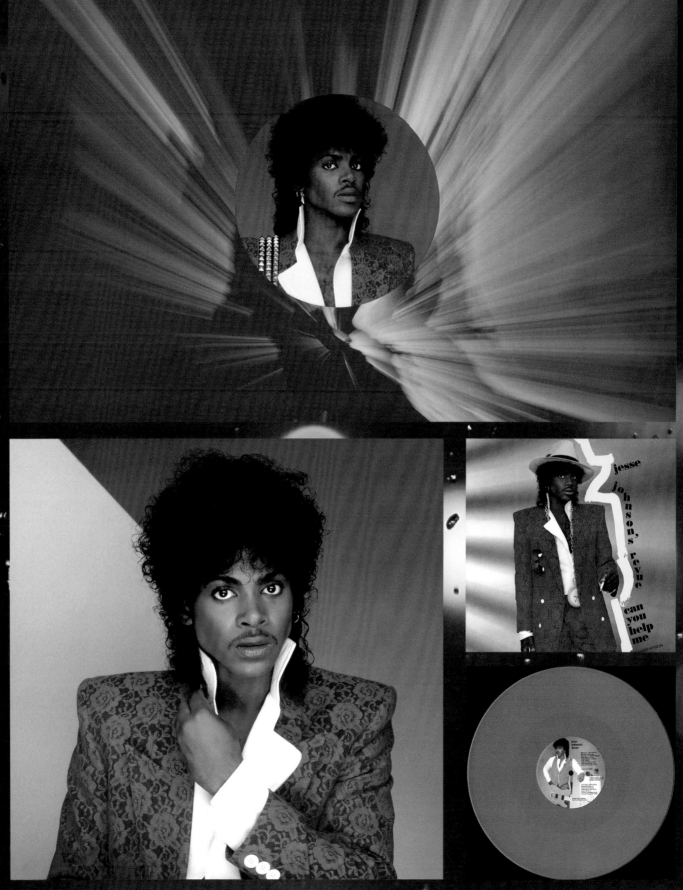

Jesse Johnson photos and album covers by Allen Beaulieu

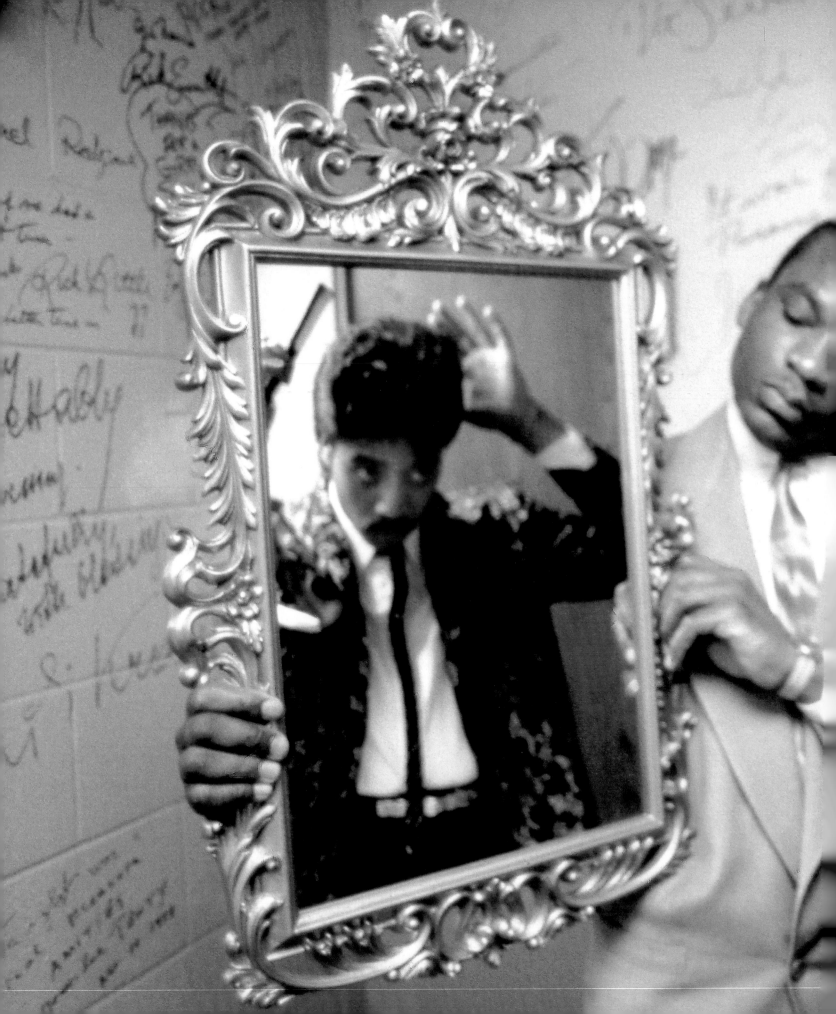

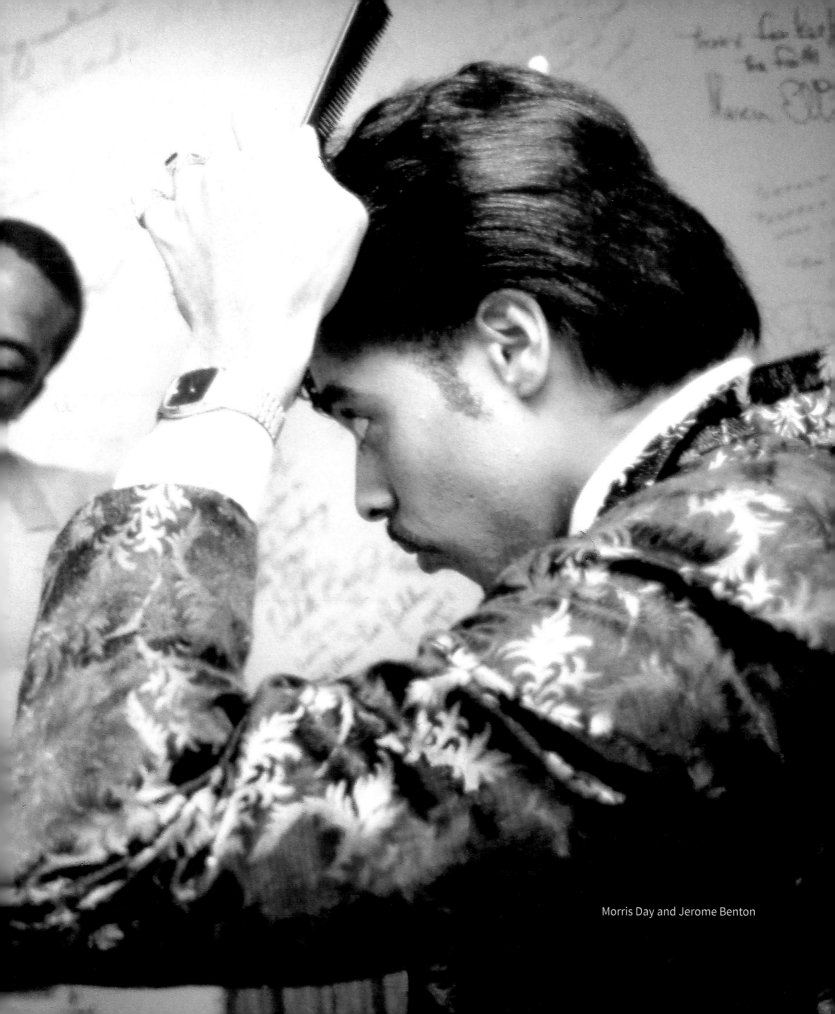

Morris Day and Jerome Benton

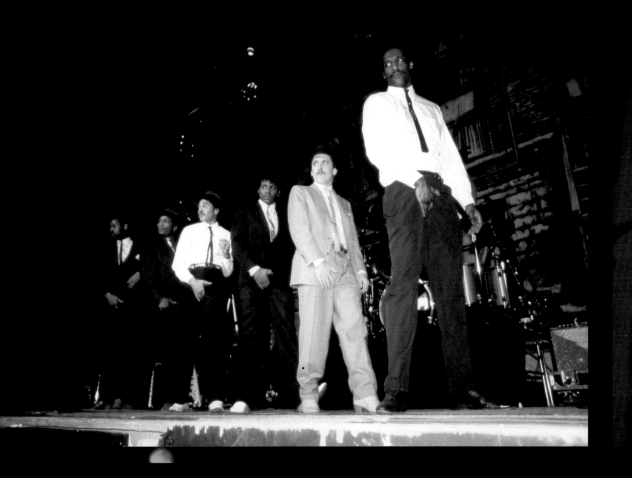

The Time onstage

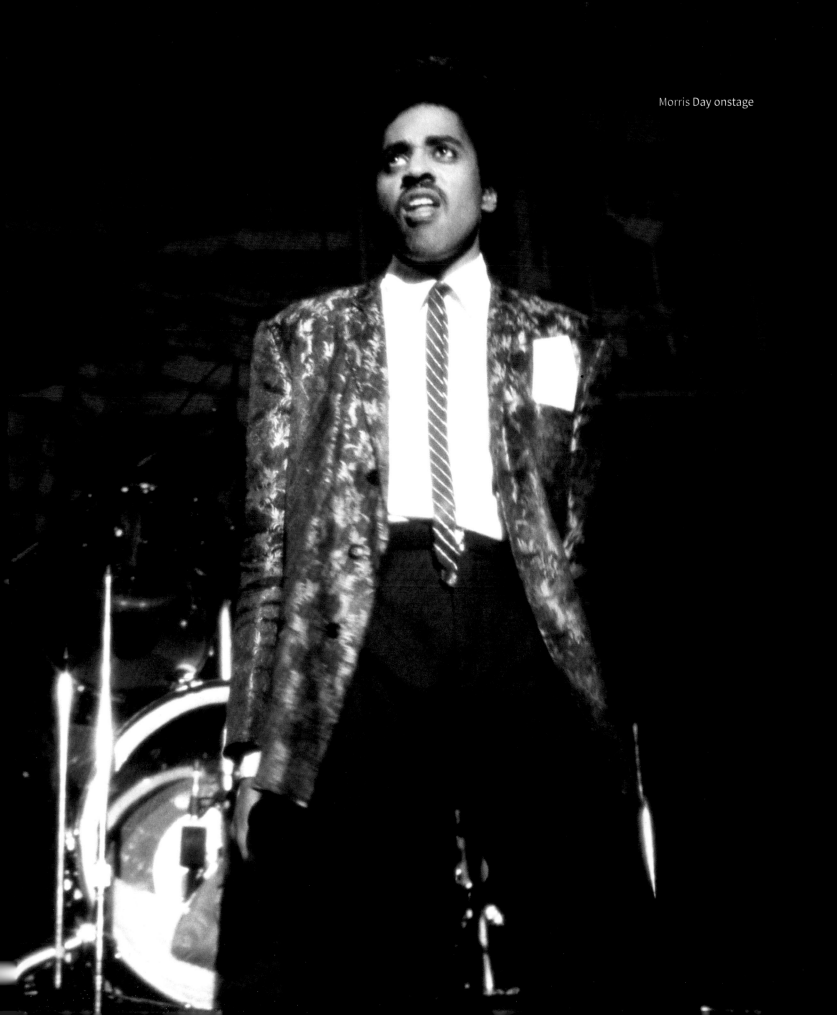

Morris Day onstage

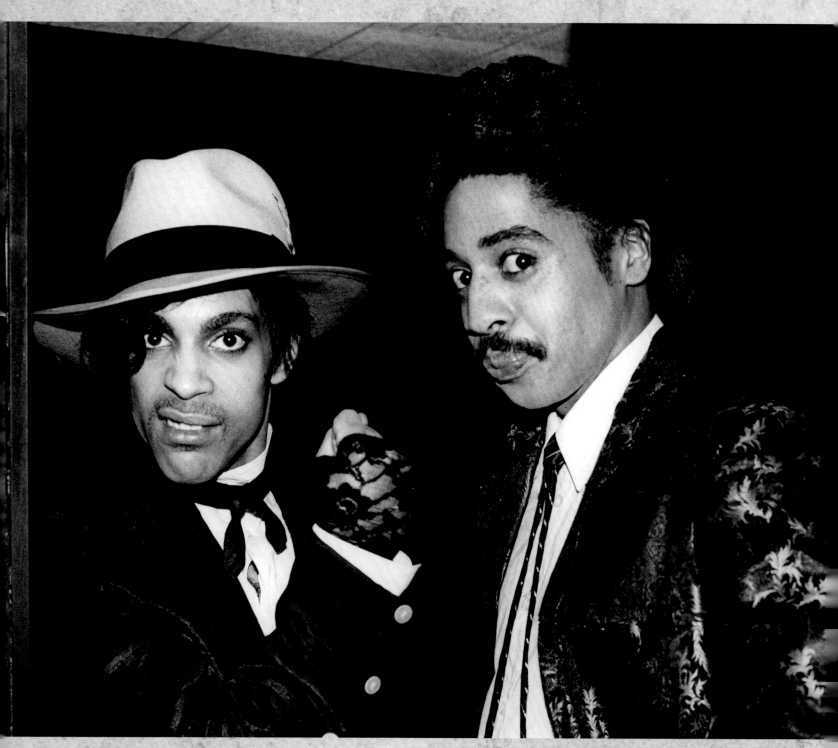

Prince and Morris Day backstage during the *Controversy* tour

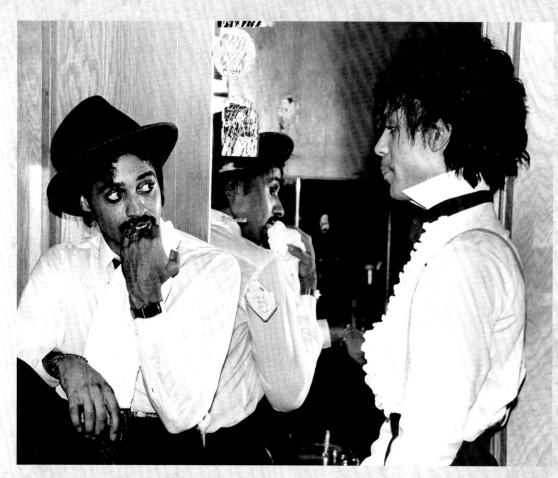

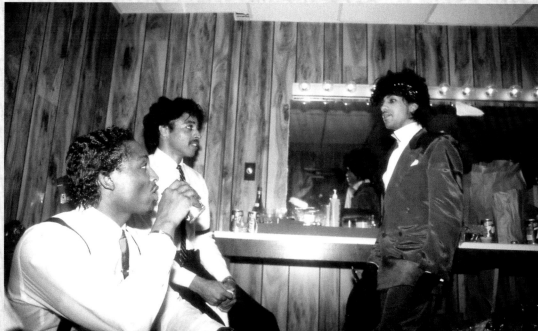

Backstage during the *1999* tour

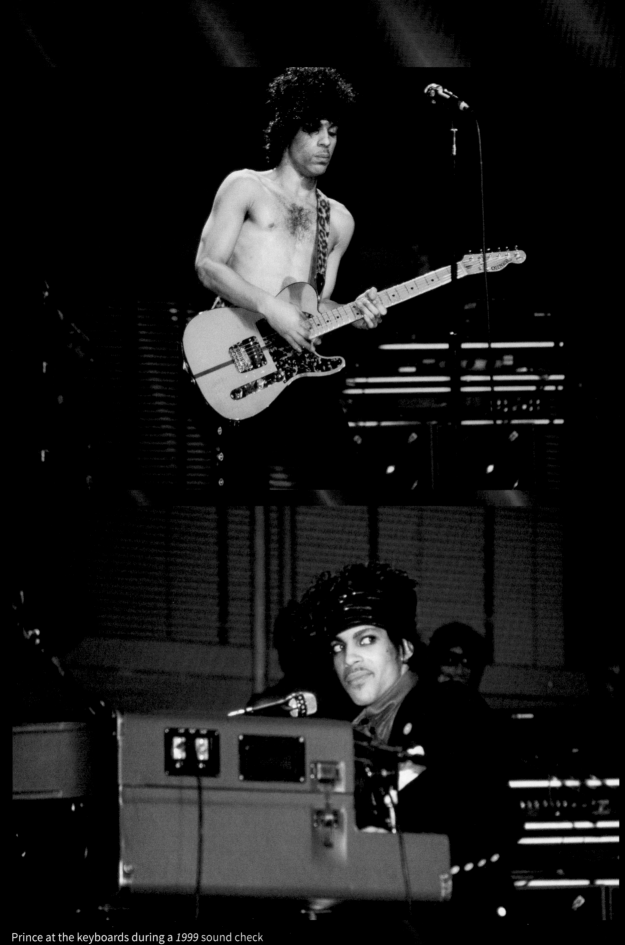

Prince at the keyboards during a *1999* sound check

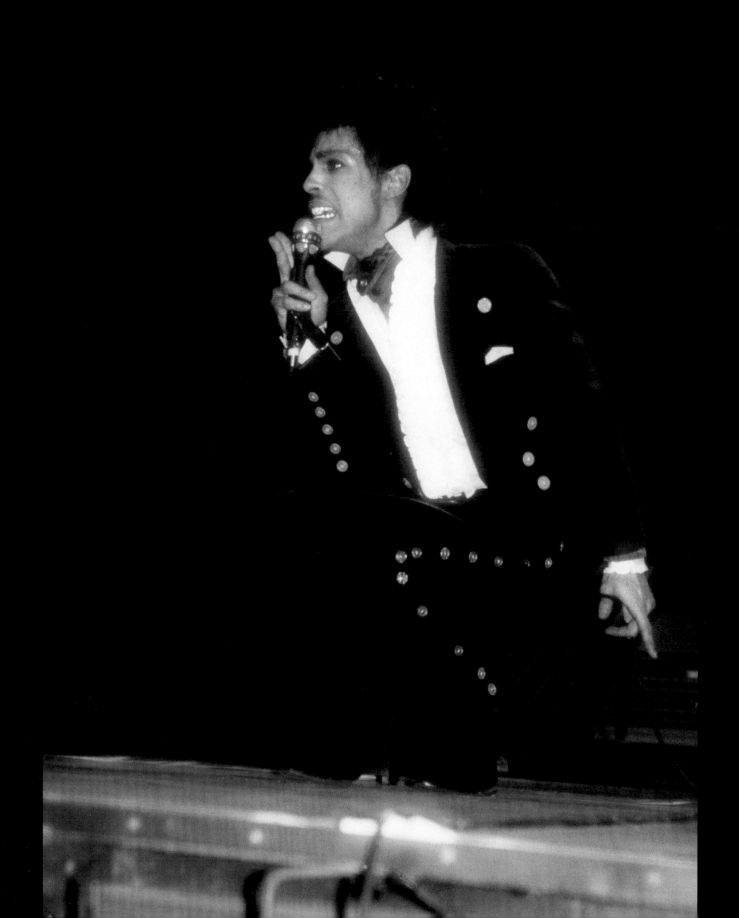

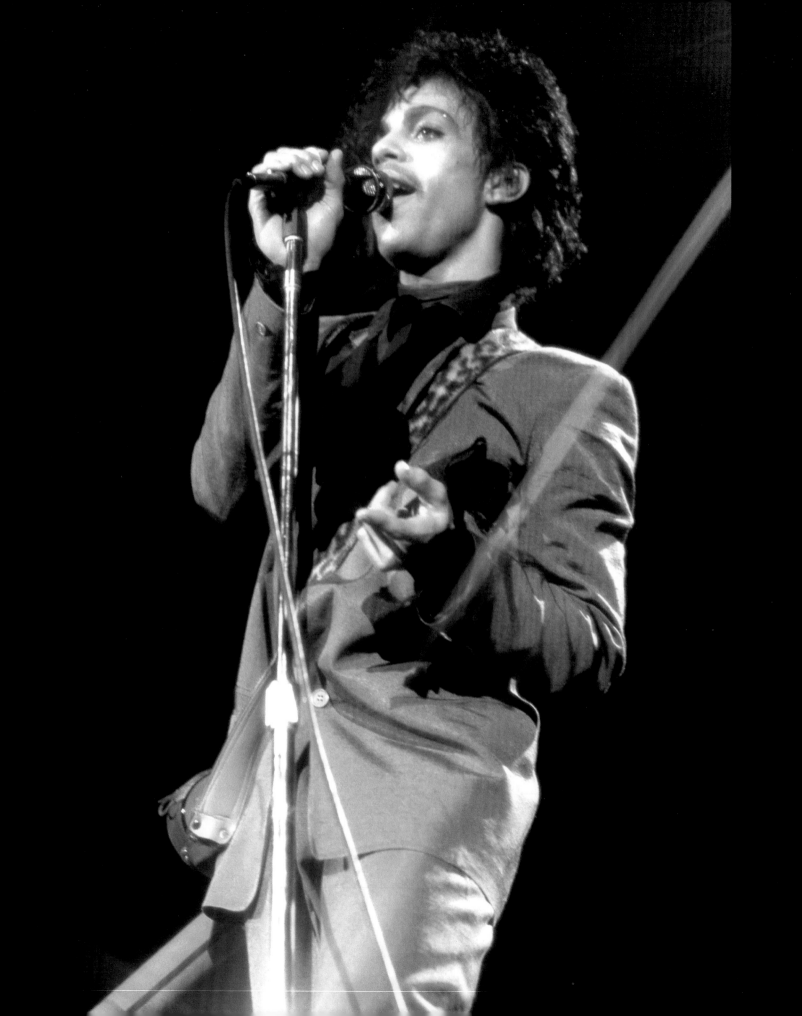

"LET'S GO CRAZY"—BY ALLEN BEAULIEU?

By Jim Walsh

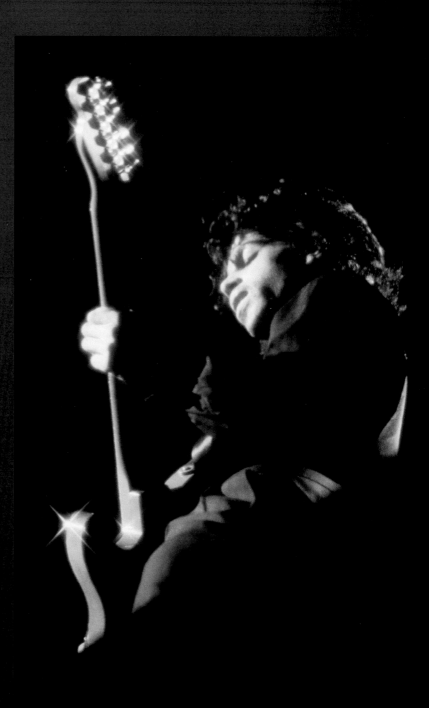

As part of their deepening friendship over the years they worked together, the musician and his photographer shared a passion for playing music, and Prince would often jam with Allen Beaulieu—longtime guitarist for the Crystal, Minnesota–based garage band Chapter Five.

"To me, Prince was almost anti-music because he was so involved with it," Beaulieu said. "He was *such* a musician."

One fateful night of jamming and musical improvisation would produce a key creative contribution to Prince's own musical legacy. "You're not going to believe this," Beaulieu explained, "but I wrote 'Let's Go Crazy.'"

Wait: Allen Beaulieu wrote "Let's Go Crazy"?

"I wrote the riff," he said. "I didn't write the words.

"We were at this place in St. Paul somewhere, and I was jammin' with Jellybean Johnson, Jimmy Jam, and Terry Lewis. I was playing guitar, and Prince got on drums for a while. I think that's his best instrument, by the way. Greatest drummer I've ever seen.

"He let me play guitar for about twenty minutes. He moved around, playing bass and keyboards, and finally he said, 'Al, I gotta play guitar.' We jammed for like four hours. Then he took me out to his house in Chanhassen, and when I played the riff that would become 'Let's Go Crazy,' he recorded me right there, plugged me into his board.

"Later, Prince was nice enough to say, 'What do you want for it?' I said, 'How 'bout I get a copy of the album before anybody else does? Just give me a cassette.' Next morning, he sends his assistant down and gives me the tape. It's not like he didn't know what it was worth. He heard something. It's only now I'm thinking: it's nothing like any song he's ever done.

"He never acknowledged it publicly; he's not that kind of guy. I never got a songwriting credit or my name on an album. That's just not Prince. But I know, and the few people that I've told know, because it's true." •

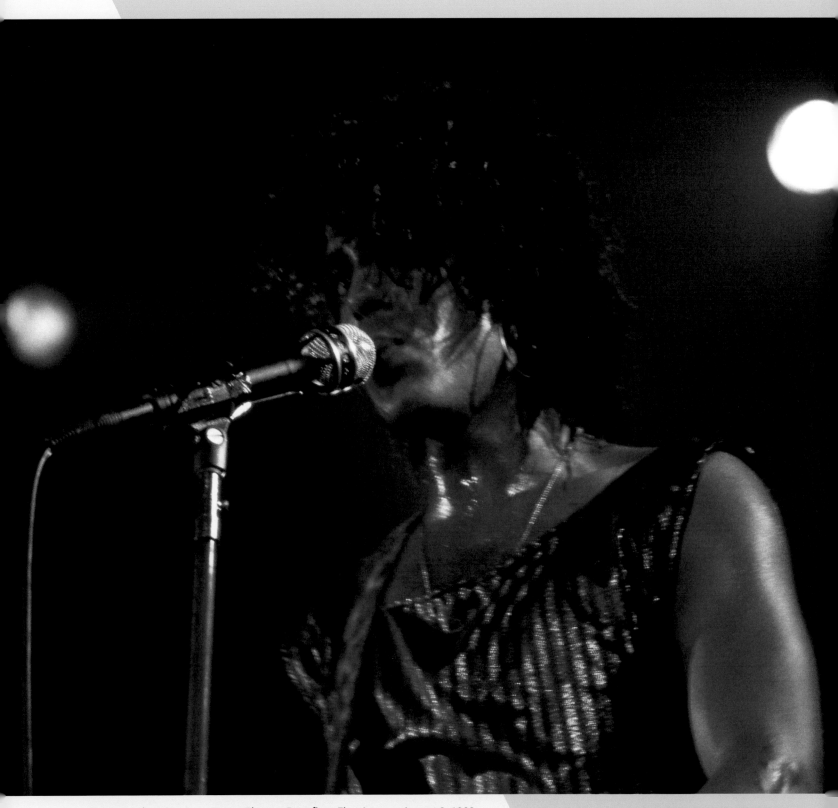

Prince at the Minnesota Dance Theatre Benefit at First Avenue, August 3, 1983

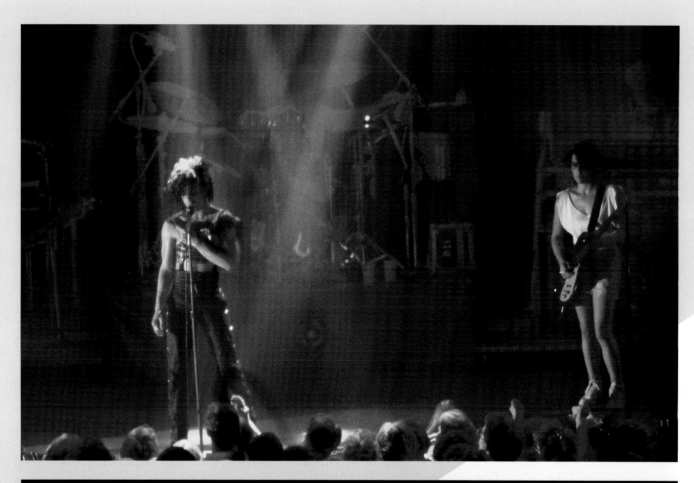

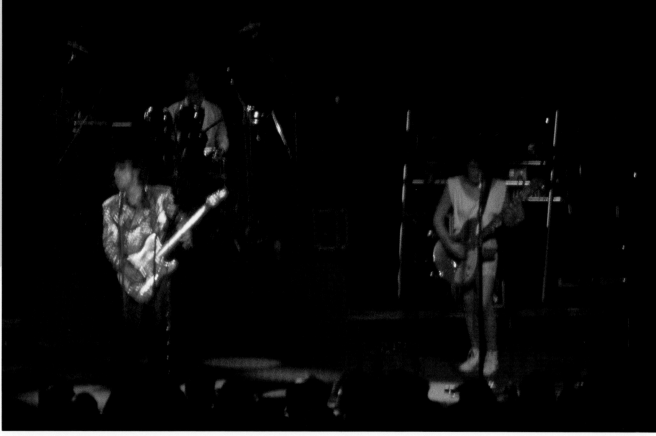

Prince performing with the New Power Generation at the Minnesota Music Awards, May 20, 1986

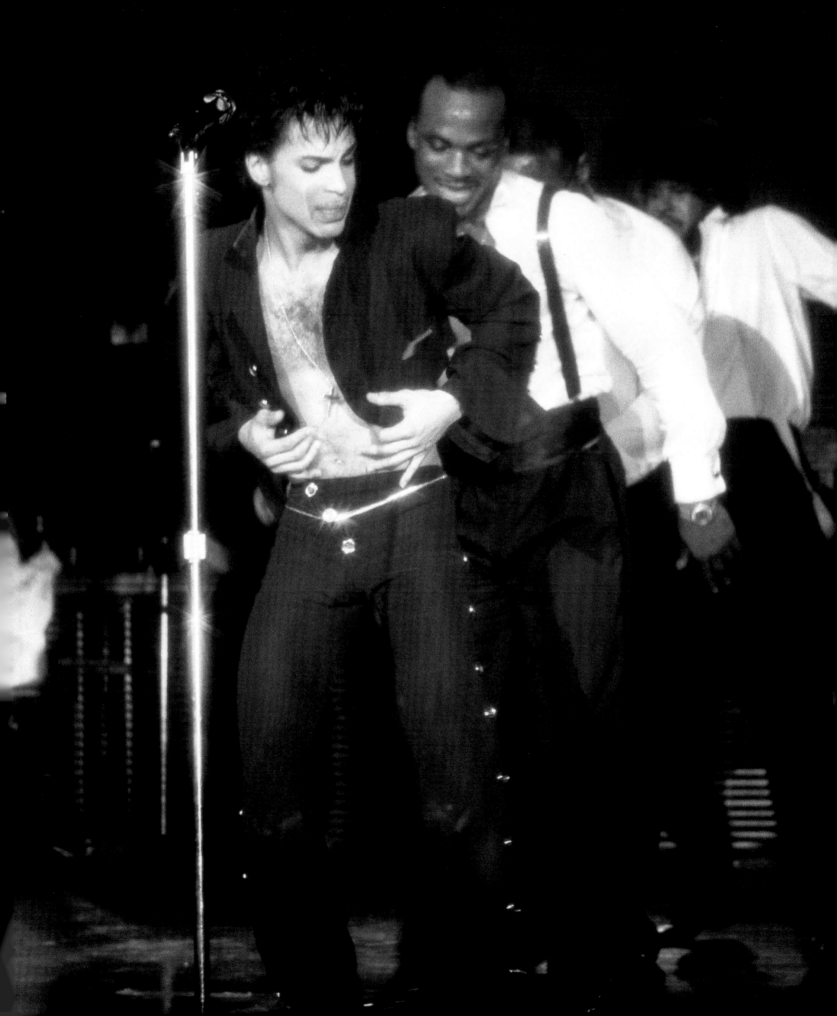

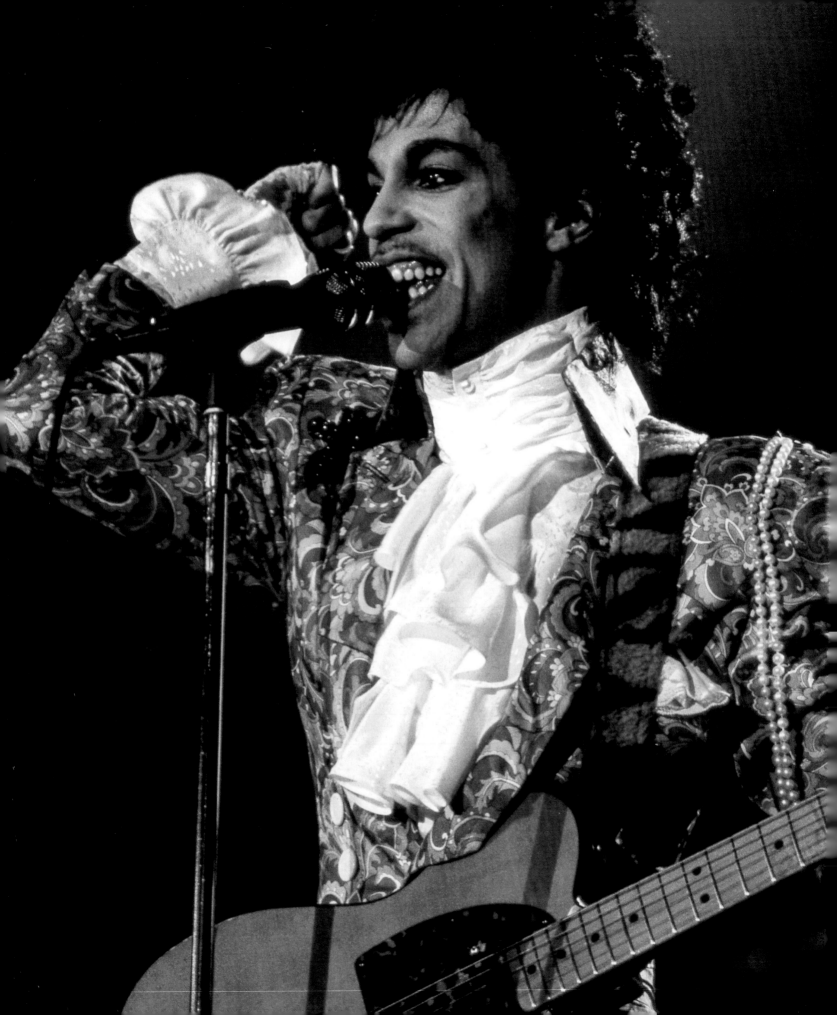

Acknowledgments

Thanks and appreciating: Prince. My dad, C. J. Beaulieu. My mom, Eileen—I think about her every day. Jenz Kulka, my rock. My brother, Rickey "Rick" Beaulieu. Mick Spence and Mary Beeman. All my assistants and Jay Smiley. Everyone that came to my studio. Also thanks to Jim Walsh and Danny Sigelman, for their contributions to the book, and to Josh Leventhal, Dan Leary, Alison Aten, and everyone at the Minnesota Historical Society Press.

— Allen Beaulieu

The publisher would further like to thank: Semira Mesfin and Lydia Newman-Heggie, for cleaning and scanning hundreds of slides; Tim Meegan, for his PhotoShop wizardry; Ryan Scheife of Mayfly Design, for his gorgeous (and fast) design work; Dean Vaccaro, for sharing his record collection with us; Eloy Lasanta, of the "Prince's Friend" YouTube channel, for his album reviews; Jim Walsh, for writing a fantastic introduction and other stories; and Danny Sigelman, for helping to bring this project to MNHS Press and for his assistance with interviews and image scanning for the book.

mnhspress.org

The Minnesota Historical Society Press is a member of the Association of University Presses.

Manufactured in Canada

10 9 8 7 6 5 4 3 2 1

∞ The paper used in this publication meets the minimum requirements of the American National Standard for Information Sciences—Permanence for Printed Library Materials, ANSI Z39.48-1984.

International Standard Book Number
ISBN: 978-1-68134-121-7 (hardcover)

Library of Congress Cataloging-in-Publication Data available upon request.

Designed and set in type by Mayfly Design. Photographs prepared for printing by color specialist Timothy Meegan.